WOMEN WHO DIG

WOMEN WHO DIG

FARMING, FEMINISM, AND THE FIGHT TO FEED THE WORLD

TRINA MOYLES

PHOTOGRAPHS BY KJ DAKIN

University of Regina Press

Printed and bound in Canada at Marquis. The text of this book is printed on 100% post-consumer recycled paper with earth-friendly vegetable-based inks.

Cover and text design: Duncan Campbell, University of Regina Press
Copy editor: Marionne Cronin
Proofreader: Kristine Douaud
Cover art: "Woman Cutting Grass" by pixelfusion3d /iStockphoto.

Library and Archives Canada Cataloguing in Publication
Moyles, Trina, author
 Women who dig : farming, feminism, and the fight to
feed the world / Trina Moyles ; photographs by KJ Dakin.
Includes bibliographical references.

Issued in print and electronic formats.
ISBN 978-0-88977-527-5 (softcover).—ISBN 978-0-88977-528-2 (PDF).
—ISBN 978-0-88977-529-9 (HTML)

1. Women farmers. 2. Agriculture—Social aspects. 3. Feminism.
I. Title.

HD6077.M69 2018 338.1082 C2017-907459-8
C2017-907460-1

10 9 8 7 6 5 4 3 2 1

University of Regina Press, University of Regina
Regina, Saskatchewan, Canada, s4s 0A2
tel: (306) 585-4758 fax: (306) 585-4699
U OF R PRESS web: www.uofrpress.ca

We acknowledge the support of the Canada Council for the Arts for our publishing program. We acknowledge the financial support of the Government of Canada. / Nous reconnaissons l'appui financier du gouvernement du Canada. This publication was made possible with support from Creative Saskatchewan's Creative Industries Production Grant Program.

CONTENTS

For my parents,
Linda and Dave

PREFACE

These stories are not mine. Over the past three years, they were generously shared with me by women and men, stories spoken aloud in more than ten different languages on three continents, stories broken like bread—memories, sorrows, and hopes—and passed across the table. Without the stories of more than 140 women who shared their experiences with me, this book would not exist. A thousand times over, thank you. Gracias. Mwebare. Chjonte. Merci. Nandri. Asante. My deepest gratitude for inviting me into your homes and gardens, for teaching me, for shaping the ideas held in these pages, and for entrusting me with your stories. Every word was a gift. "Stories are wondrous things," wrote Canadian author, Thomas King, in his book *The Truth About Stories.* "And they are also dangerous." For that last reason, I have chosen to change the names, locations, and attributes of many of the women whose stories grace these pages in order to protect their identities.

I also want to acknowledge the support of the grassroots community organizations that are working hard to support the efforts of small-scale farmers. These organizations were essential to my ability to create sensitive ways to connect with women farmers in the places where I traveled. I'm indebted

to these organizations for their willingness to lead me up and down dirt paths and to find meaningful pathways to capture narratives about women who dig, sow, and feed the world. I'm in awe of—and in solidarity with—your continued struggle for social and environmental justice.

INTRODUCTION

My great-grandmother, Eleanor, boarded a steamboat with her husband, David, and their two sons, John and Desmond, in 1925. She waved goodbye to Ireland's rocky shores, to the rolling green pastures, and to the stone-strewn farmland. They abandoned the marshy flats of Mount Mellick, a tiny village located in the geographical centre of Ireland where her husband was born. Ireland was a country that no longer wanted them. David had served the British Empire as an officer for the Irish Guard, for which the Irish separatists despised him. But beyond the fire that was smoldering between the British separatists and loyalists, my great-grandparents left Ireland because there was scarcely any land left to farm. David was the youngest boy amongst his four siblings. His father, a poor potato farmer, had nothing to offer his son. David inherited the knowledge of farming, but when it came to land, he only had rocks.

Eleanor and David fled their mother country and crossed the Atlantic in pursuit of what was called 'free land' on the vast spread of the Canadian prairies. My great-grandfather fought in WWI, and under the Soldier's Land Settlement Act of 1919 the British Empire offered him a loan to immigrate to Canada, settle on a quarter section of land outside Wolseley,

Saskatchewan, and sow wheat where the native prairie grasses once sprang from the earth. They traveled in winter, before the thaw and fertile promise that spring brings. When they arrived, Eleanor could not believe her eyes. The door to the farmhouse, a wooden clapboard structure, was wide open. The snow had accumulated inside the house like a massive heap of sugar. David handed her a shovel and they began, digging in, carving out a new life on the land only ten kilometres south of the Qu'Appelle Valley.

The story behind the naming of the Qu'Appelle River and Valley reveals that my great-grandparents were not the first people called to settle on the Canadian prairies. In 1804, Daniel Harmon, a Métis fur trader, paddled along the river and encountered a group of Cree hunters. The hunters told Harmon that a Cree spirit possessed the river, floating along the surface of the black waters, crying out in Cree, *"Kâ-têpwêt?"* *"Qui appelle?,"* meaning "Who is calling?" In 1852, the Hudson's Bay Company established a fur trading post along the Qu'Appelle River, and seventy years later, the forces of colonialism called my great-grandparents to the land that had never belonged to the Canadian government to sell.

For ten thousand years before David and Eleanor came, Indigenous communities lived in spiritual communion with the land without owning the land. Land ownership did not always align with Indigenous cosmologies: land was the foundation for the life force; it could not be owned, but it was known, navigated, and managed in complex ways, according to each group's traditional ecological knowledge and understanding of geography, botany, wildlife, weather, and the seasonal changes. The Blackfoot, the Assiniboine, the Dene, the Cree and Saulteaux, and Métis peoples, amongst many other Indigenous groups in the west, were hunting and gathering peoples who depended on the earth in diverse ways: harvesting roots, berries, bark, and wild plants, and hunting moose, elk, deer, bear, and woodland caribou. Many Indigenous groups on the prairies followed the migratory paths of buffalo throughout the expanse of what would come to be known as western Canada.

But when Eleanor and David arrived in 1925, the buffalo had been wiped clean from the prairie landscape, exterminated by the fur trade and the penetration of the Canadian Pacific Railroad. The stretch of grassland was cut up, divided and stitched back together like a patchwork quilt. In 1870, the Canadian government bought 'Rupert's Land,' western Canada, from the Hudson's Bay Company and forced Indigenous groups to sign over their former migratory territories in exchange for fragmented, often marginal, reserves of land. With the buffalo, their primary food source, long gone, Indigenous groups were essentially starved into surrendering their land. Meanwhile, the Canadian government embarked on a mission to develop the West into a breadbasket of grains and meat. Settler farmers, including my great-grandparents, converted an ocean of native grassland into millions of square patches of grains, pulses, and pastureland to feed and fuel the industrial centres in eastern Canada. Canada's first immigration policies, including the Dominion Lands Policy in 1872, offered settlers 160 acres for a mere ten dollars. These policies, and affordable prices, were devised to attract immigrant settlers to occupy land in western Canada—and they worked. As a result, thousands of European immigrants moved west across the Atlantic to build their homes from wood and sod, and to sow seed on the fields where buffalo once grazed in the thousands. From 1870 to 1930, the Government of Canada issued approximately 625,000 land patents to homesteaders. Between 1901 and 1931 the amount of prairie land turned to grains, pulses, and pasture proliferated from 1.5 to 16.4 million hectares.

My grandfather, John, grew up memorizing and immortalizing everything that happened on that patchwork square on the Saskatchewan prairie flats. His father, David, grew fields of maize and wheat, while his mother, Eleanor, cultivated an abundant garden with potatoes, carrots, purple beets, beans, peas, and giant heads of cabbage. They kept cattle, pigs, sheep, chickens, and a team of draft horses for pulling the plough through the fields. Every spring, Eleanor sheared the sheep for wool and spun it into yarn. When she wasn't farming, she was cooking, canning vegetables, scrubbing away the prairie

dust, and doing everything else that held the family together like a knit garment. Even during the 1930s, when the Great Depression ground the land into dust, scarcity, and want, my great-grandparents hung on, living off of Eleanor's preserved foods and their hard labour and resourcefulness.

Throughout my childhood and adolescence, I loved listening to my grandfather's stories of life on the farm. He and his brother, Desmond, ran wild, as farm boys do, target-shooting from the barn roof, chasing snakes, and rescuing baby owls that had fallen from their nests. When the two-seater planes flew low over the maize fields, they chased the planes with their arms outstretched, trampling the young crops, without a worry in the world. My grandfather showed me an old black-and-white aerial photograph of the farm. He pointed at two distant figures standing outside the farmhouse. It was Eleanor and David, looking up into the sun and waving.

Though their closest neighbour was a kilometre away down the skinny dirt road, Eleanor and David were social people, often entertaining neighbours with tea and meals. I treasured a small, square snapshot of two dozen men and women gathered round a large bonfire. They were holding long sticks with maize on the ends, which hovered over top of the large coals and fire blaze. Every June, after the first harvest of the sweet kernelled crop, my great-grandparents held a maize roast on the farm, inviting neighbours and friends. In the photo, David stands in the middle of everyone, roasting a long cob with a large crooked smile on his face and a newsboy hat on his head. Eleanor wasn't there. At first, I wondered if she was the one who took the photo. Later, I thought she was probably in the kitchen, boiling potatoes, peeling carrots, and tending to her guests, as farmwomen do. The photo felt to me oddly symbolic of my great-grandmother's experience on the farm. Eleanor wasn't in the picture, biting into the sweet maize, enjoying the harvest. She was a ghost behind the scenes. She was also the last to eat.

People would say that's just the way it was for farmwomen back then. They were 'farmwomen,' after all; they weren't 'farmers.' Between David and Eleanor, it was he who hitched the

team to the plough, climbed into the driver's seat, and held the soft leather reins. It was David who watched for bruised skies and rainclouds, calculated when to sow, and gathered with other men in town to complain about what to do with maize scab and to ask, "Where's the rain gone?" It was he who harvested and sold the crops, and came in from the fields to eat first. Eleanor was not invisible, of course. She was there and she was vital. But society did not see her as a farmer in the same way it saw her husband. Her knowledge and labour were invisible.

All of that changed when WWII broke out.

Eleanor soon found herself alone on the farm. In 1941, she waved goodbye to David and her eldest son, Desmond. In 1942, my grandfather, John, was barely a day over eighteen when he jumped on his horse and raced into Wolseley to enlist in the Canadian Reserves. He wanted to fly. After my grandfather was transferred to Prince Rupert, BC, Eleanor was all by herself. She was one body to nearly two hundred acres of grains, pulses, maize, and pastureland. Overnight, Eleanor had found herself a farmwoman *and* a farmer. The team of draft horses pawed at the floor, impatient to get out. They were indifferent to her gender. What was she waiting for?

During WWII, Eleanor was among thousands of Canadian women left behind on farms. They bid their husbands and sons and brothers and uncles and the farmhands farewell. They watched them drive away down the thread-thin roads. They felt the distance and uncertainty that war brings reverberating through the vast sea of the prairies. Government officials worried. Canada's agricultural productivity was suddenly in question. With farmers gone off to war, what would happen? Would production plummet like a hammer from the sky? Would the country go hungry?

When my grandfather John told me Eleanor's story, I was inspired by what I could only imagine. My great-grandmother: a farmer created out of hardship.

I imagined Eleanor inside the farmhouse, perched by the window, contemplating the swell of loneliness she must have felt looking out at the farm. I wondered how she survived the

wide-open skies and silence of the Saskatchewan prairies, of the fields of maize and wheat, of the huge garden behind the farmhouse, of the skinny yarn of dirt road that unravelled itself for kilometres before reaching the nearest neighbour.

I imagined how Eleanor's hands wrapped around the crude stem of the hand hoe to slowly open and work the earth in the garden, or the way they tenderly held the soft, warm flesh of the dairy cow's teats to gently ease out her daily milk. I wondered if her tasks on the farm—the busying of hands, the breaking of sweat and spine and muscles, the immediate worry of finishing up before dark—I wondered if these tasks eased the anguish that must have otherwise been occupying her every thought about her husband and sons. Would they come back?

I saw her waking before the sky had dawned, with everything drenched in shadow. She would emerge from bed, perhaps from a dream that led her closer to her boys. Milk the cows and turn them loose on the pasture of alfalfa. Feed the chickens; pull the warm eggs from the noisy laying hens. She would tend to the garden, bent at the waist, plucking weeds that were crowding the potato mounds, then break for lunch and eat biscuits without butter, vegetables without salt. These were part of the rationed foods, the foods Eleanor knew and liked to think were sustaining her boys, a living extension of her flesh, as they served and sacrificed overseas. Her work was their sustenance.

There were saskatoon berries to pick, the cornfields to examine for pests, the pigs to feed organic scraps. The compost needed turning, the green beans harvesting, and the caragana bushes that lined the edge of the farm property needed to be chopped for firewood. Eleanor hauled buckets of rainwater into the house for cooking, washing linens, and cleaning. She would run a damp rag along the surface of the wooden bed frames, desktops, and bookshelves that belonged to her boys. She'd push out the dust, which felt like a reminder of her aloneness in the farmhouse that held all of her longing on the vast prairies.

In the fields, Eleanor was in the driver's seat, murmuring in low tones to the draft horses with their clunky feet and long

manes concealing their eyes. Their ears would twitch, hearing her voice and responding to her call and command. She prepared the land, sowed the seed, and harvested. It was Eleanor who went to town, gathered with other women left behind, and traded farming secrets. It was Eleanor who, among the women, first began to sell what she'd grown, harvested, raised, butchered, and prepared for market.

She became the farmer.

Eleanor wasn't alone. During WWII, over a million Canadian women took to the farms and fields to farm, just as they'd taken to the factories to work in the manufacturing industry, according Ian Mosby, author of *Food Will Win the War*. But the government added a suffix to the female farmers' titles. "Farmerettes," the government called them, as though '-ettes' made what a million sets of hands did somehow dainty and light.

The title made me laugh. I envisioned a farmer without dirt under her nails, with red lips and manicured hands. Of course, that was the government's intent: to *feminize* farming, to make farming more attractive, more appealing. It was part of a larger campaign to draw rural and urban women alike back to the land to "serve their country," pitchforks in hand, to respond to the shortage of male farmers and labourers. The government distributed flashy posters of the sexy, charming Farmerettes in action—perched on tractors, picking plums from a fruit orchard, tossing their hats victoriously into the sky—to encourage women to dig in and do their part to sustain the war efforts in Canada and Europe.

In the towns and cities, the government asked women to tear up the sod in their front yards and plant "victory gardens" with vegetables and herbs to supplement their diets and ensure proper nutritional intake. Women responded in masses and became one of Canada's earliest examples of the population participating in institutionalized urban agriculture. By 1944, the Department of Agriculture reported that there were 209,200 victory gardens in the country, producing over 57,000 tonnes of vegetables. During WWII, my great-grandmother and

other women farmers and farm labourers contributed towards record-high levels of agricultural productivity in Canada. When France fell in late 1940, Britain became almost entirely dependent on Canada for grain imports. By 1941, Canada was supplying 77 per cent of Britain's wheat and flour consumption, along with 39 per cent of its pork, 15 per cent of its eggs, and 24 per cent of its cheese. Near the end of the war, Canada was still providing over 50 per cent of Britain's wheat requirements. Due to women's work on the farms and the national war efforts as a whole, which included rationing, gardening, and food preservation, grain production and exports increased by 800 per cent and hog production by 250 per cent. The women whose work was formerly overlooked suddenly became farmers in the eyes of society. Women played many roles in the success of Canada's agricultural system during WWII.

But after the war, Eleanor dusted off her hands and referred to her work on the family's farm as "just a small war effort"—as though it had been nothing. But, indeed, it was something. It represented a major shift in society's perception of what women could achieve outside of the domestic sphere. It was a shift in how women perceived themselves, as well.

After David returned to the farm in Wolseley, a military official called to offer him a promotion to Lieutenant and a position in Ottawa. My grandfather told me that he just smiled and shook his head. "No, I think I'm going to stay on the farm. My wife here has done enough," David said, winking at Eleanor, who was drying the dishes.

Despite her enormous contributions, Eleanor's efforts as a farmer barely register in Canadian history. The Farmerettes' stories were told in the footnotes of history textbooks, the ones you have to strain your eyes to see, like tiny figures in the distance, swinging the hand hoe steadfastly into the earth. I grew up listening to my grandfather tell stories about his time in England, flying low in the sky and dropping bombs on the Germans. The stories told about WWII were mostly about men, stories I learned at Remembrance Day ceremonies, in history class, and by watching Hollywood movies. Men falling from

the sky. Men at the front lines, victorious. Women tended to the wounded, fixed the bloody soldiers with their skill and solace. And on the home front, they darned socks. But women rising to the challenge of feeding a country and the war effort in Europe? What happened to that story? Why didn't women make history the way men did?

I am not a farmer. My mother is not a farmer. My grandmothers never farmed. My closest connection to planting the earth is through my great-grandmother. When I listened to Eleanor's story, I felt deeply moved by memories that were not mine. I could not put my finger on *why* I cared so much, why I longed to crawl back into history and take Eleanor's photo, not as a 'Farmerette,' but a farmer—a hard-working, capable woman farmer.

Much later along my journey of writing this book, I would come to meet an Albertan farmer who confessed that her desire to farm was guided by what she called "the cellular memory" of farming. "Even thousands of years ago," she told me, "women harvested wild seeds and stored them in woven baskets. We have always known farming, but somewhere along the way, we forgot our past."

WERE WOMEN THE WORLD'S FIRST FARMERS?

History has been written largely by men. The story of the Stone Age that is most widely understood in popular imagination goes like this: early Man was the hunter and early Woman was the gatherer. For generations, archaeologists believed the gendered division of labour was perfectly halved. Man left camp, tracking animals with spears and felling birds out of the sky with stones. Woman stayed behind, harvesting berries, roots, and wild edibles, with her infant latched on to an engorged breast. But by the 1960s, scholars began critiquing the old story, while pointing to new evidence that indicated early humans were more egalitarian, without a clear-cut division in gender roles. Scholars have postulated new narratives in which they argue that foraging societies, which survived mostly on meat,

would have involved both men and women in hunting activities. When men went off to hunt alone, women did not merely remain at camp with suckling babies, sitting idly. On the contrary, women procured large amounts of food through foraging. Their hands never lay idle; their hands flew, transforming the world around them. While men were off hunting, women were making tools for future farming societies.

In their book, *The Invisible Sex: Uncovering the True Roles of Women in Prehistory*, anthropologists Adovasio, Soffer, and Page write:

> It has come to light that female humans have been the chief engine in the unprecedentedly high level of human sociability. [Women] were the inventors of the most useful tools. [Women] shared equally in the provision of food for human societies. And [women] were the ones who created agriculture.

They argue that when women's work diverged from men's work as hunters, it eventually transformed human culture. One of the earliest pieces of evidence to support this theory is a 300,000-year-old digging stick called the "Clacton Tool." This stick is a fragmented piece of wood unearthed in 1911 near the town of Clacton-on-the-Sea in England. Originally, male archaeologists argued that it was a spearhead made by paleolithic men and used for hunting purposes. In the 1960s, female archaeologists pointed out that it could be the world's first agricultural tool: a digging stick made by women who used the point to harvest wild tubers for food and medicine.

Yet another invention by women dates back to 30,000 years ago when women, left behind at hunting camps, sliced open thin trees and reeds and braided the wet fibres into string and rope. The technology of fibre making, argues the scholarly linguist Elizabeth Wayland Barber in her book *Women's Work*, was as important to the transformation of human culture as the steam engine. Women wove fibres into baskets for harvesting foods and storing wild seeds. Baskets, made by women,

were a vital tool as evolution moved humans towards domes-ticated agriculture. It's thought the shift to domestic agricul-ture and more sedentary lifestyles began during the Neolithic Era, around 10,000 years ago. In southeastern Turkey, near the bottom of Mountain Karacadağ in Anatolia, archaeologists found einkorn, the world's oldest single-grain wheat. Archae-ologists and historians of early civilizations speculate that as cultures shifted from foraging to farming, seeds—most likely carried by women—dried, fell from their hands and baskets, and germinated in the earth. After the cultivation of wheat came barley, peas, lentils, chickpeas, and flax seed.

Evidence of wheat, barley, pigs, and sheep from 9000 to 8000 BC in southwest Asia suggests that it was one of the earliest regions in which humans transitioned to a sedentary agriculture lifestyle. Evidence also suggests that, after 2000 BC, humans in sub-Saharan Africa began cultivating rice, sorghum, and millet. In Mexico, before 5000 BC, the Maya began growing varieties of squash, avocados, peppers, beans, and maize, and by 1000 BC, Indigenous cultures in eastern North America were cul-tivating marsh elder and sunflowers. Thousands of years later, Indigenous people from Mexico would introduce beans, maize, and squash to Indigenous groups in North America.

Indigenous women throughout North, Central, and South America planted seeds of maize, beans, and squash, which they called the sacred "Three Sisters." This polycrop supported a prosperous harvest: the maize, planted first, grew tall and strong and served as a pole on which the second crop, beans, climbed as they grew. Beans deposited nitrogen into the soil, which enhanced the growth of maize. Finally, squash seeds were planted last, which, when grown, covered the soil with a leafy carpet that prevented erosion from wind and rain. In Canada, the Huron First Nations people were among the ear-liest farmers, planting and worshiping the Three Sisters on the fertile land surrounding the Great Lakes.

In the northern boreal forests in Canada and the United States, a variety of wild rice grew at the swampy edges of water bodies. Indigenous groups, including the Ojibwa and the

Menominee, paddled their canoes into the stands of rice and used wooden hand tools to bend the heads of the grain stalks. The delicate seeds showered down and filled the bottoms of their canoes.

UNFORTUNATELY, IN MANY CULTURES the cultural shift from foraging to farming also led to marked changes in equality between women and men. Scholars, including Mark Dyble, an anthropologist at University College London, believe that as societies transitioned from hunting and gathering to sedentary agriculture the social dynamics between men and women changed. Hunting and gathering cultures were believed to be more egalitarian due to the immediacy of survival. Men and women had to stick together because they needed one another to survive on a daily and seasonal basis.

But the onset of agriculture allowed people, for the first time in history, to harvest, store, and accumulate large reserves of resources. People saved food, kept livestock, and stored seeds. Women had more children and, in many cultures, men had more wives and sexual partners. Men also began to seek kinship and social alliances with other males—trading in food goods, livestock, and seeds. Women, too, became resources to accumulate and trade: wives to marry, and daughters to barter for more resources.

Did the arrival of agriculture create the foundation for patriarchal organization? Sedentary food production enabled different cultural groups to grow in population and, through power exerted across kin and social alliances, to establish social hierarchies. Societies grew and expanded. Some collapsed into dust and ruin. Other prospered by exerting violent force and dominance over neighbouring people and their resources, often on women's bodies.

Much of civilization as we know it today began, in part, with a handwoven basket filled with wild seeds. The first seeds, cultivated more than ten thousand years ago, have given rise to over seven billion people living on the earth today. Population rates

and global consumption of food, water, energy, and natural resources are all rapidly increasing and exceeding their sustainable limits. Scientists are nearly unanimous in agreeing that, at the current rate of fossil fuel emissions and rapid deforestation, climate change will increase in the unpredictability and severity of its effects. The United Nations' Food and Agriculture Organization (FAO) estimates that the global temperature will rise two degrees Celsius every year, increasing the difficulty of growing the world's most common grains, including maize, pulses, rice, and wheat. Political and economic instability, war, and conflict are causing mass displacements and diasporas of people, many of them farmers, who have fled to dense urban environments. Uncertainty is looming: how will the world feed eleven billion people by 2100? Many scholars, including Raj Patel, author of *Stuffed and Starved*, argue that food security isn't a question of producing *more* food, but challenging the unjust structures of the global food system to distribute food more fairly. The global corporatization of agricultural production, processing, and distributing is currently dictating *who* eats *what* and *where*.

Poverty and forms of malnutrition are prevalent in countries and communities on every continent. More than 50 per cent of pregnant women in sub-Saharan Africa are suffering from anemia due to a lack of protein in their diets. At the other extreme, more than 30 per cent of Americans suffer from the health complications of obesity, including skyrocketing rates of heart disease and diabetes. The global food industry affects women's bodies and women's health in different ways that vary according to geography, class, ethnicity, marital status, religion, culture, and politics. The common thread of patriarchal food systems, however, is that they tend to ensure that *women eat last*.

AFTER UNCOVERING my great-grandmother's nearly forgotten efforts as a farmer during WWII, I began to connect the past to the present. I wondered, How were female farmers, seventy years later, responding to the global food crisis in different

communities and countries around the world? What narratives, voices, and experiences were missing from the stories being told about how food is grown around the world? Were women's realities, efforts, and contributions to agriculture truly being represented? The UN estimates that women make up nearly half of the agricultural labour force in developing countries, ranging from 20 per cent in Latin America to over 50 per cent in sub-Saharan Africa. In Western, developed countries, the percentage of female farmers is significantly less: only 27 per cent in Canada and 14 per cent in the United States. The most recent Census of Agriculture in the United States showed that the number of female farmers was actually decreasing more rapidly than male farmers. I wanted to peer inside the statistics and see the faces of these women, to stand ankle-deep in their gardens, to cradle their seeds in my hands, to honour their work as farmers, and to listen to their stories.

Inspired by my great-grandmother Eleanor's story, I set out to travel around the world to meet with women in their gardens, farms, and homes. I hoped to discover how women in different countries were involved in growing and distributing food. I was curious to know how they related to farming, what it meant to them—economically, socially, culturally, and even spiritually. What were they growing and feeding their families? What did the land and the history of the land mean to them? How had they come to call themselves farmers? Did the rest of their societies refer to them as farmers? Most importantly, what challenges were they up against and how were they struggling, individually and collectively, to overcoming these challenges to feed their communities?

Admittedly, I began my journey in the same kind of voyeuristic tradition that has guided the travel narratives of privileged protagonists for centuries. For nearly a decade, I had worked in the sector of international development, collaborating with grassroots community-based organizations on sustainable water, food security, and gender equality projects in Canada, Latin America, and East Africa. Through my work, I often documented the stories of men and women—many of

them farmers—for the purposes of reporting to government donors and funding bodies, or for justifying the need for future development projects. When I set out to write a book about women and farming, I knew that I didn't want to ask questions as a development practitioner. I wanted to tell stories that moved beyond the NGO jargon that focuses on 'project beneficiaries,' 'risks,' and 'results,' without fixating on outcomes, and instead, invited humanity and complexity into the conversation. When the idea for this book was born, I wanted to engage as a storyteller: to witness, learn, participate, and listen with all of my senses. I yearned to scratch below the surface of women's stories and their complex realities. I didn't want to write a book that showcased problems and ready-made solutions. I hungered, only, for stories and all of their nuances.

Over the course of three years I followed women into their gardens of sweet potatoes, maize, beans, okra, wheat, and rice. I stood ankle-deep in the crops they grew for their families' sustenance. I sat in their kitchens, on their patios, outside on woven grass mats. I played with their kids, helped them haul water in buckets and plastic jerry cans, watched them boil *tamales* in banana leaves, milk their buffalos, goats, and cows, and chop firewood with machetes. I asked endless questions about the histories of their lives on the land, in their homes and markets, and in their larger societies. I attended community-organizing meetings with women and men where they collectively saved money, strategized together, shared ideas, and planned for their futures. I shook the hands of the women's community leaders (usually men), and on several occasions left at exactly the right moment when their intoxicated husbands stumbled home and things turned ugly.

I recognized how stories of women, land, and farming contain many layers, many voices, and many challenges and opportunities. I began to realize the enormity of my goal to capture women's experiences about food and farming. Nowhere did I struggle more with this complexity than in the place where I grew up. It was true that the story of my great-grandmother was not recorded in history books. But further buried was the

story of how agricultural expansion on the prairies uprooted Indigenous women in Canada: women who knew the skin of the earth as they knew their own flesh, who had dug beneath the ground, harvesting roots for food and medicine. Indigenous women wove baskets and gathered berries. They cut, dried, and processed the animal meats and skins. They pounded dried meat into small bits and added melted fat and berries, creating an energy-packed food called *pimîhkân*, or pemmican. Indigenous women were the first cultivators on the land, displaced by the same colonial project that gave rise to both my great-grandmother's hardship and suffering, and her historic success as a farmer during WWII.

The history of agriculture and patriarchy—and what it means today in a contemporary sense—is layered, complex. It is full of bright joy and power in resistance, but also darkness, tragedy, and suffering. It humbled me, knowing that I could not include every voice, every layer of complexity in this book. For the voices and experiences of women that I did not include in this book, I express my frustration and regret. But this much I know is true: that stories always inspire more stories—and different stories. This book is not the first, and will certainly not be the last, about a topic of huge relevance and a story that could be told a million different ways.

Over three years, I met face to face with over 143 women from dozens of rural and urban communities in Guatemala, Nicaragua, the United States, Canada, Cuba, Uganda, India, and a refugee camp in southwestern Uganda where approximately twenty thousand Congolese female farmers have been displaced.

"What does it mean to be a farmer?" I asked the women, and they responded in more than ten different languages. Some women laughed, some of them wept. And others weren't sure where to begin because no one had bothered to ask them the question before.

I. UGANDA

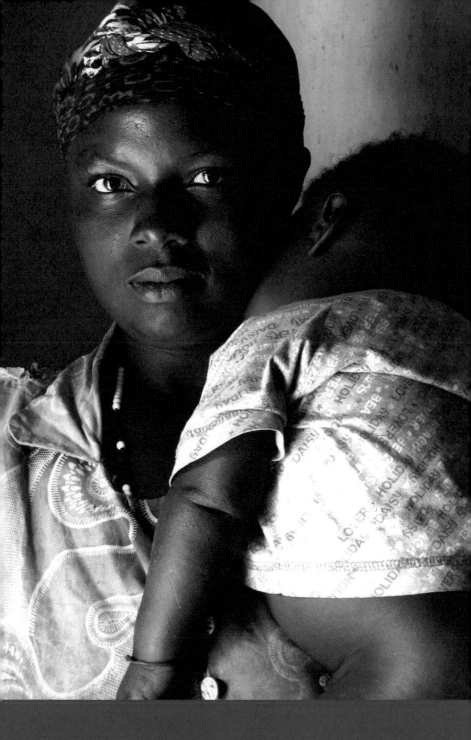

A Bakiga woman from a village in the Kabale District of southwestern Uganda holds her youngest child. Women in this region typically access land through marriage. Over 70 per cent of women in rural Uganda are engaged in small-scale to subsistence agriculture, growing food staples, including sweet potatoes, beans, sorghum, and cabbage. (Photo by Trina Moyles)

"A woman without land is not a woman," said Mariam.

She poured another glass of *obushera*, a traditional porridge made from fermented sorghum grain. "If you don't serve your guests *obushera*, your house will be eaten by rats!" cautioned a common Bakiga proverb. *Obushera* defined the Bakiga people, one of the main cultural groups in southwestern Uganda. The drink was gritty in texture and sour in flavour, definitely an acquired taste. I swallowed it down to please my hosts, seven women from the village of Mirindi who worked together in a farming group. We sat on the edge of Mariam's land, a quarter acre of thick clay-based soil, where I'd found the women digging that morning. They swung hand hoes high above their heads and down into the ground, breaking up the soil in preparation for planting beans. They made it look effortless, even graceful. A young woman sang a church hymn as they swung in and out of unison, barely breaking a sweat. The Bakiga were known throughout the country as the *abataka*, the 'people of the soil.'

At six o'clock that morning, I left Kabale town on the back of a *boda-boda* motorcycle taxi to travel to the remote village. The rains had just returned to southwestern Uganda, making the red dirt roads impassable by vehicle. Frequently, I was forced to get off the bike so the driver could pass through the small lakes and bogs that occupied the road. The red road penetrated the rolling green hills, creating a breathtaking landscape dotted with villages and houses made from adobe red bricks and sorghum-thatched roofs. From Mirindi, it took three to four hours to walk to the larger markets in Kabale town, but that distance didn't deter people from making the journey. On the way we passed many people en route to the markets: women carrying woven baskets of sweet potatoes, men pushing bicycles loaded down with pineapples and bunches of green *matooke*, plantains, one of the Uganda's staple foods. Barefoot boys flicked sticks onto the flanks of the long-horned Ankole cows and the scraggly gangs of goats, and waved to me as I passed: *"Muzungu!"* "White person!"

Uganda was an oasis of political calm, a country surrounded by periodic and ongoing chaos within other countries in East Africa: Congo to the west, South Sudan to the north, Kenya to the east, and Rwanda to the north. Agriculture was the backbone of Uganda's economy with 85 per cent of the population dwelling in rural villages, growing food for their families, and working in agriculture as small-scale farmers and farm labourers. The coffee and tea plantations—Uganda's largest export commodities—spread out like soft blankets across the gentle, flat terrain located around the capital city of Kampala. Further south, steep hills rose out of the earth and farmers climbed the slopes to sow food crops. What they harvested was sold in regions across Uganda and into the countries of East Africa. Farmers in southwestern Uganda fed the nations. The higher altitude, colder temperatures, and regular rainfall in Kabale created fertile conditions to grow sweet potatoes, carrots, green cabbages, beetroot, and a wide variety of other vegetables and fruits.

"We don't have tractors in Kabale," a male friend said, jokingly. "We have women." Nearly 70 per cent of women in southwestern Uganda were farmers and farm labourers. In Bakiga culture women cultivated the traditional crops of sorghum, sweet potatoes, peas, maize, and beans to feed their families. Traditionally, men practiced polygamy, marrying multiple wives and producing large families. The more wives a man had, the richer he was in the community. Local culture obliged him to build his new wife a home and give her land to farm. Bakiga men inherited land from father to son, but it was the girls and women who did the majority of work on the land. They cooked, cleaned, gathered firewood, and fetched water. They raised the children and tended to the elderly. On the land, they shouldered nearly every aspect of production: tilling the earth by hand, preparing the soil, planting, weeding, and harvesting. Society knew them as the *abahingi mukazi*—'women who dig.'

Despite all of their labour on the land and contribution to food security in the region, women weren't called 'farmers.' They didn't grow cash crops. They didn't drive tractors. And they didn't own land. "The woman has no land of her own. We

dig on our husband's land," said Mariam, speaking on behalf of the group. In her fifties, she was one of the oldest members. She was what they called the "big drum" in the group. Amongst the other "smaller drums," Mariam beat hers as loudly and for as long as she desired. "Even if your husband passes away, people will say, 'That is the land of late-so-and-so,'" she said. "It belongs to your sons, or your husband's brothers. Even if you buy land with your own money, your husband will be the one to sign the land titles. Women here do *not* own land."

Mariam was born in a village on the other side of the hill before Uganda's independence from the British in 1952. She never went to school—there weren't any schools in the villages when she was a girl—but her mother taught her everything there was to know about growing food and foraging for wild pumpkin, mushrooms, passion fruit, and spinach. When she was strong enough to hold the *efuka*, the traditional hand hoe, Mariam began to dig in the fields with her sisters and mother. At age sixteen, her father arranged her marriage to a young man in Mirindi. The boy's family led a dowry of goats and carried gourds of *obushera* to Mariam's home on the other side of the hill. After the wedding, Mariam followed her husband back to Mirindi and began to farm on a small piece of his inherited land.

Mariam gave birth to her first child by the time she was eighteen, labouring at home and attended to by her mother-in-law and a traditional birth attendant. They supported her in a low squat and held a hand over her mouth, muffling her cries and forcing the pain back down her throat. She delivered six children that way. The seventh came suddenly when she was alone working in the fields. Feeling the urge to go to the bathroom, Mariam squatted down in a field of cowpeas and grunted as her baby slipped into her hands: a boy, a blessing in Bakiga culture. Boys stayed on their family's land, caring for their parents. Girls always left, in search of husbands and land. Giving birth to a boy was a way of ensuring a retirement pension in Uganda.

A woman worked the land up to the ninth month of pregnancy. After delivering, she'd tie her baby on her back and return to work, breastfeeding her child in the fields. "The sorghum

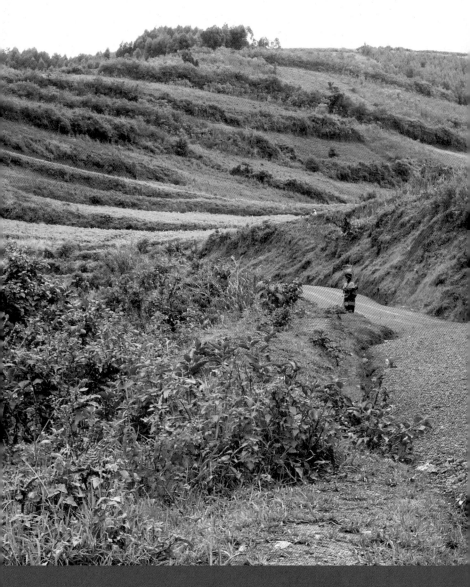

Every morning, women walk several kilometres to reach their farming plots in rural villages in southwestern Uganda. Due to pressure on the available arable land in this densely populated region, farmland is fragmented and scattered over kilometres. Some women walk up to two hours to reach their land every morning, carrying their *efukas* (hand hoes), seeds, infants and children, and packed lunches. (Photo by Trina Moyles)

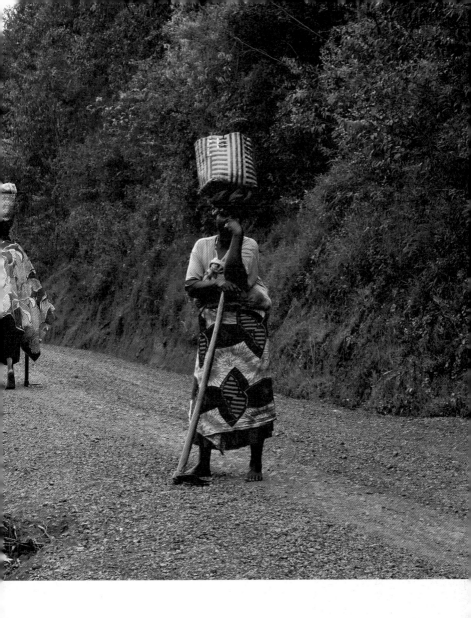

harvest is the worst," admitted Mariam. "The sorghum leaves are sharp and can easily cut your baby. You can't place her on the ground for the fear of snakes." But what was the alternative? I glanced over at Diana, one of the youngest women in the group. She was making an umbrella for her newborn baby where he lay wrapped in a cloth with purple and blue flowers, resting on the ground. Diana untied her headscarf and draped it over two sticks. He slept peacefully in the shade where the beans would soon grow. "Is there any woman more burdened

than the Bakiga woman?" Mariam laughed, revealing a dark gap between her two front teeth. "If so, I would want to meet her and shake her hand."

It was an understatement to say that rural women were burdened in southwestern Uganda. The region had some of the highest rates of child malnutrition, with 50 per cent of children under five weakened by kwashiorkor, a disease caused by protein deficiency. Even though Uganda's public health system had advanced considerably, women were still more likely, by a wide margin, to give birth at home than in a hospital. With an estimated 50 per cent of pregnant women suffering from anemia, many women risked dying from haemorrhage at home, and most were too poor to afford transportation to the hospital and the costs they would incur there. As farmers, women couldn't risk losing land. Land was the lifeline that kept their families alive. A woman was lucky if her husband found daily wage labour on larger farms or on construction sites in town. But many women's husbands were idle in the villages, socializing with other men at local pubs, playing cards, and drinking *maramba*, an alcoholic beverage, or purchasing plastic packets of *Waragi* gin for less than twenty-five cents. "The man is president in the home—he does what he wants," said Mariam. "He knows that everything belongs to him. You are his property and what is yours is also his."

The issue of women owning land and property was part of a long-standing debate in Uganda. In 2013, female members of Parliament amended and reintroduced the Marriage and Divorce Bill for the fourth time since it was originally proposed in 1964. The bill would grant marital property rights to Ugandan women for the first time in history, giving a woman equal rights to her husband's land and assets. It also recognized a woman's right to refuse having sex with her husband and criminalized forced sex as "marital rape." The bill sparked outrage in Uganda. Male politicians labeled it the 'Women's Bill' and argued that the female architects behind the bill were looking to undermine tradition and benefit at the expense of men. Wafula Ogutta, a male MP representing a district in

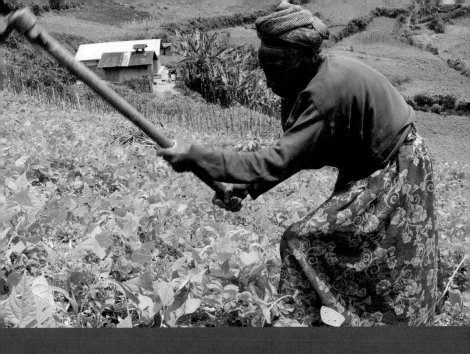

A ninety-year-old *mukaka* (grandmother) swings her *efuka* (hand hoe) in her plot of beans in the village of Mirindi, in the Kabale District of south-western Uganda. This region of Uganda is dominated by dramatic hillsides. Women must climb, dig terraces into the hillsides, and sow their seeds. Grandmothers play a critical role in caring for their grandchildren. (Photo by Trina Moyles)

central Uganda, claimed that all of his constituents had out-right rejected the bill. "Everywhere, I have been told to return to Parliament and oppose the bill instead of wasting their time with useless and dangerous *bazungu* ['white'] ideas of rich edu-cated women in Kampala," Ogutta said.

In June 2013, the bill was defeated for the fifth time in history.

Mariam first heard about the Marriage and Divorce Bill over the radio. She was appalled by the idea of a woman owning land. "People would think she'd bewitched her husband!" she boomed. The women nodded and murmured a chorus of approval. "Land is an issue for men, not women. For the woman who wants to change it—she is not a woman to us," Mariam threatened. I noticed that Diana remained quiet, her baby suckling at her breast.

THE FOLLOWING DAY, I made the treacherous motorcycle journey back to Mirindi to talk to Diana. I wanted to know if she agreed with what the older women had said. Did she want to own land? Did she hope that things would change for women?

We sat in her living room on a wooden-framed sofa with plain foam cushions. Canary yellow election posters plastered the mud-packed walls. In the posters, President Yoweri Museveni smiled down on us. He wore a trademark wide-brimmed safari hat. His political party's name, National Revolutionary Movement, was full of irony given that the 'revolution' was long over. Museveni overthrew Milton Obote's regime in 1984 and ushered in an era of peace in Uganda. He brought stability to the country, but refused to leave office. He was the longest-standing dictator in Uganda, having ruled the country for all of Diana's life. He also supported the defeat of the Marriage and Divorce Bill in 2013.

A lace curtain hung between the living room and the bedroom, bone white, delicate as a snowflake. It floated in the slight breeze that entered her home. A small window opened to let in the afternoon sunlight, and on its sill stood an iron. I caught the eyes of a young girl, one of Diana's daughters, standing on her toes and peering through the window at us. Speaking with Diana in the privacy of her home, I could ask the questions I wanted to ask, and I sensed that she could answer without fear of reprisal.

Diana was in her late twenties. Her skin was honey-toned and her white teeth flashed when she smiled. With her hair styled short, she wore a plain white T-shirt and the *kitenge*, the traditional cloth, wrapped around her waist. Geometrical shapes patterned the cloth, coloured orange, green, and navy blue. Diana and her husband had been married for six years and had four children together. The youngest, born in August during the sorghum harvest, was less than two months old. He slept in the crook of one arm, while she gestured with the other as she spoke.

"You know, as a woman, you do practically *everything* on the land—but you have no say in anything. Your husband decides what to do with the harvest," she said. She motioned towards

three bulging sacks of red sorghum seed in the corner of the living room.

Diana was farming on three plots that were scattered across the hills. Her husband only inherited a marginal piece of land from his father because his mother was the second wife. Sons of the first wives usually received more land than those of the second or third wives. But Diana was able to save enough money so her husband could purchase two additional plots of land. She was growing sweet potatoes and peas for her family's needs, sorghum to make *obushera*, and a small crop of Irish potatoes, which her husband sold in the market.

The household costs usually exceeded what she earned as a farmer. The markets were unpredictable in Kabale and rarely in favour of small farmers. "When we sell, food is cheap. When we buy, it's expensive," Diana lamented. When they were desperate for money to pay for their children's school fees, she walked for four hours to Kabale, carrying a basket of sweet potatoes on her head to hawk to people in town. As well as saving to pay for her children's education, Diana was also saving for her husband's tuition at a vocational college in Kabale. He was studying agriculture to become what society would recognize as a 'farmer.' Ironically, society cast off Diana as a 'poor farmer,' just a labourer. She had few opportunities to study. In 2013, although nearly 85 per cent of the population in Uganda worked as farmers, the government allocated less than 5 per cent of its domestic budget to agriculture. The Ugandan National Agricultural Advisory Department Services (NAADS), a government agriculture program, notorious as one of the most corrupt federal institutions in the country, folded in 2014 after years of public criticism. The Ugandan government left female farmers alone in their fields of crops.

When news of the latest tabling of the Marriage and Divorce Bill reached Mirindi, Diana witnessed men's reactions first-hand. She rented a tiny living space beside the local pub and heard every morsel of village gossip. The pub was a single room with wooden benches lining the edges of the mud-plastered walls. Inside, men slumped around a wooden table, leaning forward

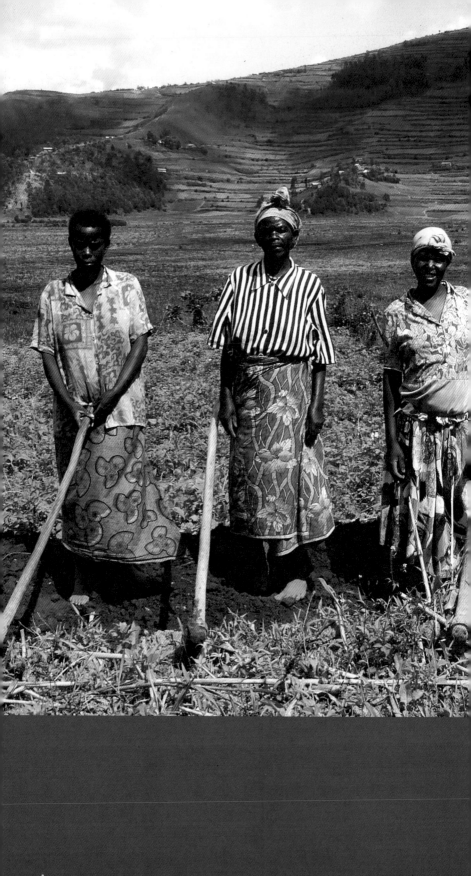

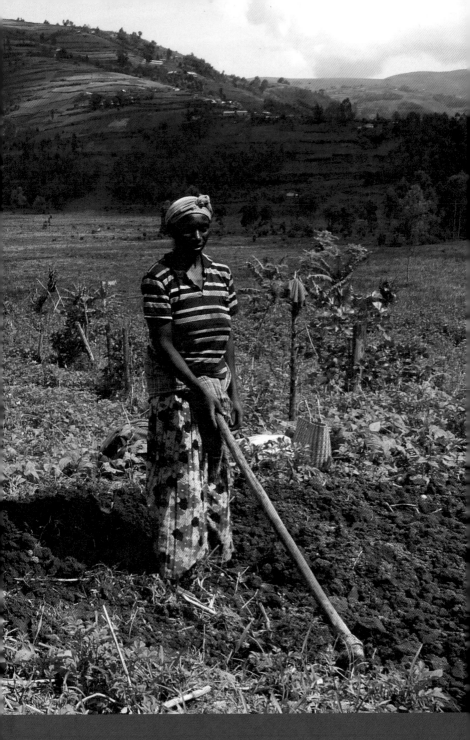

In the community of Mirindi, in the Kabale District of southwestern Uganda, a women's farming group tills the soil using hand hoes, preparing the earth to plant a crop of beans. Female farmers join forces by organizing themselves into farming groups. This group digs together twice a week, working collectively to till, sow, and weed farming plots. They also make monthly contributions towards a group savings fund, which members can access on a rotating basis. (Photo by Trina Moyles)

to share *maramba* the traditional way, sipping it through long straws from a large bulbous gourd. Men came to the pub to reflect on the news they heard on their transistor radios, to grunt and lament about the irregular rainfall, to revel and laugh in memories of being younger. The stories grew worn, soft as leather. They talked about land: who was selling, who was buying, who was marrying, who was dying. They talked about village-level conflicts over land, disagreements between neighbours about where the line could be drawn in the earth. They talked about the time, five years earlier, when two young brothers killed a schoolteacher and the victim's family took revenge by slaughtering every goat, every cow that belonged to their family. In the past, they talked about their children, their daughters. In the old days, they said, "Let me give you my daughter. Let my daughter marry your son."

Men erupted with fury when they heard the announcements over the radio. The news shook men from their docile drinking. Diana heard them quarrelling outside the pub and shouting things like, "Women can never own land!" and "Men own everything a woman owns!" Diana told me that one day when she and several younger women in the farming group were walking home after a long day digging in the hills, a group of men stopped them on the road. The sun was low in the sky, nearly swallowed whole by the shadowy hills. The men were slurring with drink. "They told us, 'If a woman signs her name to her husband's land, we'll cut off her legs!'" After that day, Diana stopped talking about the bill with younger women. Never once did she bring it up with her husband for fear of repercussions.

"But how do you feel about it?" I gently asked her.

"It would be a good thing—to own land," she said softly, running a hand across her colourful *kitenge*. She paused, searching for the way to convey her feelings.

"Take what I'm wearing, for example," she said. "It's better to buy a *kitenge* than to borrow one from a friend. If it's borrowed, I'm always wondering, 'What will I put on tomorrow when they ask for it back?' But if it's mine, I can wear it whenever I

please. It's the same with land. If it's mine, I get to decide today I want to plant this, tomorrow I'll plant that. With my own land, I'll have the freedom to make my own decisions."

Like many Ugandan women, Diana had to consult with her husband before sowing seeds into the earth. If she wanted to plant any cash crops, such as tea, coffee, bananas or fruit trees, she had to seek his permission. Land was like a piece of borrowed clothing. Although the practice of polygamy was fading away, Diana worried that if her husband decided to marry a second wife, her threadbare protection could be stripped from her. Without land she felt naked and powerless to care for her children. Even if she returned to her parent's village, looking for refuge, they'd turn her around and send her home. "We have no land for you here," they'd say. "Go back to your husband."

As a farmer, Diana wanted the security of land more than anything else.

"If next year's sorghum harvest is good enough, I'll find a way to buy land. I'll go to the local chairman to open a case and put the land in my own name," she said quietly.

"Will your husband be okay with that?"

"Even if he refuses, I'll think of an alternative," she answered, her voice rising defiantly. "Eventually, men won't have a choice. They will have to accept that women have the right to own land."

I nodded solemnly. I didn't ask, though I worried about what Diana's defiance could cost her. I imagined her walking to the local chairman's home, passing the pub with the men's threats ringing in her ears, and demanding to sign her own name to the land she bought. I wondered how the chairman would react. Would he permit her to sign? Would he call her husband? Violence was a daily, unspoken reality for women in many parts of Uganda. Amnesty International reported that more than 70 per cent of women experienced domestic violence. "We already have enough problems in our lives," Mariam argued at the women's group meeting. She saw that fighting for women's rights to land would stir up more violence. As an older woman, she saw no sense in putting her body on the line.

Mariam had likely fought many of her own battles as a woman over the years. She was tired. She knew the danger in speaking and acting out against a culture of violence that men had created and preserved for so many years.

In Kabale town, I met a soft-spoken woman with silver hair around her temples. People in town called her Sister Clara. She wasn't a nun, but she was a midwife who dedicated her entire life to helping women in the villages. She caught hundreds of babies, watched too many women die in childbirth, and counselled an unaccountable number more who suffered abuse at the words and hands of their husbands. The violence made her grow old and weary about the future. "I just don't know what's going to happen," she murmured slowly, her voice fading into dark uncertainty. She told me about a young woman from her village who became emboldened by the talk of the Marriage and Divorce Bill. The young woman saw the value of having land in her own name. She marched down to the local chairman's office and demanded that her name be included on her husband's property. The word spread quickly. By the time she reached her home, her husband was waiting for her with a wide-bladed *panga* in hand. "He cut her in pieces," she said, devastated.

When I left Diana's house, I saw a cluster of nests hanging in a tree. The male weaver birds, tiny darting blots of yellow, hung upside down in the tree's branches and wove intricate nests from grass. They were a common bird in southwestern Uganda. Dried nests clung ferociously to the branches until the winds shook them free from the trees' limbs.

On my way back to Kabale, I wondered what would happen to Diana in the future. Would she succeed in buying her own land? Her relationship with the land was dependent on appeasing what tradition demanded of her, to be a 'good wife,' to not raise her voice overtop her husband's voice, to be obedient. A woman's place on the land felt tenuous, fragile. As though tethered by grass, it could be easily broken.

Passion fruit grows wild in southwestern Uganda. Women are the pillars of food sovereignty in southwestern Uganda. Along with growing staple food crops, women spend time foraging and harvesting wild fruits and vegetables, including passion fruit. (Photo by Trina Moyles)

PEOPLE IN THE VILLAGE knew Nina as the 'second wife.' It was late in the afternoon and we sat alone in her living room, a small square-built room with hardened mud walls. The shadows expanded around us like an ink stain, absorbing what was left of the light.

"My husband just left for the pub to watch the match between Manchester United and Chelsea," said Nina. I noticed the relief in the tone of her voice. She was twenty-eight years old, but she looked a decade older with wearied eyes, her lips set in a permanent frown. The colours in her skirt had faded from the number of days she wore it working under the press of sun on the land. She had two children. Her youngest was a toddler with curly brown hair. He waddled across the room and climbed onto

her lap, plunging his hand into her baggy red T-shirt that read UGANDA across the front, hungry for breast milk.

Nina lived on the highest hill in Omukasinde, a village located on the outskirts of Kabale Town. It was a forty-minute walk to the largest market in Kabale, but she rarely abandoned the path of her daily routine around the home and in the fields. Nina knew the landscape as though it were her own flesh: she was born with a hoe in her hands, she grew up in the village on the eastern side of the hill.

When she was seventeen years old, she met her husband at the weekly market in Omukasinde. At the market, Nina sold sweet potatoes for her mother and shared words and laughter with the girls her age. She saw him, a man much older than her. Twenty years older, in fact. He smiled at Nina's ripening body and teased her, "You come home with me and be my wife!" He offered her money, land, and protection. He said everything that a young girl who hadn't finished high school wanted to hear. Only through marriage could girls gain access to land and livelihoods. To be a farmer, a woman had to marry. Nina didn't want to be a burden to her parents, who were raising her four brothers and sisters—and she saw in her husband an opportunity. He called on her persistently and they drank together at the local pub. When Nina realized she was pregnant with his child, she accepted his marriage proposal. From mud and sticks, he built her a small, two-room house on top of the hill, and gave her less than half an acre of land to farm.

From the day her son was born and she dropped seed into the soil, Nina's life soon became ensnared in conflict with her husband's first wife and his children. "I've married a man whose sons are now adults. They say the land belongs to their mother and that it's their rightful inheritance. I know his children tell him, 'Father, that woman, the land is not hers,'" Nina said. She turned her face away from me into the shadows, attempting to hide her emotion. "Being a farmer without a piece of land in her name—I may as well have nothing."

When Nina heard about the Marriage and Divorce Bill she felt a flicker of hope in her chest. She mentioned to her husband

the idea of signing her name to the land. He came at her with his fists, hitting her across the face and leaving her left eye to bruise and swell into the size of a small fruit. "Maybe you want me to die? Why am I the one to die first?" he shouted at her. "The government won't rule over my home. I am the boss of my family." "I agree with the bill—I wish it could be passed," Nina said longingly. "But I have no voice." After their fight, Nina never mentioned land again.

The one place where Nina could escape the violence of her life was singing and talking with other women farmers as they worked on the land. When she first married and moved to Omukasinde, a woman named Sandra, who was only a few years older and lived just down the hill from her, invited her to join a women's farming group. They were fifteen women who lived on the same side of the hill. They were all wives, mothers, and farmers. They all knew Nina's struggles like their own. "In the group, it's where my friends are," she said.

Outside of Nina's group, many women came together to form their own groups in villages scattered throughout south-western Uganda. The clusters of women appeared suddenly, like tiny silver *ebituza*, fine-headed mushrooms that appeared in the millions after it rained. The responsibility to grow food was, as Nina insisted, "on women's heads," yet the pressures of patriarchy and domestic violence greatly hampered the women's productivity. Quietly, women were banding together to support one another in ways that the government, or the women's husbands, weren't. In Nina's group they helped one another clear their individual plots of land and then plant, weed, and harvest. They rotated daily, working for a few hours in a woman's garden, saving her the energy of what would otherwise, working alone, exhaust all hours of the day. The women elected a treasurer and made weekly contributions to a communal pot of money. Participation enabled women, as farmers, to regularly afford larger purchases that individually they couldn't manage—more seeds, farming tools, and live-stock. This strategy also kept resources out of the hands of their husbands.

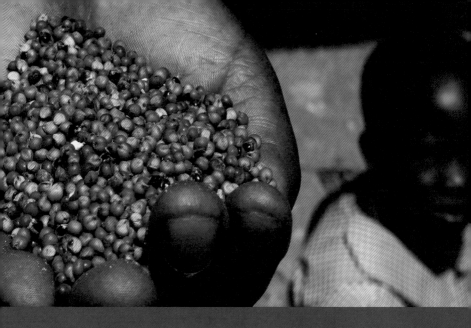

A farmer holds a handful of seeds from her last sorghum harvest. Sorghum is one of the most important cultural foods to the Bakiga people in south-western Uganda. They grow the crop to make a porridge called *obushera*, a drink prepared daily in rural villages. (Photo by Trina Moyles)

"I have no office. I have no business, or any other place where I save my money," said Nina. "It's only through the group that I can earn money. Last year I made enough to buy a goat." She tethered the goat to graze near the fields where she worked. When the goat produced offspring, she'd fatten and sell them locally to pay her children's school fees. Goats weren't for eating, they were for selling: livestock was a form of living savings accounts in Uganda. But Nina saw the limitations to her ability to earn a living as a farmer without land in her own name. She complained that the yields were becoming increasingly poor and unpredictable. She could cultivate enough food to nourish the family, but the dilemma weighed heavy on her shoulders: how would she ever afford to increase her capital? Even if she succeeded in growing more food, Nina felt entirely severed from the market.

"Women don't participate so much in the marketing of our products. I've seen that women—women who aren't even digging—are doing better by buying and selling produce."

"Has your group ever organized to try and sell collectively at the market?" I asked her.

"Even when we are looking for alternatives, there's the problem of our husbands," Nina explained. "My husband wants me in the home. I have tried all means that I can. I tried to take my sweet potatoes to the market and my husband stopped me. I tried to earn through another woman who went to the market in Kabale, and I profited from that."

But when Nina's husband found the money in her clothing, he demanded, "Where did you get this money?" He forced her to give him the money and he went straight to the pub. When he burst into their bedroom later that night, he was stumbling from excessive alcohol. He pointed his finger at her and threatened, "I don't want any woman who does business." So she stopped, fearing what her husband could do to her: beat her, kill her, and leave her without land and a means to live. Returning to her parents' house would be a shameful public acknowledgement of her failed marriage. Her husband could even demand the return of the dowry he paid to her parents: a cow and the equivalent of a year's worth of harvest.

When I stepped outside of Nina's dark home the air was fresh and comforting. Shame washed over me as I realized the relief I felt to step away from Nina's reality. I didn't know how to respond to her story, so I just sat and listened, nodding dumbly. I was left stunned by the cruelty of her situation.

"I've thought of leaving him," she said, standing in the doorway before I left. She looked hopeful and doubtful, all at once. Nina needed her husband like she needed land to grow food. She was as trapped as a bird in a hunter's snare. The land was everything she had—though it wasn't even hers. If she left, where would she grow food? What land would her son inherit?

The sun hung orange and pregnant over the hills of Omukasinde. Golden light drenched the rolling landscape, illuminating everything to look like a patchwork quilt of greens, browns, and yellows. In the distance I saw tiny blots of colour against the green canvas. Women were sowing beans and maize, giving their labour to the land and their families,

rushing to finish before the sun gave way to darkness, working against the dying light.

IN THE EARLY 1900s, the British regime tried to change the way women grew food in southwestern Uganda. Colonial administrators wanted to grow coffee, tobacco, and pyrethrum, a white flower used to make agricultural pesticides, on the same land where women were planting sorghum, sweet potatoes, beans, and cowpeas. The British preferred that Ugandan farmers grow cash crops that would be shipped far beyond the borders of Uganda and the African continent. The Ugandans wondered how such farming could ever ensure that there would be something to eat for dinner every night. The British administration organized meetings and forced men in the villages to attend. They gave the men extensive training on how to grow and care for cash crops and distributed seedlings into their hands. Much to the frustration of their wives, men cleared land and planted the new seeds, which satisfied the administrators. It appeared on the surface that their colonial plans would succeed. But after several weeks, administrators came back to monitor the plots and complained, "These fields are overgrown! Why haven't you weeded?" And the men responded, dumbfounded by the question, "But it's *women's work* to weed. Men don't weed."

The British failed to see the Bakiga women as 'farmers'— they had overlooked women's contributions and responsibilities in food security and agriculture. Women resisted the colonialists' plans by refusing to waste their time growing cash crops that would, surely, benefit the British but wouldn't directly feed their children. Over time, however, the cash crops took root on the hillsides and the men primarily held the power over the production and marketing of those crops. The British scheme rewarded men as farmers over women and placed agricultural resources directly into their hands. One hundred years later, gender inequity was still visible in the Kabale hills. Male farmers grew tomatoes, cabbages, tobacco, and Irish potatoes— all for sale in the market. Men earned money as farmers and

women broke their backs in the fields to nourish their families and communities.

"Let me tell you a proverb," said Alex.

Alex grew up under the colonial regime and for most of his career had worked as a civil servant in the departments of agriculture and rural development. Since he had lost his eyesight, he spent his days in his family's home, pulling up memories like buckets of water from a well and reconnecting the past to the present. One afternoon I visited his home and he told me stories and proverbs about Bakiga women on the land.

"The elephant wears a long, heavy trunk on its face. But do you ever hear the elephant complaining, 'Oh, my trunk is too heavy, I can no longer carry my trunk'?" Alex laughed loudly, expelling air through his mouth like a staccato wheeze. "It's the same thing with the Bakiga woman!" he exclaimed. "You will never hear her complaining, 'the load is too heavy, it's too much for me to bear!' Even if you gave her a billion shillings to stop digging, she wouldn't stop. Digging is what women do here. If she didn't dig, how could she call herself a woman?"

From his position in society, Alex believed Bakiga women were empowered and that they had nothing to complain about. When I politely argued that women owning land could help to improve the wellbeing of Ugandan society, he pointed out my glaring biases. "You're a *muzungu*, you're just a foreigner," he said, dismissing my comments. "You won't ever be able to understand our culture. Why would a woman own land? It would disrupt everything."

Alex was correct to argue that my privileged upbringing in Canada would blur my judgment of Ugandan culture, but I couldn't ignore what I'd heard from the women. "I have no voice," said Nina. Many women couldn't speak freely in their own homes, let alone in the larger society. I would speak with close to fifty women in villages scattered around Kabale town and they all told me the same thing: "No one consulted me on the issue of land ownership." Government officials never traveled to their gardens or homes. They never asked women whether they thought land ownership was a good thing and

would benefit them and their families. Government bureaucrats simply dismissed the issue as a "dangerous, 'white' idea" that was imported from Western countries and left younger female farmers like Diana and Nina praying for the security that land of their own would provide.

"YOU CAN'T LEAVE WITHOUT INTERVIEWING ME," said the woman. Her face was square, her jaw strong. She didn't smile. Her neck was thick as a eucalyptus trunk.

I swung my leg over the worn seat of the *boda-boda* motorcycle taxi when Margaret, a large barrel-shaped woman, approached. Margaret was the leader of another digging group in Mirindi. She heard that I was interviewing women farmers in the village and she wanted an opportunity to share her story. She waited by my driver's motorcycle until the end of the day. It was nearing dusk, but I sensed her determination and agreed to speak with her. She led me past the local pub and down the hill towards her house. Below her home men were working in a tobacco field, harvesting the leaves and hanging them on a wooden structure to dry. She ushered me into her house and beckoned me to take a seat on a dusty sofa.

"Wait here," she ordered and disappeared down the dark hallway. She emerged holding a folder and sat down across from me. I watched her open the folder and flip through papers. She pulled out a few and slid them across the wooden table. I looked down at the blue-lined papers, torn out from a child's school notebook. The writing was in Rukiga, the local language, with several signatures at the bottom. It wasn't clear to me what the papers represented, or why Margaret wanted me to see them.

"What are these papers for?" I asked her, intrigued.

"They're proof that I own land," she said, and my jaw fell open in shock.

The papers felt weightless, unofficial. Was this enough to ensure Margaret's ownership? She seemed to sense my surprise and reached across the table to interpret the land titles.

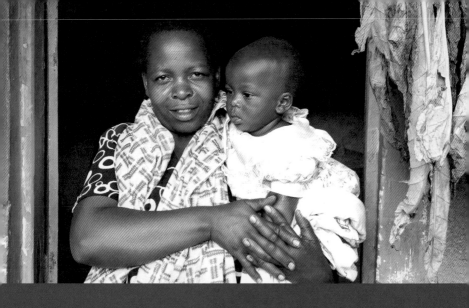

Holding her youngest child, a woman from the farming community of Mirindi, in the Kabale District of southwestern Uganda, stands in front of her home. The recent tobacco harvest hangs from the house's awnings, drying in the sun. Tobacco is a cash crop in southwestern Uganda, grown typically by male farmers. While this woman is responsible for growing the food staple crops, her husband works in the fields to grow tobacco. (Photo by Trina Moyles)

"See here," she said, pointing the words, "the date, the amount of land, and the signature of the seller and the buyer—Margaret—that's my name there and there's the name of the local chairman. He has to oversee all of the land transactions." I was shocked to learn Margaret had five land titles in her own name, three of which also belonged to her husband, as part of his inheritance, and the remaining two, which were solely hers for farming. I look up at her, incredulous, and her serious expression finally gave way to a wide, happy grin. "Farming my own land has made life easier," Margaret said confidently. "Now what I harvest is mine."

Before owning her land, Margaret never participated in taking their harvests to the market. She didn't know where to go or how to negotiate with the buyers and sellers, though she quickly learned and developed a network for transporting and selling her food to earn the best return. "If women could

penetrate the market, that would be a good thing. If they could see where their product is being sold, it would give them ideas about marketing," said Margaret. As the leader of her farming group, Margaret was a model farmer and woman with land in her name. She felt she had a greater sense of security on the land than many of the other women, particularly those whose husbands had multiple wives. Younger women in the group often approached her for counsel on how to buy their own land. "It's not easy for women," Margaret lamented. "Most women don't have any standing capital to buy land, and many others lack the support of their husbands. But these two things together will give women confidence."

Her words reminded me of Sarina, a young farmer I'd met in Omukasinde. She was eighteen years old. She named her two-year-old daughter Gift. When I asked if she was married, her eyes turned downcast and tears slipped easily down her round cheeks. "I think he would've killed me if I stayed any longer," Sarina confessed, her face shining with sorrow. "So I left him. I came back to live in my father's house." On the land where she was born, Sarina was given a tiny sliver of land from her father. It was a rare cultural practice, to give daughters land, but when it happened the Bakiga called it *ekye-miziga*, or 'something to soothe you.' The small plot did offer some solace to Sarina, though she hungered to buy her own land. She longed to plant cash crops like the young male farmers in her village. She saw that they were making a good return in the local Kabale market. "I can find a way to grow tomatoes and get them to the market," she said. "Why should men be the only ones to profit in farming?" But as Margaret mentioned, Sarina's challenge was capital. To buy land would take more than what her farming group's credit pool could cover, so she was saving—"little by little," Sarina said—to work towards her dream of buying land in her own name.

Sarina felt liberated by her decision to leave her husband. She was eager to set her plans into motion. She confessed that she had no desire to marry again in the foreseeable future. "Men think that they have everything. They own women like they

own their goats," said Sarina, shaking her head with frustration. "It's hard for them to believe they can share equally—especially when it comes to land. It's really about power." I nodded and studied the young woman farmer. Her headscarf was woven with silver threads and sparkled like a crown in the sunlight that subtly filtered through the small window. "Even if laws change, it will take a lot to change the minds of men in Uganda," she said. Sarina wouldn't ever forget the violence her ex-husband inflicted on her body and what her daughter witnessed. What would it take for men to recognize women's rights?

I wanted to understand what motivated Margaret's husband to allow her to buy land and sign the titles in her own name. What had changed his mind? But just as I was about to ask the question, Margaret's husband appeared in the doorway. He was a dark silhouette against the light, a thin wisp of a man, propping himself up against the doorframe. His eyes readjusted to the light and fell on me, sitting there with his wife. Suddenly, he lurched forward, staggering towards me. Before he reached me, I could smell him.

His clothes were unwashed, soiled with dirt, and he stank of urine and gin. The man thrust his hand in my face and greeted me, slurring his speech. His face was gray and gaunt. "Sit down!" barked Margaret. Her face contorted into a severe frown. Her body stiffened as she prepared to stand to force him to sit. He glanced over at his wife and slowly obeyed, reeling towards a chair and collapsing down. His head rolled to the side and he instantaneously passed out. I then realized that Margaret didn't own land due to her husband's generosity or his willingness to accept her rights to the land. She owned land because her husband, slumped in the chair like a sack of potatoes, was an alcoholic. She struggled to earn and save from her market sales to buy land. She convinced the local chairman to allow her to sign the papers, and, though he was reluctant, he agreed. The cost of owning land for Margaret was the community's rejection of her husband. The tribal leaders and the other men who owned every piece of land stitched together on the hillsides despised Margaret's husband. She had done what was unthinkable to

Bakiga culture: she signed her name on the land. It stripped her husband of any last shred of dignity.

"He's not considered a man," she explained.

But if Margaret felt any shame, she kept it hidden behind her sturdy, confident gaze. "It's a relief to own land," she said. Despite the stigma of her husband's alcoholism, Margaret possessed a rare kind of freedom and security as a female farmer—and a woman in southwestern Uganda. She controlled her harvests and negotiated the sale of her own crops. She had land of her own, land on which she could plant any crop she wanted to, and a harvest that she could sell to whomever she pleased. The fruit of her labour was hers only. Through the land, Margaret had security.

Before I left that evening, Margaret handed me a large mesh potato sack filled with pineapples. I protested gently. "It's our way," she said. "It's Bakiga custom." The driver strapped the lumpy sack onto the back of the motorcycle. Margaret shook my small hand in her large, leathery hand and we locked eyes. Her strong gaze followed me home that evening, up and down the skinny red road that connected rural villages like this one to a bustling, modern centre, and I marvelled at the tug-of-war between tradition and change, wondering what would stay the same and what would change for the ones they called *abahingi mukazi*—the women who dig.

2. GUATEMALA

A Maya-Mam woman clutches a dried maize husk. Maize is one of the most important cultural foods for the Maya-Mam communities in Guatemala. Farmers grow a wide diversity of indigenous maize varieties, with seeds tracing back to their ancestral roots. Imported varieties from the U.S., however, are flooding local markets and making it difficult, if not impossible, for Maya-Mam farmers to compete. (Photo by KJ Dakin)

At an elevation of nearly four thousand metres above sea level, Comitancillo, a province in northwestern Guatemala, was a formidable place to farm. The air was thin and cold. I followed Rosa towards her home along a well-trodden path on the side of the mountain. My lungs were crying for oxygen, overworking like moth wings. Maya-Mam communities had lived on these barren slopes in northwestern Guatemala for nearly five hundred years. Before the arrival of the Spanish in the 1500s, the Mam splintered off from the Mayan Empire, which had chased them off the lush green flats and up into the Sierra Madre. Looking down the mountainside, I witnessed how the Mam adapted to live on their mountain fortress: they'd carved steps into the mountainside, thousands of terraces that cascaded down to the bottom of the valley. I was awestruck by such architecture. "We've been cultivating *la milpa* for hundreds of years," said Rosa. *Milpa* was a Spanish word that summed up the three crops that had sustained the Mam for centuries: maize, beans, and squash. Planting all three crops together formed a sacrosanct principle of Mam farming.

The Mam were one of twenty-four indigenous cultures in Guatemala, a country where nearly 50 per cent of the population were indigenous people, most of whom dwelled in rural areas and depended on subsistence and small-scale agriculture for survival. Despite having a near majority of indigenous people comprising its population, the country had never elected an indigenous president. The *mestizo* elite owned politics and power in Guatemala, while the Mam formed only a minuscule fraction of the country's population. Marginalized to the mountains in the northwest, they survived on growing food and grazing livestock. Traditionally, men played a larger role in farm management while women were responsible for grazing sheep, grinding maize, cooking, cleaning, and nurturing the family.

The dusty husks of the harvest and the season past dried in the slanted fields on the mountainsides. The bright sun caught and illuminated their yellow leftovers into gold. Nothing would be wasted on the mountains. Rosa would harvest the dried crops for pig and sheep feed.

"Our seeds are hardy and meant for these mountains. The seeds people try to sell us don't do well in Comitancillo. They grow and the wind breaks them."

Years of living on the mountains had also ground Rosa into a hardy woman. The fifty-year-old woman barely reached five feet. She wore a striking turquoise blue *huipil*, a traditional blouse, embroidered with magenta flowers. She parted her long black hair in the middle and braided it down her back in a single rope. Rosa was a widow. Her husband had died twelve years earlier after falling from the rickety scaffolding on a construction site and quickly dying of his injuries. He'd been working as a migrant labourer in Xela, a city situated in one of the valley flats, nearly three hours away aboard a series of chicken buses: long yellow school buses carrying men with bags of maize and beans, and women with plastic washing basins filled with fried foods to sell in the market. Every seat, every inch of space in the aisles of the buses was occupied with bodies, limbs, livestock, and the odours of delicious fried foods and sweat.

Rosa didn't learn of her husband's death until five days after it happened. His body came home in a crudely constructed casket and she buried him behind their home, marking his grave with a small wooden cross. A green plastic rosary dangled from the cross and shook in the cold wind that whipped over the mountain and stung my cheeks.

Alone on the mountainside, she raised five grandchildren. She lived in a two-room house made of mud bricks. The façade was rounded and smoothed with mud and mortar, and whitewashed with a mixture of lime, ash, and water. Her recent maize harvest hung on a rope from below a roof made of iron sheets. The maize coloured her home with spectacular shades: eggplant purple, indigo blue, crimson red, orange like a dusky sun.

"I grow food for survival," she said plainly.

She didn't have any grand illusions about her work, or what she expected the earth to give her. Rosa didn't sell her food in the market, and even if she did sell, the return for small-scale farmers in Guatemala was marginal. It was the sad absurdity of being an indigenous farmer growing ancient maize: they grew

their staple food, preserved for hundreds of years on these hostile slopes, sold it for mere cents, and bought back the imported GMO varieties for 300 per cent more than the regular price. The market laws that promoted subsidizing and dumping imported grains from the U.S. Midwest in Guatemala punished poor, indigenous farmers. How could they compete with the mechanics and productivity of multinational farming operations?

Even so, Rosa loved to farm. When she planted maize, she remembered brighter days and memories of the past with her husband. He was a good man, she said, and also a farmer. Together they gave birth—"*dar a la luz*" she said in Spanish, which meant "give light"—to six children. Rosa was fifteen years old when she met her husband, who taught her everything he knew about working the land.

While she was born in Comitancillo, Rosa didn't grow up on the land. She spent most of her childhood working on coffee *fincas*, plantations owned by foreigners and wealthy Guatemalans that sprung up along the humid coastlines in western Guatemala. The government forced Mam and Maya farmers in the northwestern highlands to abandon their *milpa* fields and travel to the plantations to work as labourers tending to the coffee on the west coast. Rosa's family, her parents, were amongst those relocated farmers. The practice traced back to the policies of the Spanish colonial regime in the eighteenth century. According to law, every municipality in the country had to send a minimum of ten indigenous *mozos*, mosquitoes—a derogatory word for indigenous people, to build roads and work on the plantations owned by bureaucrats and landowners. Men were packed together like beans in poorly constructed shelters and subsisted on a diet of only ground maize flour. This forced labour policy continued for decades into the 1900s. By the 1930s, under the dictatorial rule of President Ubico, Mam men in Comitancillo were forced to work on the plantations for upwards of 150 days, nearly the same amount of time as the *milpa* harvest.

This policy left women alone on their farms. Harvests were poor and children fell asleep hungry. Women did everything: planting, weeding, harvesting, grazing sheep, and grinding

maize on large, flat stones into flour for making tortillas and tamales. Not until 1947 did all forms of forced labour become illegal under the governance of President Arévalo, who created the foundation for basic workers' rights in Guatemala. But by the time the law abolishing forced labour came into effect, the Mam population was so poor and downtrodden that many farmers continued to seek low-wage employment on the coastal plantations, including members of Rosa's family. Over one hundred years of forced labour had disrupted the Mam's agricultural productivity. It had severed the flow of knowledge from Rosa's mother and father to their daughter.

But Rosa didn't want to talk about how the past had imprisoned her parents on the plantations, or how it had robbed her of a childhood of experiencing the entirety of the seasons on her ancestral land. There was every reason to mourn the past, but Rosa wanted to talk about the present moment. She wanted to talk about what was under her feet. She wanted to talk about what every woman in Comitancillo wanted to talk about. She wanted to talk about the owners of the mine who had blasted open the mountainsides and whose destruction of the mountain was creeping closer to her land and livelihood every day. She wanted to talk about how the mines had already changed everything for the Mam. Like many women I'd come to meet, Rosa deeply feared the loss of her farmland, terrified that the mining company would come knocking on her door and issue an order, legitimized by the Guatemalan government. "You have no other option; you have to sell your land. You must go," they would threaten her. With force, they could remove her from the land; they could take the land out from under her feet. "When I think about my land and the little I have . . ." her voice trailed off. "If the company takes it, what am I going to do? Where will I go?"

Mam women in Comitancillo waited anxiously for that sudden knock on the door, for the government's orders, armed with weaponry and authority, to leave their ancestral lands. Fear grew in the fields. Uncertainty of what was to come hung in the cold mountain air. Women knew that, while they planted

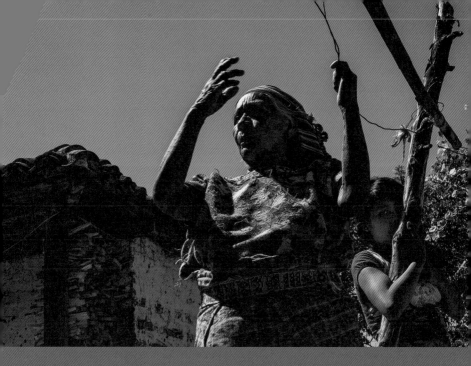

A Maya-Mam elder, farmer, and grandmother from the region of Comitan-cillo, Guatemala, speaks about her struggle to survive on the land in the face of unjust market pressures, climate change, and the continual development of gold and silver mining operations in the area. (Photo by KJ Dakin)

the *milpa* on the surface of the earth, it was what lay beneath that mattered. The mountain was a body filled with veins of gold and silver.

For women, the mine was changing everything.

THE MAM NEVER INVITED the mining company to crack open their mountains. The Marlin gold mine was supposed to be an orchid farm.

That's what the municipal government told people in Com-itancillo before the first convoy of trucks arrived with their machines and milling cylinders in late 2004. "People won-dered, What kind of orchid farm is this? They were *fooled*," said Gabriel. Anger seared the edge of his voice.

On my first morning in Comitancillo, I woke at 5 a.m. to the sound of the market vendors setting up outside my hotel window. The frigid air slipped through the window and I could see my breath. I reached for my scarf and leather jacket to cut the cold.

Outside, market day transformed the cobblestone streets of the peaceful mountain town. A sea of bodies had overtaken the streets. The vendors tied their plastic tarps together to form a massive roof that stretched seven blocks long. Mam farmers and traders gathered to sell their goods: indigenous *aki*, dried red chilli peppers; necklaces of garlic; onions; tangerines from the west coast; and a rainbow of woven tapestries, belts, and hand-embroidered blouses that would have inspired even Frida Kahlo. I watched a Mam man stop by a booth selling toiletries. He greeted the vendor, a round, smiling woman. I noticed that they didn't kiss on the cheek, greeting the *mestizo*, or Spanish way. Instead, they touched their index fingers together and then gently touched the middle of their foreheads.

"It's the Mam way of greeting. The touch to the forehead symbolizes communication, openness, and deep respect," Gabriel explained. I met him at Mama Yaya's, a small café down the street. We were the only patrons. I sat down across from Gabriel. He was a short man with pointed, bird-like features and thick black hair that fell onto his forehead. He was also bundled against the cold morning, wearing a black leather jacket and plaid scarf.

"The Spanish tried to break us, the government tries to erase us," he laughed. "But we're maintaining the ways of Mam culture."

Gabriel was a social worker with a local community organization that worked to help poor families access health care, education, and agricultural training and support. He was also a writer, he told me. He wanted to publish books in Mam to preserve their language, stories, and culture.

"Tell me about the mine," I asked him.

On December 4, 2004, when Mam communities in the San Marcos province realized the government had never intended

to grow flowers, over two thousand men and women gathered on the roadside to block the company's trucks from passing. This protest would be the first of many standoffs between the Mam and Glamis Gold, a Canadian-registered mining company. Women boiled beans, patted out tortillas made from maize flour, and steamed squash on fires lit by the roadside. Men erected tents on the road and huddled together at night for warmth. They stayed there for over a month. Their resolve was absolute: the Mam never granted consent to Glamis and the Guatemalan government. They were illegally developing the mine on the Mam's ancestral lands.

After forty days, the military arrived on the scene. Photos depict women at the front line, facing off with men dressed in full riot gear, protected by bulletproof vests. The women are wearing handwoven cloth, protected by their courage and faith. They are dressed in their traditional blue, purple, pink, green and yellow skirts and blouses, a rainbow of colour resisting the military, who wore belts of ammo across their chests and cradled AK-47s. The military fired into the crowd and killed a farmer named Raúl Castro Bocel. Men and women dropped the sticks and stones from their hands and ran back to their villages.

Ten months later the first mining blasts on the mountainsides rang in their ears. The Mam acted quickly. Women and men began organizing. They held consultations and referendums to discuss and debate what changes the mine would bring to their communities. Sixty-five villages in San Marcos placed their votes, and the results were resounding: all sixty-five villages voted against the mine. They wanted the mine to go.

But ten years later, the explosions on the mountainside could still be heard.

Goldcorp, a Canadian-owned and -registered mining company, was expanding from the original site near the village of San Miguel Ixtahuacán to a second site in Chocoyos, where they were cracking open the mountain to mine silver. Gabriel lamented that Goldcorp had illegally extracted over one million ounces of gold. And they weren't stopping at that. They'd

Seen through the dried remainders of the maize harvest in northwestern Guatemala, Volcán Tajamulco, the highest mountain in Central America, rises up in the distance. Maya-Mam farmers grow "*la milpa*", or the three sisters, maize, beans, and squash, on the arid slopes that define the Comitancillo region. (Photo by KJ Dakin)

applied to the Guatemalan government for upwards of two hundred exploration licenses on the Mam's territory in San Marcos.

"Practically all of our communities are sitting on top of potential mine sites," said Gabriel.

His black eyes look away. His face swam with mixed emotions: anger, frustration, and eventually, grief. Then he laughed and threw up his hands, ironically.

"That's development for you."

THE ROAD TO ELENA'S HOME curved and coiled up the side of the mountain like a yellow snake lying in the sun. I clutched the handhold on the ceiling of the 4×4 pickup truck as we wound around and around, ascending to 3000 metres. To the north,

Tajamulco, the tallest volcano in the region, appeared on the horizon like a bluish-gray bruise against the sky. The morning sun reflected off the yellow earth. The white light was near-blinding. A large truck, its bed packed with young boys and men, passed us, turning up a cloud of dust and grit.

"Where are they going?" I asked the driver, a paunch-bellied man. He shrugged and didn't take his eyes off the road.

"*¿Quién sabe?* Xela? La Ciudad? They're going to work."

Aside from farming, employment was scarce as rainfall in Comitancillo. Unemployment uprooted young boys and men. I'd see this trend in many other countries: men leaving their farms and migrating to plantations or cities in search of work. Some followed the train tracks north into Mexico. In Mexico, they hired *coyotes*, smugglers, who stuffed them into trucks and trunks, and led them across the Rio Grande into the United States. The ones that remained in Guatemala worked on large-scale farms, planting, weeding and spraying, or on building roads and apartment buildings.

The UN estimated that 35 per cent of Guatemalan men were employed in wage labour, while only 7 per cent of women were employed in wage labour. In Comitancillo those numbers would be significantly less, practically null. Mam women lived primarily as subsistence and small-scale farmers. "It's in our blood," they told me. During the last several decades, women had grown accustomed to taking over the farm work when their husbands migrated for work. But after the mine came to Comitancillo and dug its teeth into the earth, women were no longer only cultivating their land, they were defending it from the mine. They held their ground, sowed the sacred *milpa*, and faced off against the third-largest mining company in the world.

ELENA HAD BEEN FIGHTING against the mine since the first rounds of dynamite broke open the skin of the mountain. Although she called herself an activist, she didn't look the stereotypical part. Her hair had turned silver around her temples and her face was

like a creased map. She wore a cream-coloured apron around her vast midsection and a blouse that sagged at the neckline. Her watery eyes had signs of cataracts, likely from many years working outside in the bright white light. But she looked at me directly when she spoke and I could sense her power, her conviction. Elena didn't hesitate to move, or speak, or claim the space she occupied. She owned every breath expelled from her lungs, every movement, every word from her lips.

She invited me inside her kitchen, a small building erected from wooden planks. We sat together on low stools drinking steaming cups of *piñol*, a traditional porridge made from maize flour and cinnamon. Elena's five-year-old granddaughter knelt on the floor beside her, playing with a doll made from dried cornhusks. She looked up shyly at me with large, coffee-bean eyes. I wrapped my hands around the pink plastic mug and warmed my cold fingers. The *piñol* tasted sweet and soupy. Elena watched me, her eyes searching.

"How old are you?" Elena asked.

"Twenty-eight."

"*Verdad*? Truthfully? You look so young! Are you married?"

"No, I'm not."

"Do you have children?"

"No," I answered a little too quickly.

Her brow furrowed with wrinkles, as though she was trying to figure out why I'd traveled so far from the place where I was born. She wondered, Why was a single, twenty-eight-year-old woman working alone in a country that wasn't her own? Westerners would argue that I was privileged to enjoy that kind of freedom. I would agree, though I was unsure what Elena thought of me. She knew I was single, childless, and far from home. What kind of belonging, purpose, or happiness could that bring? I shifted awkwardly in my seat, averting my eyes self-consciously under her strong, studying gaze.

Elena married when she was fourteen years old. Before her sixteenth birthday she'd already given birth to her first child. She and her husband raised five children together. For over thirty years they lived entirely off a handful of scattered plots

of *milpa* and wheat. With pigs and sheep they were able to meet the needs of raising five kids, although they lived simply. Her husband encouraged Elena to work by his side on the farm.

"I was the first woman to join one of the all-male farming groups," she said proudly.

Through her participation in the group's meetings and training activities, Elena learned to do what most women would never do: castrate pigs and sheep, and provide basic veterinary care to livestock. She also learned the art of fruit-tree grafting. Elena considered herself lucky that she and her husband were never forced—by law or economic necessity—to migrate for work. Her husband had passed away twelve years earlier. She was glad that he never lived to witness what had become of their ancestral territory: the gold and silver mines, the severed mountains, the deep, gaping wounds. It seemed to me that Elena felt the impact of the mines as if the mountain was her own body. She was wounded and angry.

Outside, Elena led me to her orchard and vegetable garden. She shooed a hen off the path and a fuzzy gang of chicks sprinted behind their feathered mother, cheeping frantically. We passed the pigs that snorted and slopped around in the muck of their pens. Elena opened a small wooden gate that was hinged to the post using strips of a bicycle tire. She beckoned me inside. The garden brimmed with fruit trees and vegetable crops thriving in the slices of sunlight that lay scattered on the leaf-covered ground. The hen and her chicks scuttled into the garden, pecking furiously and overturning leaves to dig at grubs and worms.

"I have avocado and cherry trees. I even have peaches here," Elena said, taking my hand and leading me over to a small tree spotted with fuzzy fruits the size of marbles.

"But, sadly, production has fallen these days. Things aren't what they used to be."

Two years after the mine came to Comitancillo, Elena began to notice a sudden drop in her farm's production. She wasn't alone. Women from the neighbouring farms moaned and complained at the negligible yields. They'd sow seeds and the rains

Members of a local farming group in Comitancillo, Guatemala, open the doors of their community greenhouse, where men and women farmers are experimenting with growing non-traditional crops, such as tomatoes. In the face of economic injustice, Maya-Mam farmers are attempting to diversify crops, animals, and fibres for increased food security. (Photo by KJ Dakin)

would stop. The sun grew bolder, hotter, and the rains became increasingly infrequent. Was it climate change? Was it due to the mine? Fear began to take root in the fields of dried *milpa*, the maize stalks stunted by the heat, bean tendrils burnt to brown crisps. The aphids attacked, colonizing the underbellies of leaves. Even the wild plants they foraged for seemed to vanish into the heat, to disappear from their lives. *Epazote*, an aromatic herb that grew low to the arid slopes, was now scarcely found. Women used the small leaves of *epazote* to brew a special tea for the *chuj* ceremony, a cleansing sauna that Mam women took weekly to purify the body and spirit. How would they survive?

Uncertainty loomed, though Mam women knew one thing, they felt it down to the marrow of their bones: the mine had to go. They had never given their consent to the mine. With their world wilting around them, they wondered if the stretched-out season of sun and dust was a result of the mine. The skies emptied of moisture like a grape left to dry on a hot rock. Could it be a sign of the mine? Western science had never been on the side of indigenous women and their communities. No scientists had come to verify the cause of the extreme weather, but the women possessed a different kind of science, a deeper science, and a richer history farming on the mountainside. The science they saw with their own eyes made them fearful.

"The mines are consuming an enormous quantity of our groundwater. They mix cyanide with water to wash the rocks, which separates the gold from rock. The contaminated water then flows into our rivers," Elena explained.

Every hour that passed, Goldcorp sucked upwards of 250,000 litres of water for their mining operations in San Marcos, and yet they weren't paying a cent to the Guatemalan government. The water flowed freely for the thirsty company. Elena and other women worried the mines were drying up the mountainside and polluting rivers and streams with toxic chemicals.

"Water runs through our bodies like blood. It's the same with *Pachamama*, Mother Nature," said Elena. "If we cut a vein, the water disappears. What are we going to drink?"

Elena's sister lived and taught at a primary school in San Isidro, a village located downstream of the mine. Her sister told her that many of the children were coming to school with rashes all over their bodies. I had seen photographs of the children she was talking about. Rights Action, a Canadian-based advocacy organization, documented numerous cases of infants and children who were suffering from violent rashes on their limbs, scalps, and bodies. The children lived in San Isidro and other villages located directly downstream of Goldcorp's mining activities. Physicians for Human Rights believed that a connection existed between the contaminated water and the recurring rashes and illnesses in San Isidro because the rashes and respiratory effects that the children suffered are consistent with exposure to cyanide.

In 2010, the Inter-American Commission on Human Rights (IACHR), acting on behalf of Mam communities in San Marcos, demanded that Goldcorp and the Guatemalan government respond to the issues of the overconsumption and contamination of water by providing nearby communities with sufficient, safe drinking water. But both Goldcorp and the government denied reports of poor health among the Mam and the mine's environmental impact on the land. They ignored the commission's order.

"We've demanded for the government to cancel the exploration licenses, but they don't listen," cried Elena. "If we protest, the military hits us with water bombs. Or worse. It's an injustice."

Before I left her home, Elena wanted to show me the river. She led me down the hill from her house through a stand of cypress trees to what remained of the river. Her granddaughter rushed past us and clambered onto the large river boulders.

From the embankment, we gazed down at the dried-out riverbed, ten metres wide and three metres deep. Clear mountain water trickled along the bottom of the bed. In three months, Elena claimed, the riverbed would go bone dry.

"We can't eat gold, or drink gold. We can't use the gold for clothing. To us, it's an unnecessary luxury. It's something we

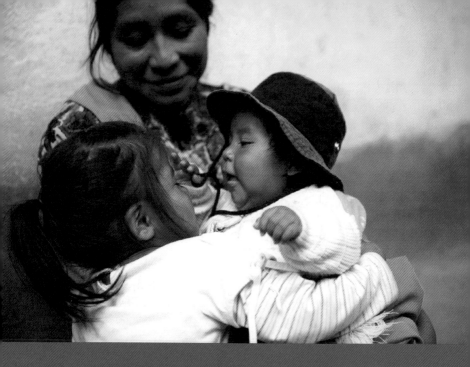

A farmer takes a break from her work to embrace her young daughters. Maya-Mam women play important roles in food cultivation and preparation, along with raising children and caring for the elderly. (Photo by KJ Dakin)

can live without," she said solemnly. "But water? Air? Land? These are vital to us. We can't live without the Pachamama."

Down below, Elena's granddaughter excitedly hopped from rock to rock. She was too young to understand her grandmother's worry and the significance of what would be lost.

LATER THAT EVENING in my small hotel room, I fast-forwarded and rewound back and forth through the recordings of my conversations with the women in Comitancillo. I listened over and over again. Their voices haunted me. "Abandon these lands?" they said. "God gave these lands to the Mam," they said. "The company should leave us in peace. That's what we want here."

One of the women asked me, "What do you think will happen?"

I didn't have an answer for her.

I didn't tell her the same thing was happening to indigenous communities in Canada, Peru, Ecuador, Brazil, and Columbia, and other countries all over the world, as mining, oil and gas, pipeline, and logging companies were operating without community consent and threatening to destroy land, livelihoods, and traditional cultures.

I didn't tell her that the company and government would likely, eventually, drive the Mam off the land. That they'd blast open the mountainsides, one by one, and drain the region of every last ounce of gold, silver, and nickel. That the mountains and forests and rivers and streams would disappear into memory and their ancient seeds would be taken from the hands of their children.

Instead, I told her, "Don't lose hope. Don't give up *la lucha*, the struggle."

I told her that I believed Canadians would hear their stories of protest and, in turn, urge the Canadian government to intervene. I didn't tell her that Canadians had already been down that path in 2010 and failed. In late October 2010, Canadian members of Parliament defeated Bill C-300, the Responsible Mining Act, a piece of legislature that would force Canadian mining companies to comply with international human rights and environmental standards.

I also didn't tell her how Goldcorp's website reassured investors that the company hadn't caused any social or environmental harm in San Marcos and that the claims in IACHR's report were false.

I didn't tell her that Goldcorp was throwing money at the community, supporting the construction of schools and health clinics in the communities surrounding the mine through the work of its non-profit organization, Fundación Sierra Madre. Goldcorp continues to claim that they are doing more good than harm with their mining activities in the region. In a recent blog post entitled "Marlin's Socio-Economic Legacy," they boasted of providing "much-needed support for health and educational programs, as well as infrastructure that will benefit communities in the long-term." During my stay in

Comitancillo I spoke with more than thirty women, but not a single person made mention of Goldcorp's schools and health clinics. I realized that the preservation of the mountain and the Mam's traditional way of life meant far more to them than the ostensible improvements to their lives provided by Goldcorp's schools and hospitals.

I did not tell her that since the first explosion in the mountains ten years ago, Goldcorp had extracted over a million ounces of gold from their mountainsides. The company's profit on the Mam's territory had reached billions of dollars.

The farmers I met were likely living on less than a dollar a day. But they would never put a price on their land. The Mam's loss to the mine was unquantifiable.

AMELIA DREW NO BOUNDARIES between her home and the land that fed her. The balance of her work as a farmer in the fields and a caretaker in the home ebbed and flowed as the sun and moon tug at the sea. I sat outside Amelia's home in Tuixcajchis, a village located less than ten kilometres away from Goldcorp's newest silver mine in Chocoyos. The sounds of dynamite shattering rock echoed too closely to home for Amelia. The mine was on her doorstep.

Amelia moved about the land with the rhythm of a honeybee. She scattered maize for the birds and removed the sun-and-starch-stiffened laundry from the clothing line. She emerged from the kitchen holding a red washing basin full of large, oval, tangerine and purple *frijoles* and spread them on a wooden table to dry in the sun.

I watched young chickens scurry in and out of the kitchen, hunting for fallen maize kernels. A gargantuan male turkey made a regal show of promenading across the patio, opening his black and white feathers like fan, making a dramatic *whooshing* sound. The white and red and purple *milpa* harvest hung under the roof awning to dry. She had piled up the season's harvest of *ayote*, a watermelon-sized indigenous squash, beside the kitchen. At my feet, month-old puppies

somersaulted about in happy play and a pied-coloured pup tugged at my shoelace.

Amelia was dressed in a navy blue skirt and red embroidered blouse with a black belt, the traditional colours of the Mam. The thirty-five-year-old woman had grown up under starkly different circumstances than some of the older women I interviewed. Her parents allowed her to walk two kilometres every morning to take classes in the single-roomed school. Amelia never graduated past primary school, but she knew how to read and write and speak fluently in Spanish, an anomaly in the isolated highlands where government services lagged behind, resulting in the lowest literacy rates in Guatemala, particularly amongst older women.

In the fight against the mine, Amelia used language as a weapon. Her words were bullets to fire back at the company, who communicated their every move in Spanish. They facilitated community meetings in Spanish. They prattled off news and updates on the radio in Spanish. Amelia's efforts to understand, interpret, and defend the Mam doubled as her mind searched for words to translate cultural meaning. The sound of Spanish came from the tip of the tongue, whereas Mam grew from the back of the throat. Often, she struggled to find the right word, the bullet that would penetrate. Spanish lacked the diversity of the Mam's lexicon for understanding the intricacies of land. But Amelia's literacy gave her power in her community. She was the president of the Tuixcajchis Women's Association, a group of thirty women who met weekly to discuss their issues at home and on the farms. They hosted agricultural training workshops to help women diversify crops and apply new techniques to prevent drought and erosion. And, with the new silver mine at Chocoyos only a short distance away, they were actively organizing and collaborating with other women's groups in San Marcos to protest against the mine.

The radio crackled and blared a Mexican *ranchera* song. The singer's voice whined of lost love and failed crops. When the song cut out, the radio DJ's voice began speaking in a fast current of Mam. I couldn't understand, but I saw how Amelia

reacted to his words. Her body bristled and she clucked her tongue in disapproval.

"What did he say?" I asked.

"He's talking about a new program that's supposed to help women living on less than a dollar a day. The government is promising to give allowances and seeds to women—as if that's going to really help," Amelia said. Her voice was bitter, sharp as a machete.

She had grown weary of the government's tactics intended to sway the Mam into surrender. Government officials journeyed eight hours from Guatemala City to host rallies and deliver boisterous speeches in Comitancillo. They paraded through the surrounding Mam villages, handing out sacks of GMO maize seeds with empty promises of building schools and health facilities bouncing off their tongues. Many women planted the maize seed, hopeful. But the cold mountain winds in Comitancillo were too much for seeds that were modified to do well within specific conditions and applications. Women couldn't afford the expensive synthetic fertilizers and pesticides that the GMO maize required. Usually, the maize stunted, bent, and broke in half. Women watched their entire fields collapse and felt the strain on their family's food stores, their savings, their means of survival. Yet these ill-suited government solutions, these cheap gifts, at best, continued in Comitancillo.

"They're trying to buy our support for the mine," said Amelia.

Only a few months earlier, Amelia received visitors, two *mestizo* men, who worked for the mining company. They wanted to talk with Amelia and her husband about the benefits the Chocoyos mine would bring to Tuixcajchis and other nearby villages. "New schools," they said. "New health centres and pharmacies," they promised. "Jobs," they added enthusiastically, nodding at Amelia's husband. She asked them to leave.

"We'll never work for the mine," she said defiantly. "The majority of men at the mine aren't Mam, they're *mestizo* men from Xela. The engineers are all from *la Ciudad*, the capital city. The Mam aren't working in positions of leadership—they only

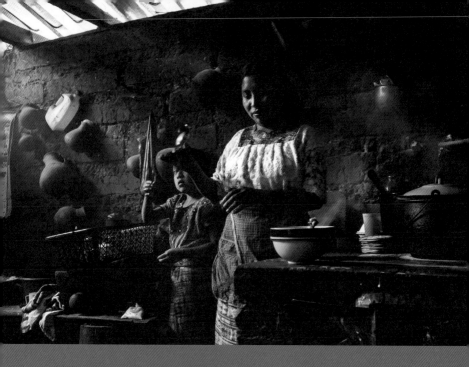

A young girl helps her mother prepare a meal of chicken stew and maize tortillas in their home in Comitancillo, Guatemala. After the maize harvest, women dry and grind the corn into maize flour, which is a staple of the Maya-Mam diet. Many women admit it is becoming increasingly difficult to grow enough maize to feed their families and generate income for household needs. (Photo by KJ Dakin)

do the physical labour. It's dangerous and the pay is very low. They treat our men like *mozos*."

In defiance, Amelia strove to make her land as productive as possible. She refused to be bought out by the government. She wanted her daughters to inherit the land and grow older knowing, deeply, what it meant to be a Mam woman. She was teaching them to feel, see, taste, and understand the satisfaction of being a farmer, how to eke from the earth different shades of cultural sustenance—the ancient maize of a thousand colours, the tangerine and purple fava beans, the seeds of *ayote*, the foraged herbs like *epazote*.

Amelia showed me around the farm. Though it was only an acre of land, every inch of the place was under cultivation. She

collected pig manure, vegetable waste, and dried maize stalks in giant heaps where she turned it weekly as the material transformed into black organic soil. "It's a solution to the productivity problem we're facing today," she said confidently.

In a rectangular garden with a fence made from sticks, Amelia let the vegetable crops go to seed. She collected a handful of thin seeds from a kale crop and tucked them into the tiny cloth purse she wore around her neck on a string. She pointed to her medicinal plants and counted off the number of illnesses they'd treat: stomach flu, menstrual cramps, sore throat and colds, skin infections, and minor cuts and wounds. In order to reach the pharmacy in town, women had to walk three hours down the winding dirt road and three hours back up. "We're resurrecting the knowledge of our Mam ancestors to treat what we can, to tend to our health in the ways that we can," she explained.

Before I left Tuixcajchis, I accompanied Amelia to one of her meetings with the Tuixcajchis Women's Association. We reached the meeting on foot, walking a kilometre along the mountain on well-trodden footpaths that cut through the empty fields. The dried maize stalks fluttered in a slight wind. A few sunken squash had been left behind. They deflated into the earth, slowly rotting and returning to the soil where they had started as seeds.

The trail led into a tightly knit forest of pine and cypress trees. The pine needles stung my nostrils, the smell provoking memories of my childhood in northern Alberta. I felt a strange sense of protection offered by the trees. I felt comforted by the familiarity of the smell.

We reached a small clearing where a group of twenty women had gathered on the hard-packed earth. The topography of their skin revealed their age or their youthfulness: the older skin full of the lines of tributaries, the young skin dry and tight as desert. Some of the women bounced babies on their laps and others wore colourful slings that held sleeping babes on their backs. Toddlers waddled about and older children played a game of tag while the women talked and laughed together. They greeted us, one by one, with a gentle touch to the forehead. *Communication,*

openness, and deep respect. I heard Gabriel's words in my mind, reminding me of the quiet, steady significance of the Mam's symbolic greeting.

Women gathered beneath these trees every week to visit with one another, to speak in Mam, to give voice to the experiences of farming, of protecting the land, of being women. Beneath the large, protective branches of the trees, the women kept a nursery for tree seedlings. Beneath the trees, women planted the seeds of pine, cypress, and avocado in tiny black biodegradable bags of soil. They watched the seedlings over weeks, from germination to seedling. I estimated around a thousand seedlings, maybe more. When the rains returned each woman would go home with the seedlings and plant the trees on her land, acts of reforesting the barren mountains. Trees would bring back and hold the rain, they said. They'd provide food, forage, and fuel to keep the Mam alive on the arid slopes.

"The streams that flowed here before are dying. Our harvests were once plentiful, but today there's only desert," explained an elderly woman holding a moon-faced baby on her lap. "We don't want our children and grandchildren to inherit this reality."

Only ten days earlier, she and other women of the Tuixcajchis Women's Association marched ten kilometres, joining hundreds of women from surrounding villages, to protest against the silver mine at Chocoyos. They linked arms and chanted *"¡Déjanos en paz! Déjanos en paz!* Leave us in peace! Leave us in peace!" The Guatemalan military stood between the women and the road that led to the mine, armed with AK-47S.

After five hours, a *mestizo* employee spoke with protest organizers and agreed to sign a letter that stated Goldcorp would cease all mining activities within two days, but nearly two weeks had passed and they could still hear the blasting of rock in the distance. They realized later that the agreement had been a hoax, a move to placate the women's anger and demands that Goldcorp never had any intention of honouring. Undeterred, Amelia and the women were continuing to organize and strategize against the mine. It had been ten long years of fighting, but even a decade wouldn't age or persuade the women to put

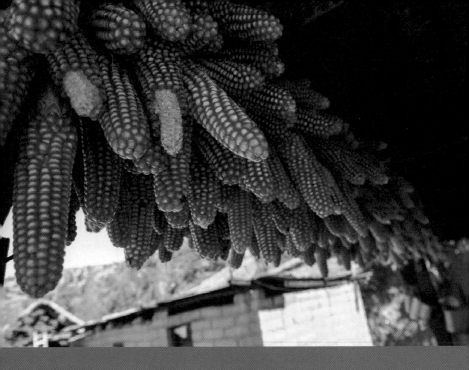

Ancestral maize hangs from the rooftop of a home in Tuixcajchis, Comitan-cillo. Women select their heartiest seeds to dry and preserve for planting in the following season. Maya-Mam farmers are facing grave uncertainties on the land in Comitancillo, citing concerns of a changing climate, along with the rapid exploitation of silver, gold, and nickel reserves by a Canadian-owned mining company. Many farmers, particularly women, in the Comi-tancillo region claim the mine has been operating for the past decade with-out community consent, and they continue to protest against the company and the Guatemalan government. (Photo by KJ Dakin)

down their stones, or to keep Amelia's tongue in her mouth, to silence her words in a language that wasn't her own.

"Let us plant trees and grow old on our land. Let us live in peace," said the old woman. "You tell that to the world."

ON MY LAST EVENING in Comitancillo, I had dinner with a local family: Ernesto, his wife Gloria, and their two young children. After a meal of pork and vegetable tamales, they invited me to enter the *chuj*, a traditional Mam steam bath. For centu-ries, Mam men, women, and children participated in a weekly *chuj*, meditating in a hot darkness that emptied the body of

everything, purifying, cleansing, and reminding what was physical, mental and spiritual to come together.

Inside a small dark room built with thick concrete bricks, no larger than a root cellar that held a few sacks of potatoes, the fire had been burning for hours. The flames smoldered into red glowing embers. Four black rocks sat atop the scorched coals. Gloria drew a curtain and told me to undress. My pulse quickened. It felt as though the walls were about to cave in on me. From behind the curtain, Gloria's voice was a distant murmur, a soft voice instructing me on what to do next. Listening to Gloria's words, I dipped a cypress bough into a wooden bowl of water, sprinkled it onto the coals so steam erupted. I laid my body down on a wooden bench beside the fire and felt the heat and dark settle on top of me like river sediment.

I felt as though I was being buried alive, tucked like a seed into the soil and nourished by the steam, the heat, and my own mineral perspiration. Closing my eyes, I thought of one of Frida Kahlo's paintings, the one she entitled *Raízes*—Roots. Kahlo painted a woman with long black hair lying on her side, bleeding out from the heart. The woman's heart shoots forth roots and vines.

As the heat grew stronger, I imagined the Mam women as they unravelled their long embroidered belts and shed their skirts, woven as colourfully as a butterfly's wings, to enter the *chuj*. What did their bodies say to the earth? I thought of what they'd told me about their desire to survive on the sharp mountainsides where they had been born, where they grazed sheep, where they planted the seasonal *milpa*, maize, beans, and squash, and where they ground the yellow and purple and red and black maize kernels on large, flat rocks and mixed the flour with water to make *masa* for tamales and tortillas. Would I ever see myself reflected in the earth, the soil, the streams and rivers and trees the same way they did? Would I ever feel the same kind of pain they felt when the mountain was cracked open and the earth's veins were cut?

How easy, I thought, to gaze from afar at the Mam's culture and mistakenly perceive the women's ancestral maize as

meagre subsistence, their fields of *milpa* as ignorance, and their mountains as untapped wealth and potential. That's exactly how the Spanish, the Guatemalan government, and Goldcorp had framed the Mam's existence for over half a millennia: uncivilized, poor, and underdeveloped. Of course, it was a masked excuse to justify their colonial agendas, to profit at the expense of the Mam, to exploit their labour and farmland, to destroy the land in which the lives of the Mam were so indelibly enmeshed.

But women's voices weren't crying for money or seeds or 'development.' They were putting their bodies in the line of fire, crying for the right to live and die on the land that fed their physical, emotional, and spiritual bodies. They were begging for the explosion of rock and the violence on the mountainsides to stop. "Abandon our lands," they said.

What would happen to the Mam women? How much older would their ancestral seeds become? I felt their uncertainty, their fear and resistance, all at once. Inside the protection of the *chuj*, I closed my eyes and prayed. I surrendered my body, mind, and spirit to an unnameable substance that swelled from inside the earth.

3. NICARAGUA

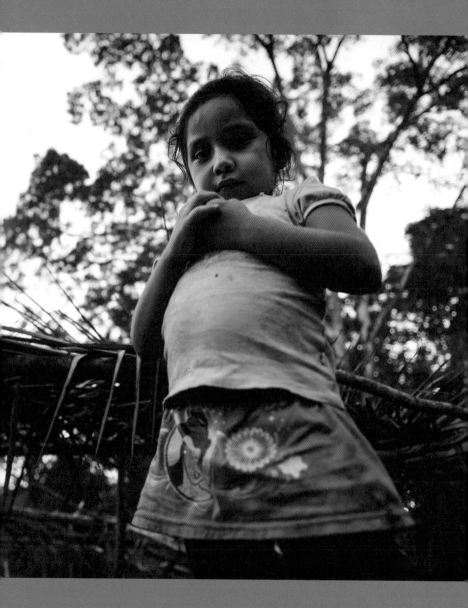

Children living in rural communities in the Río San Juan region are facing some of the highest rates of malnutrition in Nicaragua. Local women farmers are responding to issues of food insecurity and poverty by growing diverse varieties of fruits and vegetables in their gardens. (Photo by KJ Dakin)

Tamara negotiated the 4×4 pickup truck along the blood-orange-coloured, sunken road. I leaned my elbow on the open window and gripped the ceiling handhold to steady myself. The hot, liquid air wrapped around my skin.

For four days I had traveled by land from Guatemala to reach the Río San Juan rainforest in southern Nicaragua. The Río San Juan was an important ecological basin and drainage ecosystem. Some called it *el Desaguadero*, 'the Drain.' Streams and tributaries meandered through the forest like veins, flowing into the San Juan River, a body of water that cut between Nicaragua and Costa Rica and formed a natural border. Covering a distance of three thousand square miles, the Río San Juan was the second-largest rainforest biosphere in Nicaragua. The forest supported a rich ecosystem of flora and fauna, providing habitat for primates, marine life, and one of the largest concentrations of birds in Central America.

The road unravelled itself at the edges, the greenery of the vegetation absorbing the path forward. If I didn't know any better, I could have mistaken the scenery for forest. But staring out the window, my eyes weren't fooled by the enormous greenery. I saw the same tree, replicated, planted, and standing like a million foot soldiers on guard. It was a forest of one tree and one product: palm oil. The African palm had a fat trunk that spit out over thirty giant, fingered, fern-like leaves. Berries grew at the base of the trunk, appearing like a bunch of small blackish-red plums. They glistened like black gemstones.

"*¡Que lástima!* What a pity," cried Tamara. Her words echoed with disgust.

Tamara worked as an agricultural technician for a grassroots environmental organization in the Río San Juan. We met earlier that morning at the organization's office in Boca de Sábalos, a village of wooden buildings on stilts, situated where the Sábalos fed into the San Juan. Tamara was a rarity in her field. In my journey to eight different countries, I wouldn't meet a single other woman working as a technician, visiting farms, pointing out strengths and weaknesses of systems, and planting new ideas into the minds of farmers. Male farmers, particularly

in developing countries, tended to receive more support from government and nonprofit organizations than female farmers. Equally so, the agricultural experts, the distributors of expertise and advice, often wore a male face, not a female one. In a meeting at the office that morning, surrounded by her male colleagues, Tamara wore a reserved but confident expression on her face. During the meeting she spoke in a quiet but focused manner. It was clear to me that her male colleagues respected her opinions. As we left the office and traveled together through the forest that wasn't a forest, Tamara's reserved demeanour came loose. She spoke as though the frustration burned in her throat and she had to get the words out.

"The African palm oil industry is slowly eating away at the forest," she said. "Slashing the rainforest cover, burning everything to the ground, and planting a tree for a product we can't eat. Instead, we export it to countries like *yours*." Her eyes flicked over to meet mine.

Over 50 per cent of household goods in North American and Western countries, including washing detergents, cosmetics, and cleaning products, contained palm oil. The black berries were becoming as valuable as gold. They were picked, pressed, and processed into vegetable oil and ethanol. Internationally, governments and industry touted palm oil as a sustainable solution to fossil fuels. The Nicaraguan government saw palm oil as an economic opportunity. They imported fossil fuels and oil from Venezuela, but they could export the kind of oil that grew from a seed, that ripened above the ground. Palm oil production in the Río San Juan was swiftly on the rise.

As we passed through the plantation, I spotted bodies in between the blur of green. I saw young men dressed in baggy jeans, loose collared shirts, and rubber boots. Some tied square bandanas around their heads, the cloth concealing their noses and mouths. Others wore yellow plastic spray packs on their backs and held long nozzles to spray the ripening berries with pesticides. Many of the workers had long ago sold their parcels of land to what they called 'the Company.' Palmares de Castillo, a Nicaraguan-owned company, owned nearly every African

palm oil tree in the expanse of forest. Since 2007 they had tripled production, purchasing cheap land from poor farmers and promising them jobs on the plantations. Every morning, men, young and old, packed into the backs of trucks and were taken to the plantations to plant, spray, and harvest the palm oil. Their fields of beans, rice, and maize were transformed into a monocrop plantation of palm oil that ate up thirteen thousand acres of land. Over the years, the Company had amassed 12 per cent of the region's land base to grow palm oil. In the United States, the same percentage would cover the states of California, Texas, and Tennessee.

"All of that work, *para qué*, for what?" said Tamara. "These men are making, if they're lucky, maybe eighty *córdobas* (three American dollars) a day—not enough to raise a family on. And yet here is the real cost of growing *la palma*, palm oil," she added, gesturing to what lay ahead.

Suddenly, the land came undone. I caught my breath witnessing the aftermath of the massacre of what used to be called forest. I felt as though I wasn't inside Nicaragua's second-largest rainforest, but at home on the grassy expanse of the Canadian prairies. The Company set fire to the forests, burning the tree cover to ashes. I could see the sun and the entirety of the sky. A lone, gargantuan ceiba tree stood defiantly in the field like a silver skeleton on the open land. The ceiba held sacred status in Central America. Indigenous peoples believed that cutting into its trunk would cast bad luck on the community. The ceiba stemmed from the spiritual world, its roots anchored deep in the earth. The ceiba tree rose up out of the earth, half alive, like a severed limb, a crucified martyr.

"The Company will set fire to what's left on the land," Tamara explained, tightening her grip around the steering wheel. "Then the workers will plant *la palma* in the ashes."

As we passed through kilometres of the African palm plantations, I realized that I hadn't seen a single female worker. I knew that less than 25 per cent of Nicaraguan women made a living in agriculture. Instead, the majority of women living in the rural, geographically isolated parts of Nicaragua were *amas*

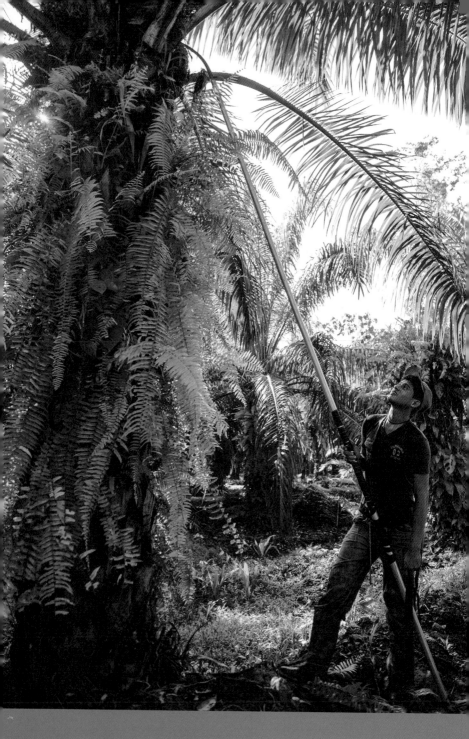

A young male worker harvests the ripe berries from a palm tree in the Río San Juan region. Due to economic hardship, many men are forced to accept low wages and risky work in the palm oil plantations, often leaving their own farming responsibilities to their wives and families. Aside from the health risks to workers and communities, palm oil production has led to major deforestation and environmental contamination in the rainforests of Nicaragua. (Photo by KJ Dakin)

de casa, or housewives. Traditionally, young boys and men slashed the forests with machetes, *limpiando*, or 'clearing,' the earth to plant beans, maize, and rice. Young girls and women tended to the domestic: raising children, preparing food, cooking, and *limpiando*, or 'cleaning,' the house. The Spanish verb *limpiar* was both female and male. In the house, women cleaned. But in the fields, women didn't clear—not for lack of ability or desire, as I'd later discover, but due to the social and cultural forces that bound women to the domestic. *Machismo* reigned over housewives and households in rural Nicaragua. The Spanish word embodied a kind of proud patriarchy like a puffy-chested rooster. *Machismo* encapsulated male aggression and dominance over women.

In the Río San Juan, *machismo* controlled women the same way the Company controlled the land. Nicaragua had the second-highest rates of domestic violence in Latin America, with one in three women reporting physical abuse. Violence manifested itself in the kitchen and at the dinner table. Women were typically the last to eat in their households. They witnessed malnutrition sink its teeth into their young children: the thinning of their bones, their hair turning a yellowish tinge as though they'd spent too much time in the sun, their bellies rounding into little gourds, and their glassy eyes indicating fatigue and disinterest in being a child.

But something was stirring in women in the Río San Juan. Feminist tides were swelling throughout Nicaragua. Women were speaking out against *machismo* and the ways it tied women to the exaggerated highs and lows of health indicators. In the Río San Juan, women were stepping out of their homes, into their family's field of crops. They were reclaiming and engendering the word *campesina*, 'farmer,' for the first time in their lives. Anger and passion burned in women. They were infuriated by a system stacked against them. They saw how *machismo* and the African palm oil industry were intricately connected, how the threat of their husbands' fists on their bodies felt akin to the threat of slashing and burning the forest cover, of shrouding organic life in a film of chemicals. Women bled and

the soil deteriorated. They were washed away by the force of rain, wind, and the persistence of time.

"We're almost there," said Tamara, as the landscape outside returned to the rainforest cover. We were nearing their homes, the women whose farms bordered on the forest that wasn't a forest, the women who were stepping out of their homes for the first time, and the women who felt the power and possibility in a fistful of seeds.

THE PEOPLE LIVING in the Río San Juan were settlers who migrated from the northern part of the country after the fall of the Somoza dictatorship in 1979. The Somoza father-son regime had ruled Nicaragua for over forty years. The father, Anastasio Somoza, reigned over Nicaragua for nearly twenty years. In 1956, he passed the torch to his eldest son, Luis Somoza, who served as dictator until he was usurped by his younger brother, Anastasio, in 1963. The Somoza family dynasty developed an international reputation for its brutal tactics of controlling land, resources, and wealth, including vast plantations of sugarcane, coffee, pineapple, cotton, and food grains for export. It denied education, healthcare, and agricultural support to the country's rural farming populations. The youngest son, Anastasio, gained the nickname 'Vampire Dictator,' based on his capital venture in blood. He bought blood from the poor population, marked up the price by 300 per cent, and sold it internationally. After an earthquake ravaged the capital city of Nicaragua in 1972, Somoza seized $30 million of relief supplies and, in turn, sold them to the highest bidder on the international market. The Somozas muzzled the media from speaking out against the regime through intimidation and assassinations. They murdered and 'disappeared' thousands of young men and women who resisted their authority.

Before 1979, the Somoza family and the bourgeois élite controlled nearly 50 per cent of Nicaragua's farmland. They grew plantations of cash crops—coffee, tobacco, and bananas— that they sold primarily to the United States, and enslaved

the country's poorest people as farmworkers. Fifty per cent of Nicaraguans were landless and living in extreme poverty, and nearly 90 per cent of the population was illiterate. The American president, Ronald Reagan, was famously quoted as saying "Somoza may be a son of a bitch, but at least he's our son of a bitch," referring to the United States' political and economic grip on Nicaragua. Somoza's brutality against the population protected American economic interests and investments in cash-crop agriculture and mining.

But the repression also gave rise to an armed rebellion. The mid-1970s saw the emergence of a rebel group made up of young men and women who called themselves the Sandinistas—paying homage to the name of a revolutionary fighter, Augusto Sandino, who had fought widely against the government's National Guard and whom Somoza killed in 1974. In 1979, the Sandinistas led victorious battles against the National Guard in cities across the country. The youngest Somoza son fled the country and millions of Nicaraguans flooded into the government square in Managua, waving red and black flags in celebration. The socialist Sandinistas promised *tierra para todos*, land for all.

The landless waited eagerly for reform on land distribution. But it didn't come. Instead, the Sandinistas confiscated the vast plantations formerly owned by Somoza and his elitist circle— over 25 per cent of the country's arable land—and transformed the private farms into state-run farms. Workers protested and demanded land distribution. The passing of the 1981 Agrarian Reform Law promised the reallocation of the confiscated land to poor farmers. Between 1981 and 1984, the Sandinistas gave away over 50,000 land titles to small farmers, but the revolution in land ownership happened too swiftly. Without substantial planning, chaos on the land ensued. In 1982, the Contras, a counter-insurgency group funded by the Americans, invaded Nicaragua from Honduras and conflict broke out, shifting the government's focus and attention from land distribution to war.

Out of hunger and frustration, the landless abandoned their impoverished lives and migrated south in search of new lives.

They squatted on idle plots and sowed their seeds. Thousands of farmworkers pushed south to the Río San Juan rainforest, which was largely uninhabited at the time, save for the Rama, an indigenous group who dwelled on the Atlantic Coast.

The landless weren't the only ones with an eye on the rainforest region: in 1985, the Sandinista government decided to establish an experimental African palm oil plantation in the Río San Juan. They enlisted the sweat and labour of the newly settled farmers in the region. In less than a decade, the population in the Río San Juan tripled, growing from twenty to sixty thousand people. By the year 2000, it had reached one hundred thousand people. The rainforests had given way to the fields of poor farmers' crops, which in turn became the ashes from which the African palm oil seedlings rose for as far as the eye could see.

"WE WERE NEWLYWEDS when we came to the forest," recalled Josefina. "We arrived with practically nothing. There were very few people living in the area. My husband made the land ours by slashing the forest and planting beans. That's just what everyone did back then, that's how we claimed land for the first time in our lives."

In the early 1980s, Josefina and her husband were among the first illegal squatters to travel into the Río San Juan, the first to erect a home from wooden sticks, black tarpaulins, and sheets of plastic, and the first to cut down the trees with machetes and long thin saws, the first to douse cloth in kerosene and lay it at the feet of giants. The forest smoldered into a layer of snowy ash, rich in nitrogen. The soil nourished the seeds like a placenta. The first harvest promised wealth to the poor settlers, but they came to know the abundant yields never lasted.

I met Josefina in the village of Las Maravillas, a community of three hundred families. A red strip of road snaked its way through the village, edged with simple clapboard houses built off the ground on stilts to prevent the entry of snakes and vermin. Outside a family-run *paupería,* general store, we sat in

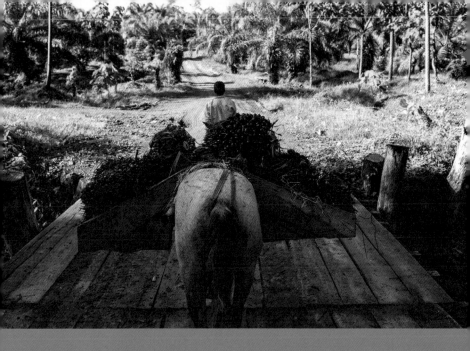

A man leads his horse, carrying a load of palm oil berries, through a palm oil plantation in the Río San Juan region of Nicaragua. Local women farmers complain of the pressure to sell their plots of land where they grow beans, maize, squash, and rice, and instead work on the palm oil plantations for low wages. Some say the farming practices of the palm oil industry, including the use of pesticides, are contaminating waterways in the Río San Juan rainforest. (Photo by KJ Dakin)

white plastic chairs and drank styrofoam cups of *horchata*, a sweet drink made from boiled rice, sugar, and cinnamon. Josefina's voice crackled like wind through a field of beans that had been left to dry on the vine. She wore a denim button-up shirt, rubber boots, and a faded pink baseball hat. Her sandy-coloured hair was cut short and flicked out above her ears. Her light green eyes peered out cautiously from beneath the brim of her hat.

"I wasn't born into a life of farming," she said. "But my life has made me into a farmer."

She came from a province located to the north of the Río San Juan rainforest. Her father laboured on a banana plantation and at a nickel mine. He struggled to earn enough money to buy rice and beans to feed Josefina and her seven siblings. She grew

up during the reign of the Somoza dictatorship, during an era when the government reserved education for the rich. Her father couldn't afford to pay for his daughters' tuitions. When I asked Josefina her age, she reached into her jean pocket and pulled out a worn leather wallet. Inside, she retrieved a laminated identification card. She handed it to me. I looked down at a small square photo of a younger woman with the same green eyes.

"What does it say?" she asked.

"You're forty-eight years old."

Josefina never learned how to read or write. As the oldest of seven siblings, she began to feel like a burden to her father and saw marriage as her only opportunity. She left home at sixteen, following her husband south into the Río San Juan. Josefina remembered the fear, the uncertainty of constructing a new home and life in the unfamiliarity of the rainforest. She spent the days alone in the house without venturing outside into the forest. The walls of her house felt thin. Outside, the sound of breaking leaves and sticks could indicate many unwanted things: a jaguar or an armed visitor claiming their land. Following the revolution, intense conflicts between the landless happened frequently, resulting in gunfire, knife fights, murder, and disappearance. Cut off from the rest of Nicaragua, men ruled the rainforest with a dog-eat-dog lawlessness.

While her husband worked his machete against the forest, laying flame to the earth and sowing beans in the ash, Josefina waited at home, pregnant with her first child. The days passed slowly. She boiled beans on an adobe-built stove and pounded maize in a wooden mortar to make tortillas. She left her home only to take lunch to her husband in the field or to collect water from a stream and carry it back to the house.

"I wanted to leave the house. I wanted to know the place," she said. "But my husband didn't like the idea of his *mujer*, his woman, away from the home. 'What could you possibly need to do?' he'd ask me. He became angry when I wanted to walk to the market. I was scared what he would do to me, but I was very young and he was my husband. I had to obey."

Josefina gave birth to three sons in the small house made of wooden boards. With each child born, her husband widened the margins of their land, planting their staple crops: rice, beans, and maize. He controlled the clearing, the labour, the harvest, the sales in the market, and the profits. He began spending his evenings hanging out with other men in the village at a one-room bar where they passed around a bottle of crudely home-brewed white rum. They sang like sad mariachis. They greedily eyed women for their generous breasts, for the exaggerated curve, the doughy weight of their asses. There were *otras mujeres*, other women, Josefina knew well. She would wake up in the middle of night, hearing him stumble into the yard, climbing the steps up to their house, cursing. Although she had her three sons, Josefina grew old in her solitude, her dismal acceptance of the situation. She became intimately acquainted with the forest's chorus: the loud trill of the cicada, the sharp call of the green parrot, and the haunting vocalization of the howler monkeys that reverberated from a distance. The forest became familiar to her.

One day her husband didn't return home from the fields. The rains had just begun to loosen the earth, signifying that it was time for farmers to plant their thirstiest crops of rice and maize. When she sent her oldest son to call his father home for dinner, the fields were like an abandoned house with no furniture: no trees, no crops, no signs of the farmer. Josefina never found out where he went or what happened to him.

"He could have crossed the river to Costa Rica to work on the coffee plantations, or maybe he went back to Chontales," she said. She shrugged her shoulders. "He probably found another *mujer*, woman. Maybe he started a family with her. That's what men do here.

"What did you do after he left?" I asked her.

"What else could I do?" she said. "I went with my sons to the fields and we planted. I learned how to farm because there was no other choice. *El hombre*, the man, was gone. I can say that it was hard work. It was the hardest work of my life. *Limpiando*,

clearing the fields for the planting of rice . . . *no es fácil*, it's not easy. But *hay que hacerlo*, you have to do it."

Her story of farming as a single mother wasn't unique in the Río San Juan. The stresses of poverty, migration, and rebuilding their lives amidst conflict and uncertainty took their toll on relationships. Like the exposed soil in the fields where they planted, where the loose layer of organic matter was easily washed away by a heavy rain, men moved from home to home, farm to farm, and job to job. They took flight like the wind through the ash, floating away like white moths. Every third household in the forest belonged to a single mother.

"Many men here don't take responsibility for their children," she said. "They live with a woman for a while, have a baby, and leave. One of my neighbours has three children from three different men. None of those children knows their fathers."

The settler women in Río San Juan were forced to leave *las casas,* their homes, and learn the land. Josefina learned the patterns of rain and sun, how to select the best seeds from the harvest, how to rotate pastures and crops, and how to care for a small cattle herd. She took the surplus crops, milk, eggs, and meat to the market for sale. Money passed into her hands for the first time in her life. And she raised her three sons into men who became fathers. But she knew that the way she was farming was consequential for the land. Machetes slashed the forests. Synthetic fertilizers inundated the soils, while chemical fertilizers burnt them. The nutrients had washed away long ago. Josefina knew she needed a solution.

"The yields are pathetic," she lamented. "If I don't use pesticides, the fields are attacked with pests or the harvest is puny. It's not a surprise that many farmers have sold their land to the Company for practically *nada*, nothing."

"Have they given you an offer for your farmland?

"Not yet," she said. "But *poco a poco*, little by little, they're expanding and coming closer to our property edge. It's only a matter of time before they send their representatives."

"Have you considered selling?"

"*Claro*, of course," she said nodding. "You have to weigh *lo malo*, the bad, with *lo bueno*, the good. But you shouldn't rush making decisions when it comes to land. If you look at who is selling to the Company, you see it's mostly men—it's also men who are working in *la palma*. They're only thinking about the short-term. They're thinking about money."

"Men use land the same way they use women," she added. "But women recognize the consequences of how we're living here in the forest. The pesticides we use are contaminating the streams, the river, even the water we drink. We don't want to clear more trees."

"So what's the alternative?" I asked.

"Women," she said. Her green eyes shone and smiled. "*Somos organizadas*, we're organized."

"WE'LL HAVE TO GET OUT and walk from here," said Tamara as she brought the truck into park on the edge of the road at the muddy junction. The road bled like a messy wound, the mud bright red and practically knee-deep. I saw the tracks where a vehicle had gotten stuck, the front tire spinning and spinning until it sank into the muck. I followed Tamara's lead and we sloppily trudged along, the mud making loud sucking sounds on our rubber boots.

"Most girls don't want to get into this kind of work and this is part of the reason why," Tamara said wryly, her short black ponytail swung back and forth as she shook her head and laughed aloud. "It's as far away from the city as you could possibly get."

Tamara was tall and built like a long-distance runner. She and I were the same age: twenty-eight years old. She had been born into city living. Her parents didn't grow food for a living. Her mother worked in the bus market selling fried *empanadas*, deep-fried tortillas stuffed with chicken and pork filling, and her father was a bus driver, shuttling passengers back and forth from Chontales to the capital city of Managua. Tamara

One of the members of an all-women farming group in a community in the Río San Juan region of Nicaragua stands in their demonstration garden. In order to combat poverty and food insecurity, women farmers are coming together, with the help of local organizations, to learn organic farming techniques to grow a wider diversity of fruits and vegetables to feed their families. (Photo by KJ Dakin)

graduated at the top of her high school class and obtained a scholarship to study agricultural sciences at a technical institute.

"Why agriculture?" I asked her.

"We're the second-poorest nation in the Western hemisphere," she said. "Yet Nicaragua is a country with *tanta riqueza*, so much wealth. We have forests, rivers, lakes, mountains, and volcanoes. We have arable land, but we're using the wrong methods to grow food. The use of pesticides is diminishing the potential of our resources and the health of *el pueblo*, the people. We have to discover and share new ways of farming *campesina a campesina*—farmer to farmer."

Twelve months ago, Tamara began visiting the homes of women from a handful of villages in the Río San Juan. She sat with them, drank their *horchata* and sugary black coffee, ate

rosquillas, fried cheese biscuits, and inquired about their lives. She invited them to attend meetings with other women and to hear what she had to say about new possibilities, a new kind of women-led agriculture in the rainforest region.

"Why did you approach women?" I asked Tamara, wiping the sweat pooling on my upper lip. Under the rainforest canopy I felt the humidity all over my body like a second skin.

"Because they listen," she said easily. "Women see what's happening here, they recognize what's at stake. They have a desire to learn from one another. Women listen. They're open to taking in new information and they're motivated to do something with it."

I heard a soft trill of women's voices up ahead. As we rounded a corner and the road opened up into semi-forest, I saw them beneath an enormous ceiba tree. The tree stood over sixty metres tall and shone silver, the same colour as an old woman's hair. Beneath the mammoth branches of the ceiba, the women stood between the rows of a large, square demonstration garden, which Tamara had helped them plant four months earlier. The women had heaped the soil into long rows of vegetables. The carrots and onions spiked out of the earth. Cucumbers wound themselves snakelike around a short wooden trellis. The shiny, fat watermelons appeared ready to harvest. One of the older women bent to pluck a nearly mature carrot from the earth. She smiled at the carrot and held it tenderly to her nose like a flower. She drew in its fresh, carroty, and damp-soil smell, and then smiled even more widely.

"*Qué rico,* how beautiful," she murmured, focusing her loving gaze on what she'd harvested. The woman's name was Maria de los Santos, 'Maria of the Saints.' She looked up and locked eyes with me. "*Bienvenido querida,* welcome my dear," she crooned and I leant into her grandmotherly embrace and kissed her leathery cheek. She pressed the carrot into my palm like a gift.

"Straight from the earth," she whispered to me. "*Orgánico.*" Her watery eyes twinkled.

The women surrounded us with their warm, excited energy. Their eager voices flowed with stories like the tributaries that

emptied into the San Juan River. They had also migrated to the Río San Juan with their families. Many of them worked as *amas de casa*, the wives of slash-and-burn farmers. Some of their husbands had left them, seasonally or permanently, to work on the plantations in Costa Rica, or to start new lives with other women. Many of their husbands worked for the Company in the African palm oil fields. We squeezed together on several long wooden benches beneath the tree, overlooking the garden.

"Most of *los hombres*, the men are working for the Company," said a thirty-year-old woman named Aura, and the other women nodded and murmured a chorus of "*Sí, sí, sí*, yes, yes, yes."

"We wake up at three in the morning to prepare *gallo pinto*, beans and rice, for their breakfast and lunch and they're gone by five," said Rebecca, a woman dressed in a skin-tight lip-stick-red blouse.

"*Sí, sí, sí*," said the women.

"The Company pays our husbands every two weeks, and although it isn't much, at least it's steady money that we can count on. These days we buy more food than we grow," explained Miriam, an older woman whom the group affectionately nicknamed *La Gordita*, the Little Fat One.

"*Sí, sí, sí*," they all said at once.

"But it's risky work!" cried Aura. "The men have to spray pesticides in the plantation. They risk ingesting the chemicals through their skin and lungs. *Es muy grave!* It's very serious!"

"*Sí, compañera*, yes, comrade," the women lamented.

"Last year, my husband couldn't work for two weeks because the chemicals badly burnt the skin on his left forearm," said Jessica, a fifty-year-old mother of five children. Her name was pronounced *Yessica* in Spanish. "It was a deep burn," she said mournfully.

"Did the Company compensate your husband for his injury?" I asked.

"No, no," said Jessica. "*Eso no*, absolutely not." She shook her head as though it were a far-fetched notion.

Maria de los Santos, the matriarch of the group, spoke up in her sweet, gravely voice.

"The violence on the land, on our husbands—on our own bodies—it's all too much," she said. "We joined hands last year to come together, to share experiences, to organize ourselves. We're learning how to grow food without chemicals."

When the women migrated south to the rainforests, they didn't know how to grow food, let alone build organic soil. Tamara was teaching women's groups in the Río San Juan how to layer different kinds of organic waste—rice husks, cow manure, slashed grass—to create a nutrient-rich compost, how to make soil in the region where rain was constantly washing the topsoil away.

"This knowledge is a beautiful thing," said Maria de los Santos. "It's *un regalo*, a gift."

Tamara taught the women how to double dig, a technique used to increase soil fertility. They dug up the land and layered the organic compost into the soil, replaced the layer with soil and buried vegetable seeds into the thick black mixture. They grew their favourite vegetables, the ones they used to buy in the market, the ones that were grown elsewhere in Nicaragua and shipped into the isolated region along the vein of the San Juan River. Food prices, factoring in the cost of fuel and transport, were unaffordable for many women. After establishing the group's demonstration garden, the women helped one another to dig and plant individual vegetable plots near their homes.

"Growing food gives us the strength to live alone," said Miriam. "I've doubled my family's fruit and vegetable consumption. If only you could come to my home and see the size of my watermelons." Then she leaned forward and smiled mischievously. "They're really helping to *mejorar la carne,* 'improve' the meat!" she giggled, playfully slapping her large, round rump. The other women and I burst into wild laughter at the one they called *Gordita*, round as a ball of dough, who regularly made the women shake with laughter.

"It's just the beginning for this group," Tamara explained as we trudged back along the muddy road towards the truck. "The

hope is that by sensitizing women to the idea of organic agriculture on a small scale, *poco a poco*, little by little, they'll integrate the technique into their fields of staple crops, use more organic manure and fewer pesticides, and rely on rotation techniques instead of cutting down the forest. We need to grow food the way ecology grows a forest."

"What do you mean?" I asked.

"*Vamos a ver,* we shall see," she said with a coy smile. Tamara revved the engine. We were heading to the village of Las Collinas to visit what she called *una solución con raíces,* a rooted solution.

WE ARRIVED AT ANA'S FARM as the sun was beginning to colour the sky in brushstrokes of yellow, pink, and orange light. We approached a large wooden house with a courtyard that held all the signs of farming life: watering cans, sprayers, hoes, and rakes. Ropes and jerry cans hung on the wall behind the house. Ana had transformed cracked buckets into planters for growing vegetables, and they attractively lined a path to the house. Greenery spilled over the edges of the planters: green peppers, tomatoes, eggplants, and tiny red chillies. Ana waited at the door with her two teenaged daughters. Her delicate features were mirrored in the faces of her daughters.

"Ana is one of our model farmers," said Tamara, bending down to kiss the shorter woman's cheek. Ana barely stood above five feet. She chuckled and shrugged off the compliment.

"No, no, *querida,* dear," she said. Her voice was smooth as butter. "It's *nada,* nothing. I'm just a *campesina humilde,* just a humble farmer."

"*Mami, es verdad lo que Tamara dice,* it's true what Tamara says!" cried her oldest daughter, proudly throwing an arm around her mother's shoulders. She was fourteen years old and already half a foot taller than Ana.

"Well, let's go see," chuckled Ana, and she turned to lead us behind the house.

Several women from a local farming group ride in the back of a pick-up truck, returning to their homes after a group meeting at one of the member's homes. Women are finding strength in numbers in the Río San Juan region, banding together to share knowledge and resources, fight back against *machismo* and domestic violence, and support one another as farmers and women. (Photo by KJ Dakin)

I was expecting to see a field of crops, but was surprised to see that the landscape was scattered with tree cover. The native trees rose to forty metres tall, interspersed evenly on the land. Tamara had taught the women a method called agroforestry, a technique that mimicked the way a forest grows: planting at all levels, from low-lying crops to shrubs, bushes, small trees, and larger trees. By planting forests as opposed to crops, farmers could produce a greater variety of grains, vegetables, fruits, timber, and medicinal plants in one space. The roots of the trees held water and moisture in the soil and prevented the topsoil from eroding.

In the understorey of the tree's branches, a plethora of fruit trees grew to a height of two metres. Spanning an acre of land, the fruit trees stood like stoic yogis frozen in tree pose. Their

branches formed perfectly lifted, symmetrical Ys. As we moved closer, I noticed the alien, elongated fruits—red, yellow, and green—growing from tiny stems on the bark. They grew like colourful tumours on the tree's trunk and upwards along their thickest branches.

"I bet you've never seen this type of fruit tree before," Tamara said excitedly.

"Is it a variety of papaya?" I asked, wracking my brain for comparable tropical fruits.

"*Compañera*, comrade," she began, using the term of endearment that the women in Las Collinas had used with one another. The word meant more than 'female friend' and 'female colleague.' Those two meanings combined signified a kind of respect, trust, and even solidarity between women. During the revolution, female rebel fighters used to call one another *compañera* as they struggled for liberation. I loved how the powerful word transcended the history of rebellion and revolution into the fields of female farmers.

"This is *cacao*, cocoa," continued Tamara. She pulled a pocketknife from her belt and bent under one of the tree's branches to cut one of the tumorous yellow fruits off the short stem. "I believe it's what you *gringos* call 'cocoa,'" she laughed sassily, making an exaggerated double 'o' sound with her lips. "Or chocolate," she added, drawing out every syllable: *cho-co-la-te*. Tamara made an incision down the long side of the yellow fruit and halved it with her hands. Inside, the seeds smiled back at me like teeth. A layer of translucent flesh encased the seeds.

"It's part of our strategy to counter what the African palm oil industry is doing to the rainforest," Tamara explained. "Palm oil isn't indigenous to a rainforest environment. You have to slash and burn everything. You have to shower it with pesticides. You burn the soil, you pollute the waters. But with cacao, you plant amongst the trees. There's no need to cut anything down."

Only three years after planting the cacao seedlings into a semi-forested landscape, Ana was harvesting the colourful fruits twelve months of the year. She initially learned about the potential of cacao from a male farmer whose land bordered her

property. He participated in a farmer-led cacao cooperative in Río San Juan. The cooperative owned a processing centre in the village of Boca de Sábalos. Members who grew cacao sold their crop monthly to the cooperative for a guaranteed price. At the centre, the cacao seeds underwent a process of fermentation and drying. They were weighed and sold to national and international markets, including *Ritter's*, the German chocolate empire.

"It just made sense to me," Ana said humbly. "If I sold my land to the African palm oil industry, what would I do to feed my daughters and send them to school? I learnt that one cacao tree produces for up to twenty years. Twenty years! *Imagínate!* Imagine!"

Ana had been one of the first female farmers to become a member of the cooperative. Over one hundred farmers in the Río San Juan grew cacao. Only 20 per cent were women. But Tamara was hopeful that Ana's example would inspire other women to convert part of the land that they used to grow staple crops into land for the perennial fruit trees.

"Cacao is helping us in many ways," said Ana. "Economically, yes. But it's also helping us to help the environment, to ensure we have *aire pura*, pure air, circulating in our lungs, to ensure that our rivers and streams run clean. It's saved me days of worry and stress. Now I have a guaranteed income, not for one month, one year, however long the Company gives work in *la palma*, but for twenty years. *Verdad,* truthfully, it's liberated me as a farmer and a woman."

"It's a small step in the right direction," Tamara agreed, nodding her head seriously. "The cacao covers just over five hundred acres of the arable land base in Río San Juan, but *la palma* has eaten up over thirteen thousand acres of rainforest, so we have a lot of work to do yet." She stood with her hands on her hips, looking out at the acre of agroforestry, seemingly weighing the gravity of her words and the situation in the Río San Juan.

Ana grabbed my hand and led me back along the path to her house. Inside, we hovered above the adobe stove in her kitchen. She told me how she'd built the stove from a mixture of bricks, mud, and cow manure. The manure insulated and preserved

the heat, which meant Ana used less firewood. She set about boiling a blackened pot of fresh cow's milk. Then she removed a large ceramic urn from the wooden cupboards and measured three heaping spoons of dried cocoa powder. Ana stirred the milk and cocoa. As the liquid bubbled on the stove, she added a pinch of dried and powdered cinnamon.

"They say women have been harvesting cacao seeds and making chocolate here for over four thousand years," said Ana, whisking in the last of the dried clumps of cocoa powder. "Our ancestors used this same recipe to make hot chocolate. They called it 'xocoatl.'"

The brown liquid frothed in the blackened pot and rose up to the surface. Before it spilled over, Ana expertly removed the pot from the stove and poured it into five ceramic mugs.

"*Pruébalo,* taste it," she said proudly, handing me a steaming mug.

I wrapped my hands around the mug and sipped tenderly at the scalding beverage. The chocolate was thick, bitter, sweetened only by the cow's milk. I looked up at Ana.

"Do you imagine your daughters will be involved with agriculture in the future?"

"*Claro, querida,* of course, my dear," she crooned. "Apart from their studies at school, I'm teaching them about agriculture. They are learning to grow their own food. They're learning how a woman can provide for herself."

I cupped the hot drink between two palms and felt warmed by the woman's comforting smile, her buttery words. They tasted just as sweet as the fruits of her harvest.

THE FOLLOWING DAY, Josefina invited me back to her village to talk with a handful of her *compañeras*, comrades, in the women's group. Outside Josefina's wooden home, six of us sat on long benches under the liquid shade of an avocado tree. Her son brought down a metal tray of *empanadas*, fried chicken rolls, and tin mugs of black coffee. The coffee was thick with

sugar. "*Gracias hijo,* thank you," she said to her son. The twenty-year-old had the same emerald eyes as his mother.

Josefina's house was situated alongside the skinny, red-dirt road. She kept animals in her patio, including a wooden pen of snorting pigs and a free-range hen with a fuzzy army of chicks. The hen and chicks were pecking at a fat fallen mango underneath the large fruit tree. The flesh split open and the putrid smell stung my nostrils. As we sat and ate, the women chatted noisily about the progress they were making in their gardens.

"*Ah mami,* oh my, the aphids are attacking my cabbage!" protested a woman called Maria.

"*Mira,* look," said Josefina. "Boil a few cloves of garlic in water and let it soak for a day or so. Add a little soap and splash it onto the cabbage leaves. It repels the pests."

"*Ah, en serio?* Seriously?" asked Maria, nodding her head enthusiastically.

As I listened to the women's gossip and banter, I witnessed how their relationships with one another transcended the definition of being 'members' of a group. They shared intimately with one another, as friends and colleagues, in their fields and gardens. "*Compañeras,*" they called one another. They were supporting one another not only with farming advice, but advice on relationships and parenting. Suddenly, a piercing whistle cut their passionate discussion in half. We looked up as a large truck carrying a load of fifty or so men drove past along the road. The men looked back and hollered at us, making loose kissing noises. "*¡Ven aquí!* Come here!" "*Mira a esas mamacitas!* Look at these women!" "*¿Qué pasan bonitas?* How's it going beautiful ladies?" As the truck rumbled away around the corner, the women exchanged bemused looks with one another and laughed uneasily.

"This is the kind of *machismo* we've put up with for years," said Josefina. "It was worse when I was a *niña,* a girl. Twenty years ago, my father would say to my mother, "You're mine. I tell you what to do." But today women are learning about their rights in society. Today I don't answer to anyone."

The other women nodded.

"My husband used to say to me, 'I'm the man of the house,'" said Erika, a woman in her late fifties who had given birth to eight children. "He called himself *El Macho*, the Commander. But, *gracias a Dios*, thank god, the conversation for women is changing."

"In my house," Josefina said, her voice trembling with passion, "There's rice, beans, there's furniture. I have everything. I'm the woman of my house."

"*Sí, compañera,*" said Maria. "In the fields, it's not only men who can be farmers. I wear pants. I can also grow food. I will never think, oh, it's better to be a man. No, because we can all produce, because we all have the same right to work."

"We all have the same right to farm," Erika finished her friend's sentence, and the women nodded and the crescendo of their conversation grew bolder and louder as they traded back and forth the experiences of working in the fields and gardens. They talked about what the future might hold for the women of Rio San Juan and the changes they wanted to see in their lives. They wanted improved access to education and healthcare for their children. They hoped for a justice system that would take domestic violence seriously. The women aspired to plant cacao and crops, instead of cutting down the forest.

Beneath the shade of Josefina's avocado tree, I sat and listened and remembered the words of Gioconda Belli, a Nicaraguan feminist poet who fought and struggled against the Somoza dictatorship. She wrote:

> *Y dios me hizo mujer*
> And God made me woman . . .
>
> I was born with ideas
> dreams
> and instinct...
>
> Every morning
> I rise up proud
> and bless my sex

Y dios me hizo mujer
And God made me woman.

"In my house, I am a woman and I am a man," said Josefina. They had grown weary of violence and transience. They longed to live more harmoniously with the forest. As I listened, the women's voices vibrated together, as though forming an anthem for gender equality. The women knew they couldn't have one without the other.

4. UNITED STATES

A female migrant worker from Mexico stands amongst the rows of grapes in a vineyard in Sonoma County, California. Like tens of thousands of other women, she immigrated illegally into the U.S. to work on vineyards and orchards. Whereas work in the vineyards was once dominated by male farm-workers, some women say that in recent years they've seen an increase in the number of women taking to the fields. (Photo by KJ Dakin)

"*Quién es? Who* are you?" demanded the woman's voice over the phone.

"Marie from *el centro*, the centre, gave me your number," I said, attempting to relax the sharpness of my Canadian accent, softening my tongue so the syllables spread more evenly like butter on warm bread. "*Ella me dijo,*" I began, the words melding together, "She said that you were interested in sharing with me your story as a farmworker."

Silence echoed in my ear and then finally:

"No, no, no," insisted the woman. "*No tengo tiempo*, I don't have time for that."

And, *click*.

I stared glumly at the folded piece of paper that Marie, a social worker in Sonoma County, had handed me that morning: a handwritten list of several dozen women who expressed a vague willingness to talk about their experiences as farmworkers in California. Many of the women were employed seasonally in what people referred to as *la uva*, the grape, the vast vineyards that blanketed more than sixty thousand acres—70 per cent of Sonoma County's agricultural production. Mexican female migrants in the United States juggled multiple tasks as farmworkers, domestic workers, nannies, gardeners, and food processing factory workers.

Marie worked at an employment support centre for migrant day labourers in Sonoma County. The centre sprung up in a tiny town after migrant workers, mostly undocumented workers from Mexico, flooded the street corners every day, looking for daily work from landowners in the area. They performed an array of odd jobs: planting flowers, digging irrigation ditches, and scraping the sludge out of eavestroughs. Men waited on the corners for work, congesting the entry to shops. Eventually, the community's storeowners angrily protested, "It's bad for business!" and "They've got to go!" Politicized students from Sonoma State University heard what was happening in the community and showed up on the streets, urging the workers to organize. They needed a centre and a more dignified system for finding work and establishing minimums for fair pay. Eventually, the

town council conceded and granted the workers land and materials, and the workers secured a single room in which to hold their meetings. The storeowners posted signs that read NO STREET HIRING, with an arrow pointing to the worker's centre.

That morning I had attended a workers' assembly at the centre, a gathering of fifty men, both fresh-faced and weathered, dressed in their work clothes: jeans, steel-toed boots, jean jackets, large sweatshirts with hoods, baseball caps, and straw cowboy hats. Some men would find jobs that day and others would not. The unlucky ones would creep back to the street corners, careful to stay out of the way of storeowners and customers, just in case a homeowner drove by, looking for hired help. I only counted two women at the assembly.

"Where are all the female workers?" I asked Marie, and she shrugged.

"It's harder for women to come to the centre every day," she said. "They have more responsibility to manage in their lives: the cooking, the children, their absolute necessity to find work. Women have more on the line. They can't always wait around for work."

I dialled their phone numbers again and again.

"What is this all about?" one woman inquired sceptically.

"I'm writing a book about the experiences of women working in agriculture," I explained.

"Oh, *no soy agricultora*, I'm not a farmer," she said quickly. "I only pick grapes."

"That's exactly what I'm hoping to—"

Click. Slowly, I worked my way down Marie's list of names, crossing off the 'numbers no longer in service,' the refusals, and the politely uttered "Don't call me, I'll call you," responses.

"Does this cost money?" another woman asked suspiciously.

"*No, señora*, ma'am," I said too quickly, surprised by the question. "I am looking for stories, *not* money."

Click.

I had come to Sonoma County, California—the lesser-known wine country to the west of the Napa Valley—where grapes and apple orchards saturated the landscape, and where

the majority of the farmhands that picked the fruit were Mexican, Latin, and other migrant labourers, many of whom had crossed illegally, without papers, into the United States. Officials estimated that eleven million undocumented immigrants were living and working in the United States, with the highest concentration—nearly three million—living in the state of California. The most common source of employment for undocumented migrants in the United States was in the agricultural industry, both in the fields and in the food processing centres. Women constituted 50 per cent of the migrant workers and approximately 30 per cent of the farmworkers. According to the 2012 Census of Agriculture, Latin farmers represented one of the fastest-growing demographics of farmers across the country.

California, a major breadbasket in the United States, employed undocumented female farmworkers in every dirty, back-breaking, mind-numbing task in the 'field to fork' movement, stooping low to pick strawberries and other labour-intensive crops, including spinach, lettuce, chard, and tomatoes, or hand-weeding in between the tightly packed rows of vegetables and fruits. As well, women slaved long hours on poultry, beef, and pork factory farms; they harvested apples and grapes, pruned trees, and worked in factories, processing juice and salsas. They sprayed, picked, planted, tilled, plucked feathers, shovelled shit, and dug with their hands in the dirt—but they reaped little glory or recognition for their enormous contributions to the United States' food economy.

They existed outside the social welfare system. Their bodies, their labour, did not count. I came to California to see their faces, to learn their names and histories, and to hear about their experiences. Many worked long, exhausting hours for marginal pay and endured uncertain, if not risky, working conditions to help put food on American tables.

"Americans don't want to even touch migrant workers," said Marie. "They don't want to live near them. Yet Americans want to live in communities where they can purchase

and eat fresh, organic produce. They do not see our workers as part of the community."

But when I reached California, I realized my naiveté: I wanted to meet with these women, but they did not want to meet with me. Why would they trust a white Canadian writer with the details of their identities, how long they had lived in the United States, and where they lived and worked? "I won't use your real names," I explained. "I'll photograph your hands, not your face. Or you can cover your nose and mouth with a bandana." As I dialled their numbers, I silently sympathized with them. "I know, trust me, I would not want to talk to me, either," I wanted to say to them. But I still called every name on the list.

In 2013, U.S. government crackdowns on undocumented workers reached a record high when the government deported nearly half a million people—mostly Mexicans—to their country of origin. Many of these migrant workers had lived in the United States for decades, working, raising their families, and watching their children graduate from colleges and universities. In December of 2015, the U.S. Centre for Migration Studies released a study indicating that the number of undocumented migrants living in the United States had plunged to its lowest levels since 2004. In California the number of Mexican workers dropped by 250,000 between 2010 and 2014. But critics, including Marie, argued this statistic had less to do with migrants choosing to leave the United States than it did with the enforcement of government policies that targeted undocumented workers. Under Obama's leadership, more than two million undocumented people had been deported since 2008.

As I would learn, few Mexican women would choose to go back to their home country. That journey would entail crossing the border into Mexico and traveling through the areas controlled by heavily armed drug cartels. Many women applied for political asylum in the United States, claiming that returning to their mother country was the equivalent of a death sentence.

Over the past thirty years, the majority of undocumented workers had come to the United States from Mexico by crossing

the Rio Grande, a three-thousand-kilometre river that formed a natural border between the two countries. Crossing the river earned migrants from Mexico and Central America the derogatory name *los mojados*—the wetbacks.

Millions of men, women, and children fled Mexico, escaping the escalating levels of poverty, the pathetic opportunities for work, the lousy price for Mexican maize in the market, the lack of government services, the corruption, and the brutality that spun out from the cartels and drug wars. For women, the dangers of *machismo,* patriarchy, gender-based violence, and the dearth of proper channels for women to seek justice in Mexico created inconceivable difficulties for their daily living and survival. The United Nations ranked Mexico as the twentieth-most-dangerous country in the world in which to be a woman. As early as the 1990s, the word *feminicidio,* or femicide—the murdering of women—surfaced in Mexico after an explosive series of disappearances and slayings of women occurred at the United States border town of Ciudad Juárez.

Many of the women who risked their lives to enter the United States were *las hijas del maíz,* daughters of the corn. They had grown up in the maize fields of their fathers and mothers, and their ancestors before them, who had selected the hardiest maize seeds—blue, white, purple, black—to ensure that the seeds would survive for seasons beyond their own lives. International trade policies dictated by their American neighbours to the north had devastated the economy of small-scale farming agriculture in Mexico. Women did not leave Mexico, cross the Rio Grande, and travel through bone-dry desert, away from their children, parents, siblings, culture, and language because they hoped to live the American dream. They did not grow up dreaming of life as third-class citizens in the United States, where people would look on them as vermin. Drugs and violence drove women across the borders. They did not come with any grand illusions. They abandoned their shrinking farms in Mexico for large-scale farms in the United States. They came because circumstance had forced them to face their dilemma and decide: *lucha o huida?* Fight or flight?

The women fled from Mexico by any means necessary: on foot, with fake identification papers, lying under blankets and boxes and other bodies in the back of pickup trucks, or tucked into the fetal position, planted like seeds, in the compartments of vans where additional seats should have been stored. From the late 1980s to 2015 they migrated north in the millions, looking for crops to tend in the soil of California.

In late autumn, the leaves on the vines in Sonoma County turned from green to the colour of an egg yolk or spun gold, depending on how the light fell. The long, perfect rows ran up and down the countryside. Photographers stopped on the roadside to capture the late sun on the orange vines. Some of the images wound up on postcards sold at the vineyards, where thousands of tourists came to swirl rose, red, and peach-coloured wines in long-stemmed glasses and let them settle sensuously on their palates. Did they know whose hands picked the grapes of the wine they tasted? Did they ever wonder or care to learn about their stories? By November, proof of the workers' existence had vanished in the picturesque, oh-so-pretty vineyards. They were nowhere to be found.

Months earlier, the winemakers and the vineyard managers inspected the grape clusters with their eyes, hands, and mouths, checking for a specific shade of purple: a fresh-bruise, blackish purple. They tested grapes between their fingers, squeezing them until they bled, splitting them open with their teeth, and tasting the explosion of the tart sweetness. At the winemakers' will, thousands of seasonal workers, most of them undocumented workers from Mexico, flooded the long rows of grapes. They took to the vineyards at nine o'clock at night, when the temperature was cool and forgiving and would not blister the fine skin of the grapes or compromise the sweetness of the fruit. The workers' hands harvested grapes the same way a pianist's fingers flew on the keys. In swift motions they clipped the grapes and filled their baskets high with fruit. Their wage accumulated by weight. With only so many grapes on the vines and only so much money to be made, the workers picked as quickly as their fingers could manage, paying heed not to puncture the

A mother gazes at her child's art work during an evening at the family's tiny, cramped apartment in Sonoma County, California. Migrant farmworkers work grueling shifts in the fields under the hot sun for only $12 an hour; however, they face steep costs of living, often forcing two families to share a single apartment. (Photo by KJ Dakin)

grapes. Damage to the grapes would result in deductions from their pay. After the last grapes were picked, and the vines had been pruned and cut back to regrow in the season ahead, the contractors paid the workers. Their labour no longer required in the vineyards, the workers left to find jobs elsewhere. In the fields, the few remaining and forgotten grapes, hidden clandestinely under leaves, dried on the vine, shrivelling up into raisins.

Tania, a fifty-eight-year-old woman from the central state of Guanajuato, Mexico, had wrapped up her picking contract by the middle of October. The harvest came two weeks earlier than it had in the previous year due to the warming weather and changing seasonal patterns. Five years ago, the grapes in Sonoma would be ready for harvest at the end of October, with some varieties remaining on the vine until November. Sonoma's grapes thrived in cooler temperatures, including the Pinot Noir

and the famous Zinfandel, which attracted millions of tourists every year. The warming temperatures, the lack of rainfall, and the stubborn drought in California had sounded the alarm for winemakers in Sonoma. The stakes were high for their fields, where too much sun could easily spoil the cold-weather grapes and the quality of their wines.

Farmworkers carried the heavy worry of climate change as well. Tania counted on the September and October income from picking grapes for ten hours a day. She worked overnight, harvesting under the glow of industry lights that lit up the vineyards like a night game at a football stadium. She tallied up her daily wage at the weigh scale, reckoned by the basket-load of grapes. The sum worked out to roughly ten dollars an hour. The harvest provided a sudden influx of money in her pocket, which she would need to stretch out over the coming months during which the majority of undocumented workers in Sonoma were all out of work, hungry, and hunting for jobs, willing to do anything for a meagre income.

In the low season, Tania scrubbed the floors and insides of refrigerators and toilet bowls of homeowners in Sonoma County. "It's good money," she admitted, her mousy-gray hair that she wore back in a bun frizzing around her temple, "but I feel alone when I'm working in people's houses, cleaning their belongings. I prefer working outside in teams of people, taking in the fresh air and the elements, with my hands on the plants."

I dialled Tania's number in the early afternoon. I heard the edge of doubt in her voice, but surprisingly, she agreed to spend a few hours with me. "When would you prefer to meet?" I asked her. "*Ahorrita*, right now," she said. An hour later I shook Tania's small hand and sat down across from her at a wooden picnic bench outside the centre. An elderly man sat on the curb in the shade beneath a coniferous tree. He picked at a small *guitarra*, guitar, with clunky plastic strings and played a somewhat out-of-tune but upbeat song. A handful of the male workers uprooted the dried yellow sunflower and maize stalks from a series of raised beds. They tossed the long, stiff leftovers onto

a compost heap. Tania nodded in greeting to one of the men. Her wrinkled face smiled with kindness.

"This interview doesn't make you feel nervous?" I asked her.

"*No, no,*" she said in a gentle voice, "I've lived here for half of my life—more than twenty-seven years—I have a good idea of who I can trust. I feel good with you." Her bluish-grey eyes smiled and I felt myself relax.

Despite having lived in the United States for nearly three decades, Tania lacked the proper identification and paperwork to file income tax, apply for a social insurance number, and secure support from the U.S. social welfare system. She gave birth to her youngest child in Sonoma County, a boy whom she called Rafael. As a child born to an immigrant mother on American soil, Rafael received some government support: food stamps for powdered milk, meat, and vegetables. Legally, Tania was not allowed to work. But landowners and farm contractors in California—as in states all over the country—often turned a blind eye to the law when it came to undocumented workers, particularly when agricultural workers were in high demand. The U.S. laws did not prevent Tania from finding a multitude of short-term, contract jobs. Every few months she sent money to Guanajuato, where her mother brought up the five daughters and two sons she had left in Mexico. Slowly, Tania would set aside the money necessary to pay the *coyotes*, or guides, to smuggle them across the border. "With all the pain in my heart, I had to leave my children behind," she lamented.

In 1990, Tania first crossed the Mexico–United States border on foot. A *coyote* led her across a section of the Sonoran Desert. She spent three days walking through the desert, populated only by varieties of cacti, scrub brush, and reptiles with armoured skin that had adapted to the extreme temperatures. Tania reached Texas at night. It was mid-January, the temperature dropped, and snow fell gently from the sky, cascading on to Tania's open palms. "I had never felt such cold," she said. "But I didn't mind the snow, I was just so happy that I made it." She paid the *coyote* two hundred American dollars for the journey.

Decades later, the cost of hiring a *coyote* had risen exponentially. By 2015, the fee to employ a seasoned guide ranged anywhere from $3,000 to $5,000. Now these guides were mostly controlled by the cartels and the drug traffickers at the borders and heavily taxed by them. "When I crossed thirty years ago, it was very easy," she shrugged. "My thirty-year-old daughter, Karina, remained in Guanajuato and today she begs me, 'Ah, mami, *por favor,* please, find a way to get me to the United States,' but I say, 'Are you crazy?' These days it's too expensive and far too dangerous."

Tania left her home without the company of any family members, or friends, to travel to the United States, although she did not arrive alone. From 1990 to 2010, more than seven million Mexicans left their families, land, and livelihoods to fill the labour gap in the United States. During the 1990s, the demand for low-skilled workers in the United States, primarily in the agriculture sector, sky-rocketed. To the south, millions of Mexican small-scale farmers, many with ancestral links to ancient indigenous farming cultures, including the Maya and Aztec, struggled to sell their grains in the market. The dual cross-border phenomena of low-skilled jobs opening up in the United States and farmers abandoning their land in Mexico had not occurred independently of one another. On the contrary, they stemmed from the same cause: the signing of NAFTA, the North American Free Trade Agreement between the United States, Canada, and Mexico, first conceptualized in 1990 and ratified in 1994.

The architects behind NAFTA predicted that the opening of borders and the free flow of goods, including grain products, would displace millions of small-scale farmers in Mexico and force them into daily labour jobs on larger-scale farms, into overcrowded Mexican cities and slums, and north into the United States. Critics argued that NAFTA's terms were written to favour the American agricultural sector and the flooding of their heavily subsidized corn into Mexico's markets. While American corn farmers received over $10 billion of U.S. government subsidies by 2010, NAFTA prohibited Mexicans from

supporting, subsidizing, or stocking surplus grain production in their own country. With the Americans selling their subsidized corn surplus at 40 per cent of the cost of production in Mexico, small-scale Mexican farmers were, essentially, put out of business. Their indigenous varieties sold for a fraction of the price they used to command when the Mexican government supported the costs of production. The Mexicans could no longer afford to be farmers. The government prioritized labour-intensive cash crops bound for export, such as limes and strawberries. Some of the displaced farmers moved to work at the large-scale export farms. Many others, including Tania, set their sights north of the border, on the United States. She left Guanajuato, already mourning what she was leaving behind: her children, her family, her connection to land, culture, and community.

Tania grew up on a *rancho ejido,* a communally owned farm in Guanajuato, where her parents and approximately one hundred other families in their village tended to their individual parcels of land, while also collectively maintaining the fields. In this system, called *ejido*, families strove for self-sufficiency, but the larger community ensured equitable sustenance for everyone from the whole of the land. They redistributed surplus crops to families who had suffered poor farming seasons, lost relatives, or experienced losses from pests and plagues. Tania's father and mother planted traditional varieties of maize seed, which date back thousands of years to their ancestors in the Mesoamerican period of 8000 to 2000 BC. The Nahua people, commonly called the Aztecs, subsisted on indigenous varieties of maize, beans, squash, amaranth, chili peppers, and tomatoes. Tania's ancestors grew food relying on advanced techniques, including the construction of *chinampas,* or artificial islands made within shallow lakes. Men and women layered levels of mud, lake sediment, organic vegetation, and 'night soil,' or human waste, and built the beds to a height above the surface of the water. The technique allowed the Nahua people to produce six to seven harvests in one year on the nutrient-rich lake islands. As a young girl, Tania learned by watching her mother

Migrant female farmworkers in Sonoma County, California, strive to connect with their native roots through traditional foods. In her apartment, a Mexican woman slices steamed *chayote* onto a plate for her children. She grows traditional herbs in pots on the patio, with seeds brought over from her home town in Oaxaca, Mexico. (Photo by KJ Dakin)

and father work in the fields, mimicking the way their hands moved amongst the crops.

"I grew up in the *campo*, on the land, sowing our seeds, and *pizcando el maíz,* harvesting the maize,"recalled Tania, smiling at the memory. A *pizcador* was a traditional hand tool used to cut the dried ear of corn off the stalk. Made from carved wood or bone, or out of iron, farmers slipped their fingers through two leather hoops attached to the tool, and with it, harvested maize efficiently. The tool had survived for thousands of years. As a young woman, her mother taught her how to use the *pizcador.*

"My mother was a beautiful person," Tania nodded. "She always worked so hard: she cooked, made tortillas, she wove, she made cheese—I saw everything that she did. Of my six siblings, I was the closest with my mother, *pegado a su lado,* glued to her side. We were so close. My mother taught me that

any kind of work is good work, that, *como mujer*, as a woman, I could do any kind of work."

Tania paused and reflected back on the loneliness of her first days living in the United States, without the ability to speak English and without support from relatives from whom she never could have imagined living apart. "Before coming, I heard stories from the north about these difficulties, but I couldn't have imagined how, psychologically, it would be so hard on me as a mother," she said.

When Tania arrived in Sonoma County, she obtained a job as a live-in nanny and domestic worker on a small vineyard outside the town of Sebastopol. While the father of the family spoke fluent Spanish, the mother, originally from Minnesota, could barely communicate with Tania. She recalled the difficulty of living and working in the family's house, raising their children, whom she grew to love as her own: Frida, a two-year-old sparkplug of a girl, and her baby brother, David, swathed in cloth. "The children used to call me, 'Mama Tania! Mama Tania!'" she laughed sadly. "I think they loved me even more than their own mother. It was a very strange feeling knowing how far away my own children were." Tania toiled tirelessly for the family: cooking, cleaning, and doing the laundry. The husband demanded that, in addition to her domestic chores, she help in the vineyards with the farm work. "The owner used to say to me, 'You have good hands, the right hands to work with *la uva*.' During the harvest, we started the day in the fields at five in the morning, before the light came, and worked until ten o'clock. It was easy work, easier than the maize harvests in Mexico. The difficulty was doing both—the farm work and the domestic work—and the expectation that I would do both, but only be paid to do one."

"How long did you live with the family?" I asked Tania.

"Ten years," she said slowly. "I was so afraid to leave. I barely knew another soul in Sonoma County because I was so isolated on the farm. Initially, they only paid me two hundred American dollars a week—for fourteen, fifteen hours of work a day,

seven days a week. And sometimes they didn't pay me at all. But what could I do?"

"How did you eventually leave?"

"I became pregnant and I think the wife used that as an excuse to get rid of me. The husband disagreed. He said, 'No, Tania! You can't leave. You're part of our family.'" She frowned, and shook her head angrily. "His children loved me like a mother, but I was not family. In reality, I was more like his slave."

Tania worked on the vineyard up until her ninth month of pregnancy. When she gave birth to her son, Rafael, she waved goodbye to Frida and David, who were by then twelve and ten years old. The children cried and Tania cried. She felt guilty leaving the children that were not really hers behind. She had come to see in their faces the faces of the daughters and sons she left in Mexico, years before. "Mama Tania! Don't go!"

With nowhere else to turn, she decided to move in with her boyfriend, Rafael's father, who had also migrated to the United States from Mexico. They lived in a low-income apartment unit in Sebastopol. After weaning Rafael, Tania began hunting for work in the vineyards that surrounded Sebastopol. She joined hundreds of workers in the fields, fulfilling multiple contracts on different vineyards, and earning as little as nine and as much as twelve dollars an hour. Tania picked, planted, sprayed, pruned, and set irrigation lines in the vineyards. She wore what her male colleagues wore: loose fitting jeans, baggy button-up cotton shirts with long sleeves, leather gloves, rubber boots, and bandanas tied around her temples to keep sweat from creeping into her eyes. A wide-brimmed straw sombrero kept the wickedly bright sun out of her eyes and off her skin.

Tania had to juggle about twelve different contracts in a year. Employment was fickle, never a sure thing, and as a result the burden of paying rent, buying groceries, and sending money back to her mother and children in Mexico felt relentless. "We earn more in the United States, but we also consume more," she admitted. "It's been difficult to save."

"What's it like to be a woman working in the vineyards?" I asked her.

"Usually there's more men than women," said Tania. "The contractors divide us into teams of twenty or so workers—usually they're mixed with men and women. The foremen are typically men from Mexico, or Central America, and they're the ones who give the orders and oversee the pace of the work. In general, I prefer working with women. It's safer."

"Why do you say that?"

"At times, female farmworkers face prejudice in the fields," she began. "In Mexico, we have a saying: a man will go as far as a woman lets him . . . "; her voice trailed off. "Anything can happen out there. We're working long hours. Women in the fields know there's always a sexist or racist foreman you have to ignore. But we accept the risks because the money is good. And *gracias a Dios,* thank god, it hasn't happened to me," she added quickly.

'It' was a two-letter euphemism for a much larger, darker, and frightening reality that many migrant female farmworkers faced while labouring on American farms: sexual assault, abuse, and even rape. It hadn't happened to Tania, but she knew 'it' had happened to other women. The possibility of verbal and sexual abuse hung over women in the fields as their hands flew, their backs ached, and they thought of their children and other commitments back home.

In a PBS documentary called *Rape in the Fields,* journalists investigated numerous cases of rape and sexual assault against migrant female workers in the United States' agricultural sector. In southwestern Florida, five female migrant workers filed charges of rape and sexual assault against their male supervisors at Moreno Farms, where they were working in a vegetable packing factory. Sandra Lopez, a migrant worker from Chiapas, Mexico, alleged that she was ordered by a male foreman to do a 'special task' for him. Outside, he grabbed Sandra from behind, dragged her into an office trailer, tore off her clothes, and raped her for an hour. Two of Sandra's colleagues testified on the stand that they had also been raped at Moreno Farms, and two more swore that the male supervisors had tried to assault them, but they escaped. When three of the women went to the local

police station, the sheriff dismissed their claims. Months later, by the time the U.S. federal authorities finally recognized the women's claims, the owners of Moreno Farms had abandoned the plant. They vanished entirely.

But for women like Tania, those who had crept clandestinely across the border, trekking through the desert, on foot, without papers, or proof of their residency in the United States, the fear of being raped in the fields was doubly worrisome. They lived outside the judicial system. The fifty-eight-year-old mother of eight children was a criminal according to U.S. law and subject to deportation back to Mexico, back to the land that no longer belonged to her, back to the grave of her mother, whom she had never been able to see before she died. American laws criminalized women like Tania despite how much the national food economy depended on her broken body to work the fields. And when these women were victims of rape, the judicial system did not protect them. Whom would they tell? How would they seek justice? Rape and abuse added another level of risk to the burdens undocumented workers shouldered. They were not supposed to exist in these fields of labour, yet they did. No matter that they fed the country, the level of danger and vulnerability they accepted as inevitable remained invisible in the eyes of American law.

SANTA ROSA, the largest city in Sonoma County, was a half hour by car from Graton. The vast majority of migrant workers lived in the city and commuted everyday to the vineyards. Many could not afford the steep costs associated with living right near the vineyards. In Sebastopol, the organic grocery stores charged eight dollars for two litres of milk, nearly the equivalent to the vineyard worker's hourly wage. Renting a two-bedroom apartment could cost $1,500. Outside a real estate office in one of the small, touristy vineyard towns, I saw posters listing properties and land at more than $8 million. The towns near the vineyards attracted tourists, rich foodies, and wine connoisseurs. Gentrification could not have been more obvious: inside the

cafés, mostly white Americans sipped five-dollar lattes and ate overpriced panini sandwiches, while outside brown-skinned migrant workers sat on the curb, hungry for work, but trying not to be seen. Marie's words rang in my ears: "Americans want to eat fresh, organic produce. But they don't want to even touch migrant farmers."

Lucia, a forty-nine-year-old woman from Oaxaca, Mexico, could not afford to live close to the vineyards where she worked. Instead, she and her husband, a man from Jalisco, Mexico, lived with their three children in a two-bedroom apartment in Santa Rosa. Pulling up along a residential street, I followed her directions to an apartment complex and walked into the square compound in the middle of it. I noticed a few men outside, smoking. Their faces looked familiar and I recognized them from the centre that morning. They waved and smiled. I found Lucia's unit on the second floor. The red paint peeled on the door. I knocked and heard a commotion of footsteps inside. Lucia's six-year-old son, her youngest, flung open the door and looked at me with wide-open eyes. "Moooooom!" he bellowed, followed by *"Ya vengo hijo! I'm coming, my son!"*

Lucia approached, a tea towel draped over her shoulder. She stood less than five feet tall. *Bajita*, a short one, her friends teased her. She had high, pronounced cheekbones and large, oval eyes. Her skin gleamed like dark honey and she parted her black hair down the middle, securing it in a high ponytail with a green plastic clip. She welcomed me into the living room, which I gathered, judging from the king-sized bed in the corner, also served as the master bedroom. Her two sons, six and seven years old, wrestled on a couch covered with a sheet. Cartoons flashed on the television screen, glowing in the dark room. A guitar hung on the wall, along with a few photographs. Leather suitcases were stacked high in one corner.

"Ah, you've just caught me in the middle of cleaning," she said, leading me into her small kitchen with mustard-yellow walls and fluffy white curtains. "Have you eaten? Let me serve you some food, I have some leftover food here," she said in one solid breath, not allowing me to say otherwise. She set a small plate

of steamed *calabaza de chayote*, a variety of soft green squash with a spiny skin, on the table and urged me in a motherly voice, "*Cómetelo, cómetelo*, eat, eat." The sweet squash melted in my mouth. A young teenaged girl came into the kitchen and sat beside me at the table. "Meet *mi hija*, my daughter, Erika," cooed Lucia, smiling proudly at her daughter. Erika smiled and introduced herself in English. She sat at the table with me.

"The *chayote* is delicious," I thanked Lucia, as she stacked the clean plates in the cupboards.

"It's a variety from Oaxaca," she said. "I'm trying to prepare the foods we ate back at home here, but many of the ingredients aren't available. I make tortillas, black beans, *queso*, cheese, but my kids, sometimes they whine, 'Oh, we don't want beans!' When I grew up in Mexico, I ate natural, healthy foods. But here, the kids want *pura pizza, pura hamburguesa,* only pizza and hamburgers!" cried Lucia, making a disapproving clicking noise with her tongue against her teeth.

At the table, Erika rolled her eyes at her mother's words. I offered her a sympathetic smile.

"My daughter barely eats," Lucia continued. "It's like she has no interest in food. *Mira,* look at her dinner," she said, motioning to a plate of steamed squash, rice, beans, and chicken. "And the food she eats at school should not be considered food, it's so full of grease!"

"What's the food like at your school, Erika?" I asked her.

"It depends on the day," she shrugged, tossing her ponytail over her shoulder. "*Hay una línea especial para pizza.* There's a special line up for pizza. *Hay una* salad bar and turkey and ham sandwiches," she said in 'Spanglish.'

"Americans don't know the meaning of food," ranted Lucia. "I grew up in a place where people *viven para comer*, live to eat! We ate *mole, pan chocolate, carne asada, tortillas calientitas,*" she cried, the cultural dishes from Oaxaca rolling off her tongue. She said them with such reverence and longing that I could almost taste them. Food culture in Oaxaca, a southern state in Mexico, was known for its rich diversity of ingredients and dishes, particularly the variety of *moles*, sauces made from

fragrant herbs, fresh tomatoes and chilli peppers, and even chocolate, which Oaxacans served with meat, rice, and beans.

"Oh, let's see, we have *Amarillo mole, chichilo mole, negro, coloradito, manchamanteles, rojo, verde . . .* " said Lucia, naming the multitude of mole sauces that originated in Oaxaca.

"But what are the cultural dishes of Americans? Pizza, hamburgers, hotdogs, French fries. *Pura grasa!* Full of grease!" Lucia scowled. "You would think in such an intelligent country as the United States, people would know how to properly nourish their children."

Erika slid out of her seat at the kitchen table and tiptoed out of the kitchen. I tried to hide a slight grin. I suspected that the issue of food was a sore spot between Lucia and Erika. While I sympathized with Erika, her mother certainly had reason to express frustration. Many others shared Lucia's criticisms of the U.S. public school lunch programs, which typically were poorly funded. Over one third of Americans qualified as obese and suffered the accompanying health issues, including heart disease, high blood pressure, and diabetes.

"I was born on a *ranchito*, a little farm, in Mexico. When I was a child, I'd go with my parents to plant the *milpa*—maize, beans, and squash—and we ploughed the land with teams of oxen. No one used tractors back then. My father only used organic manure on the fields. It was a very natural, beautiful life." She sighed. "But there was no work, so I knew I would have to leave. My older brother and I hired a *coyote* at the border and crossed by foot. I was only eighteen years old."

Lucia crossed the border to Arizona in 1995, only a year after Mexico agreed to the stipulations of NAFTA. In California, she moved from contract to contract on farms and in food processing centres. Without documentation, farm work was the most accessible employment available to her. Lucia laboured on a garlic farm in southern California, following a tractor as it dug and pulled up garlic bulbs, and bent to place the garlic cloves into a basket. "After I bent all day, digging, digging, digging like this—*eiiiii*," she said, placing a hand over the small of her back and cringing in pain. "That was a terrible contract. I only

worked one season and never went back." She picked strawber-
ries and sorted through massive bins of salad greens, picking
out the dead or wilted leaves. In huge greenhouses Lucia picked
cherry and hothouse tomatoes, bright on the vine. In orchards
she plucked citrus fruits such as naval oranges, giant grapefruits,
and lemons off the green limbs. When she was single Lucia
had more freedom to move from contract to contract, trav-
eling to new towns and locations. But after giving birth to her
daughter, Erika, she realized the difficulty of maintaining work
as a farmer twelve months of the year, while providing some
stability for her daughter. Lucia looked for employment off the
farms to supplement her income during the low season. She
sold Mary Kay cosmetics, door to door. "They were beautiful,"
she murmured. "But *carísimo,* damn expensive!" At home, she
prepared *camote en dulce,* a traditional Oaxacan dessert tart,
crispy pastry dough stuffed with a sweet potato mixture, and
sold them to other tenants in their apartment buildings. "You
have to do a little bit of everything to survive," she admitted.

"The type of labour depends on the region you're in," she
said. "In southern California, there was citrus and vegetables.
So I picked citrus and vegetables all day. In Sonoma Country,
there's *la uva,* the grapes. My work is about picking and
pruning, mostly."

"Are there many women in the vineyards?" I asked.

"Ten years ago, I was often one of the only women working
in a crew of all men," she said. "But these days, I would say
there's more women than men. Of course, it depends on who is
hiring. I try and get on with the contractors that hire all female
teams."

"Only women?" I said, surprised.

"*Sí, sí,*" she said, nodding her head vigorously. "I think some
contractors recognize that women often have more *ganas,* desire,
to work than men. Men easily grow tired and lose that desire to
work hard. Women have more endurance. We pick faster and
we damage fewer grapes than men. When I'm working with
other women, I feel good about myself. We socialize, we laugh,
and we encourage one another."

"But *no es fácil*, it's not easy work," she added.

Lucia worried about the health risks associated with handling the grapes and vines after they had been heavily sprayed with chemical pesticides. In Sonoma County, the majority of the vineyard managers applied pesticides to ward off pests. The rows were wide enough for a tractor to drive slowly through and mechanically spray two lines of vines at once. Lucia explained that most of the contractors waited until two days had passed before ordering the workers to pick or prune in the sprayed area.

"The amount of pesticides that Americans use to grow food makes me very nervous," stressed Lucia. "I don't know whether or not I'm ingesting chemicals at work. The contractors say it's okay, but how can they be so sure? I know chemicals are residual, that's why I always wear gloves. I worry about the risk of getting cancer, so I won't touch the leaves, or the fruit, without gloves. I would much rather work at an organic vineyard, but I don't have that luxury."

During the summer, Lucia slaved in the vineyards under the intense California heat. She wore a straw cowboy hat, carried a plastic bottle of water, and often argued with her contractors, demanding that they allow her to take regular breaks. She watched other, often younger, women push themselves in the vineyards, usually at the expense of their health. Lucia recalled an incident that took place the previous harvest season. She had been working side by side with a friend from Sinaloa, Mexico, picking the bountiful bunches of grapes, one by one. They worked quickly, using small knives to cut the grapes, their hands flying. Her friend suddenly screamed, dropped the grapes, and clutched at her hand. Her pinkie finger was sliced clean through to the bone. Blood gushed from the tear in her glove.

"You have to be so careful," said Lucia with a grave expression. "The contractors don't care about your health. You are the only one who can be accountable for your health in the fields. My friend should have taken a break. If you get tired, you get careless. And one cut, that's all it takes. Lose a finger, lose your ability to work and earn your living."

Over the past decades, hundreds of thousands of women, many of them from Mexico and Central America, have risked their lives to cross the border into the United States. Today, undocumented female farmworkers continue to face high risks working in the vineyards, orchards, and fields: they are often subject to gender-based discrimination, harassment, and even sexual abuse from supervisors and coworkers. Local organizations in California are working to help women speak out and seek justice. (Photo by KJ Dakin)

"Aren't there standards that contractors have to adhere to?" I inquired. She only shrugged.

"*Mira,* look, some are better than others. Some contractors provide you with water, with regular breaks, with toilets, and they treat you with respect. Others don't. As a farmworker, it's on you to decide how much risk you take."

In 2005, the state of California passed a law that required all farms and farm contractors to provide all workers with water and regular breaks in the shade. The law passed in the wake of ten deaths—four of them farmworkers—in a period of only two months. This law was the first of its kind for farmworkers in the United States. But the legislation proved difficult for officials to enforce.

On May 14, 2008, in Stockton, California, when the temperature soared above thirty-five degrees Celsius, Maria Isabel Vasquez Jimenez, a seventeen-year-old undocumented worker from Oaxaca, collapsed from heat exhaustion and dehydration. She had been working along the vineyard row, tying grape vines. Maria's colleagues said the nearest water cooler had been a ten-minute walk away and the foreman did not allow regular water breaks. Maria was in a coma when she arrived at the hospital. Her body temperature was over one hundred degrees. She died two days later. The doctors discovered the young woman had been pregnant. Maria's death sparked protests across the country. "The machinery of growers is taken better care of than the lives of farmworkers," said Arturo Rodriguez of the United Farm Workers' Union at a protest following the incident. "You wouldn't take a machine out into the field without putting oil in it. How can you take the life of a person and not even give them the basics?" Maria's death prompted the addition of stricter regulations to the legislation, but nonetheless Lucia insisted she had "seen it all" from different contractors. "As a farmworker, you have to be very, very careful," she said. "No one is looking out for you because you are dispensable."

Before I left, Lucia and I stood outside on her balcony and chatted casually. She showed me her balcony garden: a row of potted herbs, including *hierba santa, hierba Buena,* a

variety of Mexican mint, and *pitiona,* an essential ingredient used in many of the Oaxacan *moles.* She told me her friends had brought them from Oaxaca, tucked into one of the bags they carried across the border. She treasured these herbs. They offered a shred of connection, a few threads that linked Lucia to her former homeland. She asked me about the book I was writing and the countries I had traveled to, and I told some of the stories from Guatemala, Nicaragua, and Uganda.

"How lucky you are," she said longingly. "To have a passport that can take you anywhere."

"Yes," I said softly because it was the easiest thing to say in that moment to the woman who had come illegally to the United States, forced by economic circumstances, and would likely never be able to go home to Oaxaca to see her mother before she died. "Yes, I am lucky," I heard myself say, but knowing that it had little to do with luck and more to do with the forces of modern-day imperialism and economic trade liberalization.

Lucia confided in me that she worried about her daughter's health. "She doesn't eat," she said. "I wish I could take her back to Mexico and teach her about the meaning of food. There, I could help her fall in love with food, to know food. *Vivir para comer.* To live to eat."

THE FOLLOWING EVENING, I went out with a friend to a small country bar in Petaluma, a nearby town in Sonoma County, to listen to a blues band. People, young and old, packed the dance floor, shaking their limbs, dropping low, and moving their hips to the beat of the heavy bass and the electric guitar.

While my friend went off to dance, I sat down at a table and sipped at a pint of a Californian-brewed pale ale, watching the band play. A couple, who appeared to be in their mid-fifties, sat down across from me. "I'm John. Whereya comin' from?" asked the man, and I told him about the three-day drive along Highway 101, all the way down from Canada to California.

"I bet you're enjoying the wine tasting here in Sonoma?" asked John.

"Um, not exactly," I smiled. "I'm here to interview female farmworkers for a book."

"Farmworkers, hey?" he said a little defensively, straightening his posture. His expression changed from friendliness to suspicion. "Well, I can tell ya it's damn better here than in other places."

"Oh, how so?" I asked, trying not to sound antagonistic.

"Well," he sputtered. "At least here they get water and toilets. Not like in Texas."

"How is it in Texas?" I asked.

"Well, I don't know exactly," he said, leaning across the table, his voice getting louder. "I just know it's better. Besides, them Mexicans that come here, they're used to living and working in dirt-poor conditions. They're only here to make money and send it home. They don't give a shit about working long days, or what—they just wanna work. They're just going to tell you sob stories. But there's two sides to every goddamn story."

"Why are you so defensive?" I wanted to ask him.

Or, perhaps: "Have you ever spoken to a farmworker before? Do you have any idea of what it's like working long days in the vineyards? Do you think people *wanted* to come here? Aren't Mexican farmworkers people, also? Have you *no* fucking decency?"

But I just stared into my beer and regretted not lying earlier.

"Yes, I am enjoying the wine tasting," I could have said. "What pretty country it is."

The daughter of a farmworker, miner, and union activist, Dolores Huerta was born in 1930 in New Mexico and raised by her single mother in the central valley of California—the epicentre of U.S. agricultural production. The name, Huerta, means 'garden.' Huerta's mother, Alicia Chavez, ran a seventy-room hotel in the town of Stockton, renting affordable rooms to low-wage farmworkers and, occasionally, even allowing families experiencing hard times to stay free of charge. Her mother's keen sense of justice and compassion influenced Huerta profoundly. As a young woman, she studied education at a community college and began teaching at a primary school

in Stockton. Later in life, she confessed in her biography: "I couldn't tolerate seeing kids come to class hungry and needing shoes. I thought I could do more by organizing farm workers than by trying to teach their hungry children." Huerta quit her job and began a lifelong struggle as a community organizer and social activist to help farmworkers in the United States, particularly women, achieve economic and social justice.

In 1962, Huerta cofounded the National Farm Workers Association (NFWA), alongside the future president of Venezuela, Cesar Chavez. The NFWA became one of the first worker's rights organizations in the United States. In 1965, Huerta and the NFWA joined forces with the Agricultural Workers Organizing Committee (AWOC), led by Filipino migrant farmworkers, to organize a statewide strike against grape farmers in California and their unfair treatment and marginal compensation. On September 8, 1965, in the town of Delano, farmworkers walked off the farms, demanding wages equal to the federal minimum wage. Huerta lent her voice to the strike and helped to organize a series of consumer boycotts, marches, and other events of non-violent resistance. The strike against grape farmers spread to involve two thousand workers in California. In 1966, the NFWA and the AWOC merged to form the United Farm Workers (UFW). Huerta directed the UFA's national boycott of grapes, urging the public not to consume grapes and blocking grape distribution centres so the product would rot before reaching grocery store shelves. Her tireless work to protect the rights of grape farmers in California paid off in 1970, when the entire grape industry folded and signed a three-year collective bargaining agreement with the UFW, which significantly increased workers' wages. This agreement marked one of the earliest successes of the farmworker's rights movements in the United States. Huerta's activism as a woman set a precedent.

In the town of Sonoma, I met Jimena, a mother, undocumented farmworker, activist, volunteer, and community organizer, and also one of the migrant women whom Huerta's work had inspired. Born in Guerrero, Mexico, Jimena crossed the border into California in her early twenties. "For

twenty-four years I've lived here," she said at her family's home in Sonoma, "And for *twenty-two* years I've been working with the community."

We sat in her living room, a large, spacious room painted bright yellow, in the house where she lived with her husband and eldest son, who had just graduated from university. Jimena worked in a chilli-packing plant and volunteered as the Sonoma County representative for Líderes Campesinas, an organization created by female Mexican farmworkers in 1988 in Coachella, California, to educate, support, and advocate for the rights of female farmworkers. Líderes Campesinas worked in twelve regions in California with the goal of informing women about their rights, developing their leadership skills, and encouraging them to participate in community organizing. "Many women believe that if they come to the United States illegally, they do not have any rights," said Jimena. "But these women do have rights. They are working, and therefore subject to protection under universal human rights. The women have the right to water, shade, fair wages, safe working environments, and decent treatment from their employers."

Jimena hosted regular meetings for female farmworkers at her home, where women could come to learn about their rights and the resources available to them—including crisis support and legal advisory services for women experiencing physical, sexual, and emotional abuse at home or in the workplace. In recent years, she had seen many positive changes among the female migrant farmworker community in Sonoma County. "Before women didn't bat an eye at *machismo*, or patriarchy, it's so engrained in our culture," commented Jimena. "But now, with more information and knowledge about their rights, I've seen women stand up against their employers and husbands and say, 'This is wrong. I know my rights.'"

In 2000, the U.S. Congress passed the Victims of Trafficking and Violence Protection Act, and specifically created the U Visa to support migrant women. The U Visa allowed undocumented women to report incidents of mental, physical, and sexual abuse, whether at work or at home, without fear of

deportation. "These days women are speaking out more," said Jimena. "There used to be more abuse and violence against women in the fields. I think that scared many women into doing more domestic work. But the fear in the fields is lessening, particularly when women understand their rights and the resources that are available to support them."

ON MY LAST AFTERNOON in Sonoma County, I met Valentina, a forty-five-year-old woman from a small fishing and farming village along the Pacific coast of Mexico. She was relatively new to life in the United States: in 2011, she and her husband hired a *coyote* to cross the border at Tijuana. At the time, she was pregnant with her son. When they arrived in Sonoma County, Valentina found work in the vineyards. "I truly enjoy being a farmworker," she said, as she reached into a large pleather purse slung under her arm and retrieved her cell phone. She flipped through the photos and played a video of her harvesting grapes. It had been taken only a month earlier by one of her colleagues. In the video, Valentina was cutting bunches of grapes and placing them in the basket she wore tied around her waist. Her hands worked quickly. *"¡Dale, dale, dale, dale!"* a female voice cried in the background. Go, go, go, go! Valentina laughed. The industrial lights shone down on her, silhouetting her figure. I wanted to crawl into the scene and see the harvest with my own eyes.

Outside the town of Sonoma, Valentina and I walked along a quiet road lined with long miles of orange-coloured vineyards. She pointed to a cluster of white shrivelled grapes. "If the owner is making red wine, they leave the white grapes to dry on the vine," she said. "It's such a waste." The vine roots were thick and coiled around the wire trellises. Some of the vineyards in Sonoma County had been planted nearly one hundred years earlier.

"Mira, look," said Valentina, and I looked up ahead, surprised by the sight. A farmer had rigged up a massive star-spangled flag to a lone tree in the middle of the orange vineyard.

The rooted flagpole bent under the weight of the enormous American flag. A soft wind carried through the fields and the flag gently rolled back and forth.

"The Americans like their flags," I said jokingly to her. She smiled and nodded.

"Some people say that we shouldn't be here in the United States," she said slowly, thoughtfully, her hands dug into the pockets of her pink hooded sweatshirt. "They say, 'Go back to Mexico!' They believe that we don't belong here. That kind of patriotism doesn't make space for us here. But our work here is important. I feel important."

And so I took a portrait photograph of Valentina standing in front of the vineyard with the late afternoon sun dazzling the orange vineyards and the slow lap of the American flag waving so bizarrely behind her. It was the full picture. It was the post-card that told the truth: the American-owned vineyards and the body of the migrant female farmworker, the woman whose hands picked the grapes to eke out a living, to feed her four-year-old son. The moon was already out, a faint thumbprint against the November sky, draining of light.

5. CANADA

Jessica Walty, a small-scale farmer in the Peace Country of northwestern Alberta, affectionately cradles a twenty-pound Emden goose. Walty is raising heritage poultry, including chickens, ducks, and free-range geese, to harvest organic eggs and meat. (Photo by Trina Moyles)

"No daughter of mine will ever farm," said Mary's father.

After turning fifteen years old in the summer of 1975, Mary told her father she dreamed of following in his footsteps and becoming a grain farmer on the Saskatchewan prairies. But when she spoke the words aloud, her father's face did not light up with joy or pride, but clouded over with disappointment. Forty years later, and her father's words of disapproval still stung.

"It felt like slap across the face," Mary remembered.

Mary grew up on her family's grain farm, the youngest child after six boys, doing everything her older brothers did. She learned how to drive the tractor, haul grain, dig up potatoes, and help pull stuck calves out of their mothers during calving season. She discovered the beauty of giving herself to a task, exhausting herself on the land, and feeling the immense value of touching the earth to produce food to be eaten at the dinner table that night.

"I worked with my father everyday. I was a natural at farm work, and while my father acknowledged that, I knew he was not going to give me any land to farm," she recalled. With sadness and uncertainty, the young woman left behind the familiar fields of grains where she spent her childhood, the vegetable garden where she watched her mother pull carrots out of the earth, and the barn on the Canadian prairies where she and her brothers played. As many young women and men did, she moved to the city, the world around her urbanized, and the land on which she imagined her life shrunk to the size of a small flower garden or a few tiny herb pots lining a windowsill.

Following World War II, the viability of small-scale farming began to wane as large-scale industrial agriculture rapidly expanded. Post-WWII technologies, including goliath combines, monstrous field irrigators, and the use of pesticides and high-yielding seeds—elements of what would become known as "modern agriculture"—took root on the Canadian prairies. So-called modern agriculture emphasized the greater value of producing a single crop, which began to alter the traditional practices of small-scale farms growing and raising a diversity

of crops. The corporatization of agriculture allowed large-scale farmers to purchase larger quantities of land, access farm capital in bulk, and as a result, produce higher yields. Small-scale farmers struggled to compete and secure markets. Over time, smaller operations would lose their ability to compete with large-scale production; thousands of small farms were absorbed into the hundreds and thousands of acres of monocrop grains. People raised on farms moved, in hoards, to urban environments. They lived in shoebox apartments, three stories above the earth; they purchased food in the grocery stores; and ate hamburgers and French fries at drive-in fast food joints. The vast majority of the generation born on farms after wwII lost all connection to land, seeds, and farming. But for Mary, the love of the land never disappeared.

She decided that if she could not be a farmer, she would dedicate her academic career to researching food, agriculture, and farming. Mary traveled across Canada, to India and Sri Lanka, throughout parts of Europe, and to Cuba, to interact with farmers, conduct research, and study how communities were feeding themselves through alternative agriculture methods, including organic production, urban agriculture, and permaculture.

"How have the roles of Canadian women in agriculture changed over the years?" I asked Mary. She sat across from me in her office in downtown Edmonton, Alberta, where she worked as an Associate Professor at the University of Alberta's Faculty of Extension.

Mary leaned back in her desk chair, surrounded by books and papers, and with a faraway expression in her eyes; I imagined she was thinking about her life back on the golden wheat and flax fields, under the vacant blue skies. She spoke to me about her grandmother and mother, both of whom lived the life of farmers and farmwives on the Canadian prairies. In the early 1900s, Mary's grandmother was only nineteen years old when she crossed the Atlantic Ocean on a steamship, emigrating from Croatia where peasant farmers faced land scarcity and unemployment. She journeyed west to meet her husband,

a Croatian man who had already purchased a 160-acre plot of farmland in Kenaston, Saskatchewan. Between the 1880s and 1930s, hundreds of thousands of European immigrants came to Canada, accessing "free land" through the Dominion Lands Policy of 1872, a tactic used by the Canadian government to expand westwards and use the prairies to grow wheat, millions of acres of wheat, to feed the growing population in Eastern Canada. The Canadian government's efforts to lure peasant farmers from Europe succeeded: between 1901 and 1931, the amount of cultivated land on the Canadian prairies increased exponentially from 1.5 to 16.4 million hectares.

Tragically, the land was never as free as the government promised in its flashy advertisements that targeted poor, land-less farmers in Europe. The grassland prairies of central Canada were home to a number of Indigenous groups, including the Plains Cree, the Blackfoot, the Assiniboine, the Saulteaux, and Métis peoples. The Indigenous groups did not "own" the land because, drawing from Indigenous cosmology, land was not something to be owned, but something to tread lightly upon, to use with respect, and to relate to with reverence. Indigenous cultures did not commodify or privatize land as did the European settlers who claimed ownership over North America. As history unfolded, the European settlers arrived, used violent force against the Indigenous groups, and manipulated treaty agreements to push the 'Indian problem' onto marginal reserves of land. With the expansion of the railroad, the extermination of the buffalo population, and the sowing of wheat seed on the Canadian prairies, the Canadian government strove to 'absorb the Indians onto the land,' and 'cure' them of their migratory culture.

New-age hippies, wannabe farmers, and people who identified with the 'back to the land' movement of the 1960s, tended to simplify and idealize the experiences of early European settler farmers as idyllic, simple, and spiritually rewarding. But the experiences of Mary's grandmother, my great-grandmother Eleanor, and other immigrant women who arrived from Europe, were anything but simple. Many of them did not

speak English, or French. Many of them did not know a soul, except for their husbands. Immigrant women lived in hostile conditions on unfamiliar prairie landscapes. Many answered to their husbands.

"The lives of settler farmwomen would have been very difficult and complicated at that time," said Mary. "Society expected women to be subservient and submissive to their husbands. Their work was critical to the survival of the family. But women had no control over capital and resources." Her grandmother gave birth to six children and the family depended entirely on their field crops, animals, and garden to survive the frigid grip of winter on the prairies. Survival required all hands—male and female—to pitch in on the land, yet the division of household labour between the sexes was far from egalitarian. Settler men controlled the land, while their sons inherited it, as well as wealth and political influence. Mary's grandmother had mastered every single farm task, even those performed by her husband and sons: driving the team of horses and then, later, the tractor and ploughing the fields. She taught her daughter, Mary's mother, to do the same chores inside and outside of the home. "My mom first provided meals for a threshing crew at age thirteen," she said. "She learned how to drive the tractor and haul grain. She knew how to plan and plant a homestead garden, how to seed the fields. She was born a farmer, so it made sense that she decided to marry a farmer."

Mary's father, a first generation Canadian, also grew up on the Canadian prairies. He inherited farmland from his father and settled with Mary's mother outside of Kenaston to raise their family. Mary remembered her mother as headstrong and independent. In 1962, after Saskatchewan's provincial legislation changed to allow women to enter pubs, her mother "made a big show of it," donning a stylish dress and going to town for a pint—"just to prove that she could," laughed Mary. On the farm, she showed the same grit and determination as her husband, and worked just as hard as he did.

"My mom's ideas, born of her experience and knowledge, were absolutely critical in the design of the farmyard,"

explained Mary. "It was so well laid out in terms of efficiency, light penetration, and aesthetics. My dad often enthused, 'My wife's the one—she did that!'" But regardless of her efforts, the Croatian-Canadian settler community, along with many other European descendants on the prairies, did not think of women as farmers, but rather as farmwives. Mary's father attended educational workshops on agriculture and gathered at meetings with other male settler farmers. "But my mother never had those opportunities," said Mary. "Early settler women in Canada definitely did not have very respected roles on farms, even though they were indispensable."

"Why do you think your father denied you land?" I asked Mary.

"My father was a part of the European and Slavic immigrant community in Canada," she explained. "He held on strongly to conservative views about what women could and couldn't do in society." She paused for several seconds. "But today I wonder if his decision had anything to do with the two women who lived on the neighbouring farm," she said.

Mary described the elusive women, sisters, born to English immigrant parents, who—for reasons she never knew—broke the cultural expectations of women at that time, and refused to marry. They remained on the farm, working alongside their brothers to sow, harvest, and thresh the fields of grain. The sisters dressed in worn jean overalls and rubber boots, forgoing ladies' fashions of the day. The town of Kenaston did not know how to acknowledge or refer to the women and their taboo lifestyle as farmers. "We never referred to them as sisters, or women," said Mary. "We just lumped them together with their brothers. We called them 'the brothers.' It was as if those women had to give up a part of their gender identity as women in order to farm. Of course," she added, "my father was completely aghast at what those women had done with their lives!"

"If you want to farm, marry a farmer," Mary's father said, carving up the family's land on the Canadian prairies and evenly distributing the pieces to two of his sons.

The founding of European agriculture on the Canadian prairies firmly entrenched patriarchal gender roles: boys became farmers and girls became farmers' wives. Access to farmland, equipment, livestock, and knowledge of farming practices typically passed from father to sons. In both rural and urban societies, women were traditionally seen as inferior to men—their voices did not carry much political weight or importance outside the home. Women could not vote in federal elections until 1916. Much worse, Indigenous women could not vote until 1960.

Under the Married Woman's Property Act—passed in Manitoba in 1900, Saskatchewan in 1907, and Alberta in 1922—married settler women could legally purchase property and land. But in the early 1900s, not all women co-signed their names to their families' farms and property, and women were not protected by marital property rights until the late 1970s. Marital rights ensured a woman's equal rights to property and land after the dissolution of a marriage. In 1975, a rancher named Irene Murdoch, who had worked with her husband on their ranch for over twenty-five years, divorced her husband and sought compensation in court. But the judge denied Irene access to an allowance based on the worth of her husband's property, citing that she had no right to it because she had done "just about as much as the ordinary rancher's wife does," which, apparently, was not recognized as having any value whatsoever. Outraged by the courts' sexist ruling against Irene, women's rights groups used her case to lobby for a change to the law, and by the late 1970s, most provinces were pressured to adopt matrimonial property acts.

Indeed, Canada's agricultural past continues to shape and influence how food is grown today, and more importantly, *who* grows food. In 2011, the national agricultural census revealed a startling gender gap in farmers. Only 27 per cent of Canadian farm operators are women. The average Canadian farmer is white, of European descent, middle-aged, and male: not so different from the Farmer Joe stereotype that persists in the popular imagination. I remember the images from childhood cartoons: a pot-bellied, gray-headed man wearing jean overalls

Women in Canada are playing an important role in sowing and saving heritage seeds, such as these heritage bean seeds. Due to the influence and expansion of global seed companies, many varieties of vegetable and grain crops are rapidly being lost. Women grow heritage crops, not only for taste preference, but also for political reasons, to keep the world's diversity of seeds alive and thriving. (Photo by Trina Moyles)

and leaning against a wooden fence, with a blade of grass stuck between his coffee-stained teeth. But even the image of Farmer Joe, a hard-working family man, seems to be disappearing on the Canadian landscape. Only 2 per cent of Canadians call themselves farmers. Although the numbers of farmers continue to shrink, the size of farms on the prairies is swelling. As well, large tracts of arable land are being sold to foreign buyers for oil and gas development, residential expansion, or land speculation.

"We call it the disappearing middle, that midsized family farms are going out of business. Farms are getting bigger and bigger. It seems if you want to make it as a farmer in Canada, you need more land, more capital, and higher yields," explained Mary, shaking her head in frustration. "What's the average size of the farm on the prairies today? Fifteen, sixteen hundred acres? The cost of land has gone sky high. It's a huge investment to get into farming today. Some people are lucky in that

they get land and equipment passed on to them, but for many, inheritance is not an option."

"And especially not for young women," I added.

By 2011, the average farm size in Saskatchewan had grown to sixteen hundred acres, and in Alberta, twelve hundred acres. The cost of farmland on the Canadian prairies had risen exponentially throughout the 1980s, 1990s, and first decade of the twenty-first century. Farm Credit Canada estimates that from 2000 to 2012, the value of farmland increased by well over 100 per cent. Emerging, aspiring young farmers—male and female—faced insurmountable debts and mortgages to get started in farming. The cost of starting a large-scale farming venture would be in the millions, and upwards of a half a million dollars for a small-scale farm. Young aspiring Canadian female farmers faced the same question Mary faced as a fifteen-year-old girl in 1975: how to access land, farming equipment, and the tools to begin?

Despite the uncertainties, young Canadian women—many two, three, even four generations from their farming ancestors—still hungered to become farmers. In post-secondary institutions across the country, Canadian women outnumbered men in the faculties of agriculture and natural sciences. At alternative agriculture workshops, including permaculture, SPIN (small plot intensive), and urban agriculture classes, female participants typically vastly outnumbered the males. I knew these women: they were my friends. I had grown up with some of them in northern Alberta, and other women I had met along my own personal journey of learning about agriculture. Their stories inspired me.

If the majority of Canadian women could not access the millions of acres of farmland on the Canadian prairies, I wanted to know where and how they were farming. On the fringes of conventional agriculture, fields of wheat, cattle ranches, and large-scale dairy operations, I discovered women—many, many women—who were acquiring land in unique ways, growing food, and feeding their families and communities. Most of the women I met had been, like me, disconnected from farming for

two or three generations. Most of them admitted, "I never could have imagined becoming a farmer." And yet, increasing numbers of women were climbing into tractor seats, trading in their office apparel for rubber boots and leather work gloves, and managing their own operations. Women grew food, harvested honey, and raised poultry, cattle, sheep, goats, and rabbits. They built and repaired fences, constructed greenhouses, chicken coops, and barns. Women sold their products at farmer's markets, distributed food through community-supported agriculture (CSA) programs, and nourished newborns with their raw goat's milk.

Who were these women finding alternative ways to buy and access farmland? How were they confronting the persistence of patriarchal systems and fighting to change society's perception of women who dig? More importantly, how were they using farming as a political tool for social change? How were they addressing environmental and social injustice?

How were Canadian women making farming a political act?

"PEOPLE OFTEN THINK that the farmer is the man. Even at times, my customers at the farmer's market assume that I'm the farmer's wife," Dawn said, her mouth tugging upwards into a wry smile. Her brown eyes glittered mischievously. "But I've grown used to it."

We sat at a table in the loft area of the Strathcona Farmer's Market in Edmonton, Alberta, overlooking the rows of vendors selling their farm-fresh produce and the early morning customers who were already packing the aisles. Her partner, Kate, managed the booth. A chalkboard hung above their table, the words SUNRISE GARDENS written in bright yellow. Dawn's organic produce filled the table: butternut squash, Nantes carrots, bags of sunflower sprouts, and black trays of electric-green wheatgrass.

Outside the sky was a true blue and the March sun had started the gradual melt of snow. March reminded people of what spring felt like and they emerged from their homes and flocked to one of Edmonton's largest Saturday markets.

I threaded my way past couples walking arm in arm, women pushing winter-equipped baby strollers, and trendy hipsters wearing pea coats and scarves. I entered through a garage door and my eyes fell and feasted on the colours of fresh farm produce. A young boy played the fiddle with his black fiddle case in front of him, wide open for tips. The smell of deep-fried green onion cakes wafted from the food vendors section. The abundance of the market made the standard grocery store feel like an empty, sterile shoebox.

I had come to meet Dawn, the thirty-five-year-old farmer behind Sunrise Gardens, a ten-acre organic vegetable farm near the town of Onoway, Alberta. She was one of the only female farmers at the Strathcona market who managed her own farm. She wore a pink and yellow tie-dyed T-shirt and earrings dangled below her earlobes like small tangerines. She smiled with a slight gap between her front teeth and said, "I've met many farmers and I've met farmer's wives, but I've yet to meet another woman in Alberta who has a story quite like mine," she said. Then she laughed and admitted, "Although it's true that I'm always farming, so I don't get out a lot."

Dawn grew up on her family's acreage outside of Onoway. She had not been born into a life of farming, but from a young age she felt a natural connection with the land. As a child, she watched the whitetail deer graze in the fields around her home and watched the leaves transform from green to gold to burnt orange in the fall. She listened for the piercing caw and throaty croak of the raven and hoped to see a moose and her calf nibbling at the edges of wheat fields. After graduating from high school, Dawn decided to try her hand at working in construction. She loved the physicality that construction demanded, although being one of the lone female workers on the all-male work sites came with challenges. The attitudes of her colleagues varied from supportive to sceptical to misogynistic. Patriarchal stereotypes of women in Alberta prevailed: women did not belong on construction sites. During the 1990s, approximately 30 per cent of construction workers were female, and it remains a male-dominated trade. But on the work site,

Dawn enjoyed the challenge of proving herself to her male colleagues. "I was one of the first women in Alberta to work in rebar," she said. "Back in the 1990s, there were few women in construction. That felt very satisfying. I did not realize it at the time, but my experiences in construction were preparing me to become a farmer."

In her mid-twenties, Dawn began to help her father in his garden. "He always grew way too much of everything," she laughed. "We had so much produce, *too much*, and we did not know what to do with it all, so a friend suggested we sell some of it at the small farmers' market in town. Before that year, it never occurred to me that growing food could be a way to make a living." She remembered the immense satisfaction of selling the garden produce at the market. Dawn felt inspired by the customers' eagerness to purchase cucumbers, onions, and squash, and to chat with her about how she grew the food. The experience motivated her to plant her own small garden the following year and to experiment with growing different crops.

After Dawn gave birth to her son, she grew weary of the long distances she had to travel for construction jobs, the uncertainty of securing her next contract, and not knowing whom she would have to put up with. "I could not choose which men I worked with," she said. Dawn longed for independence in her livelihood and began thinking about how to make a living closer to home so she could spend more time with her son. "In my head, I kept coming back to the idea of gardening," recalled Dawn. "If I tripled what I could manage in my garden, I would be farming. Was I ready to be a farmer?" she laughed. "Is anyone ever truly ready to become a farmer?" She shook her head. "It felt risky, but I really felt it could be something that I loved."

The advantages of many years working in construction, enduring subtle and not-so-subtle encounters with sexist colleagues, would eventually pay off, not only in being prepared for the physical labour, but also in working a job that paid well above what she would have earned in more traditionally 'female' jobs. In Alberta, women earned, on average, only 60

Rising numbers of young women are getting involved in small-scale, organic farms in Canada. At this mixed farm outside of Edmonton, Alberta, several women manage the greenhouse, field vegetable, and poultry operations. The farm also hosts a regular influx of young women volunteers from around the world, who come to work on the farm in exchange for room, board, and the opportunity to learn hands-on about organic agriculture. (Photo by Trina Moyles)

per cent of what men earned. Men typically dominated the trades, oil fields, industry, and higher-paying, working-class jobs. With the support of her father, Dawn used her earnings in construction to secure farmland outside of Onoway, and set to work clearing a small plot of land to sow an array of vegetable seeds. At first she sold her goods at smaller farmers' markets in Onoway, a small town of only a thousand people, but after a few years she applied for a permit to sell at the Strathcona Farmer's Market in Edmonton. On her first day at Strathcona, Dawn sold out of everything she had brought. Inspired, she began expanding her garden, acre by acre, into a small farm.

"Truthfully," she said reflectively. "I still identify as more of a gardener than a farmer. My technique is mostly by hand. Only in the spring do I tend to use the tractor to till the soil. Otherwise, I plant by hand, weed by hand, harvest, and process by hand."

The farms that rubbed up against the edges of Sunrise Gardens grew thousands of acres of wheat, barley, oats, and rye—and the farmers were all men. When Dawn first got started, the men glanced at Dawn's tiny garden, just a mere fraction of the massive size of their farms, and laughed. "It has taken nearly ten years for them to take me seriously," she admitted. "Of course, when you say 'farmer' in Alberta it's typically assumed you have cows, or a thousand acres of land and you drive your tractor most the time."

"And that you're a man," I added.

"Yes—and that," she laughed, nodding her head.

Dawn longed to break free of the conventional farming methods that surrounded her on the Canadian prairies. Where most of the neighbouring grain farms relied on mechanization and the use of pesticides, Dawn preferred the idea of growing without chemicals. "I knew if I was going to farm for a living, I would have to feel really good about what I was doing—and why. Organic production, simply, is better for the environment, and it's better for our health." She immediately applied for organic farm certification. Despite the lengthy process it can take to become organic-certified—anywhere from two to five

years, or so—Dawn felt it necessary to provide proof of certification to her customers.

"What has been the most challenging aspect of farming for you?" I asked her.

Dawn would never forget the date. July 18, 2008: the day she came close to quitting the farm.

"When I first started out, I felt this pressure to compete with other farmers, particularly the larger-scale vegetable vendors at the market," Dawn explained.

Bolstered by her early success as a farmer, she decided to double the size of her farm, focusing on the expansion of her carrots and squash, crops that she would be able to store and sell over the course of the winter. Winter crops were particularly important on the Canadian prairies where the temperatures plunged below minus 20 degrees Celsius and the land disappeared under a thick coat of snow and ice. Without a greenhouse or cold-house frame, a small glass covering that protected plants from frost and snow, prairie farmers could typically only grow food for five or six months of the year.

Dawn dug in, struggling to balance being a single mother caring for her now seven-year-old son and being a full-time farmer. She woke up at five o'clock in the morning, went out to irrigate the crops, then came back inside the house to prepare breakfast and lunch for her son. Dawn worked in the fields, planting, transplanting, and weeding, until her son came home at the end of the day. She made him dinner before heading back out to her fields.

"By the middle of the season, I realized I could no longer keep up. The weeds took over. The quality of my crops nosedived. And soon, I also crashed and burned. I literally ran away from the farm. I told myself that I would never go back: it was too much work, too physically exhausting, and too economically risky. I blocked the farm from my mind."

Dawn returned to construction work, abandoning the carrots and squash to rot in the fields. The season turned cold again, the leaves fell from the trees, and the first snowflakes began to fall, when Dawn felt a pang of regret. "My failure

that year made me ask myself, deeply, Did I really want to be a farmer? And the answer was yes," she said. "But I knew I had to do it my way, on my own terms, and not just doing what other farmers were doing. I really had to figure out what kind of farmer I would be."

She decided to start small again. Dawn let the six acres grow fallow and began to research what niche product she could bring to her booth at the farmer's market. One day, she spotted her solution in the grocery aisle: small plastic containers filled with bright green wheatgrass. "In those days, there weren't any 'how to' videos on the Internet, and I'm pretty sure YouTube didn't exist," she laughed. "So I just began experimenting on a very small scale. I was *highly* motivated to make it work. And, of course, it *didn't*." Dawn shook her head and laughed at the memory.

But within a year she had mastered the art of growing wheatgrass and other microgreens, including radish, sunflower, and sweet pea shoots. Ingeniously, her tiniest crops had become the most profitable food growing on her farm. It yielded nearly half of her income, yet demanded significantly less labour than field crops like carrots and squash.

"Would you encourage other women to get into farming? I asked her.

"Sometimes I overhear other farmers complaining, 'We need to hire more men because they can carry more,'" she explained. "There's a stereotype that a woman isn't going to work as long or as hard as a man. Society does not encourage girls to pursue careers that involve heavy work. But women can accomplish just as much as men on the farm by working smarter, not necessarily harder. My hope is that one day gender does not even come into the farming equation."

After a decade, Dawn finally felt like a farmer who could hold her own on the Canadian prairies. Meeting face to face with customers to sell her organic crops, the ones she produced, by hand, from the earth, Dawn contradicted the Farmer Joe stereotype on every front. She embraced the challenge of breaking down gender barriers, experimenting on the land,

relying on environmentally sustainable practices, building her own organic soil, and feeding her community.

Below us, the farmer's market buzzed, a blur of colourful foods being passed palm to palm from farmer to customer. Sunrise Gardens stood out, the spiky wheatgrass like a green utopia drew and caught my gaze. I watched a woman wearing a mustard-yellow pea coat and a bright red scarf stop and run her hand through the wheatgrass. The woman bought a tray. I imagined that she would take it home and place it along her kitchen windowsill, a tiny green connection to the land and to Dawn's story.

"WE CAN DO IT!" said Rosie the Riveter. She wore a red and white polka-dot scarf around her shiny black hair and pulled up the sleeve of her blue work shirt to flex a bicep. The iconic poster, first printed in 1942, was part of a larger political campaign to entice American women to join the workforce during World War II. Rosie's image would be appropriated, decades later, in various waves of North American feminism.

Seventy years later, Jane pinned up the poster of Rosie to her kitchen wall in the small cabin on the north side of Salt Spring Island, the largest of the Gulf Islands that lay in the mist between Vancouver Island and the mainland of British Columbia.

I had traveled to Salt Spring at the urging of friends who were starting a homestead project on the island. "Come," they said. "You'll find more women farmers than you could have imagined." Driving along the single highway that wove around the island of ten thousand people, I marvelled at the number of farm stands lining the road. They were small wooden stands packed with farm goods for sale: cartons of eggs, long strands of bulbous garlic hanging like Hawaiian leis, bunches of kale and Swiss chard, bright orange carrots, and deep purple eggplants. Salt Spring Island felt like a mecca for women growing food.

"Milk?" Jane asked casually, and I nodded. She poured a one-litre mason jar of creamy raw goat's milk into blue ceramic

As the cost of farmland continues to rise dramatically on the Canadian prairies, many female farmers are unable to assume the debt required to break into large-scale grain and meat operations. As an alternative, women are turning to small-scale solutions, including growing niche crops such as micro-greens. These pea shoots can be grown in urban locations, stacked on trays, year-round. (Photo by Trina Moyles)

mugs. Every morning at six o'clock she milked the goats. "I milk the ladies twice a day," she explained. "Trust me, you can't find anything fresher than this." She handed me a steaming mug of coffee and goat's milk and sat down at the kitchen table across from me. Jane took off a faded green baseball hat and ran a hand through her cropped brown hair. When she smiled, the skin around her eyes wrinkled into crow's feet. I took a sip of the caramel coffee and tasted the strong, sweet flavour of the goat's milk.

"My first days on the island," she recalled, "that's when I realized how expensive it was to live on Salt Spring. You go to the grocery store, see for yourself. Compare the prices of, say, vegetables or milk here on Salt Spring to a grocery on the mainland. It's unaffordable for most. That's why so many people, so many women, keep gardens and get into farming. Honestly, that's why I got into farming too. I wanted to make it easier on families."

Only five years earlier, Jane bought Willow and Barley at a livestock auction, two Nubian female goats, the same colour as dark honey with black stripes running across their backs and down their short legs. The Nubian breed was known for producing thick, creamy milk with a butterfat content of 5 per cent, ideal for making cheese, yogurt, and even soap products. "As soon as I bred them, I was hooked," said Jane, smiling at the memory. "After Willow and Barley gave birth to two healthy kids, I began to milk them everyday. The milk is raw, fresh, and full of probiotics. It's improved my health, I'm sure of that." Willow and Barley produced more small, bouncy offspring, and, slowly, Jane's herd of female goats grew in size. Their milk flooded the brims of the metal milking containers. "Eventually, I was milking upwards of twelve litres a day!"

Every day, Jane poured the creamy goat's milk into one-litre mason jars and sold them directly to families for only half the price of milk in the grocery stores. She recognized how young families living on the island struggled to afford organic food and produce. Word about Jane's organic raw milk began to filter across the island, and her customer base grew.

"Many people prefer goat's milk to cow's milk because it's healthier," explained Jane. "Some people on the island even feed the milk to their newborn babies. Last year we had a newborn who couldn't latch onto her mother's breast for the first two weeks of her life. Her parents fed her my goat's milk during that whole first year. For me, it was deeply satisfying."

"How do you get around the dairy regulations?" I asked her. "Is it not illegal to sell raw milk in Canada?"

"Well, yes," she said. "Technically, the national and provincial laws require that commercial dairy products undergo pasteurization."

In the late 1800s and early 1900s, Canadian officials and scientists linked outbreaks of E. coli, listeriosis, and tuberculosis to consuming unpasteurized dairy products. In 1862, a French scientist by the name of Dr. Louis Pasteur developed the process for killing germs and microorganisms, including the Salmonella typhi bacterium that causes typhoid, by heating

raw milk to temperatures upwards of seventy degrees Celsius. Ontario was the first Canadian province to make the sale of raw milk illegal. In 1938, the provincial government passed legislation that required all commercial dairy products to undergo pasteurization. Ten provinces in Canada passed similar legislation, with the exception of the Northwest Territories. British Columbia had gone a step further in 2009 by officially declaring raw milk a 'health hazard' under its Public Health Act. Those caught selling raw milk could face a fine of up to $3 million, or a jail sentence of up to three years.

"Public health officials claim that the bacteria in raw milk is a danger to society," said Jane. "But the same can be true for pasteurized milk, which is essentially 'dead milk.' They heat the substance to a temperature that kills everything, including vitamin A, C, and B12, along with healthy kinds of bacteria. A little bacterium in our systems is actually a good thing because it helps us to build a healthy immune system."

Down south of the Canadian border, the sale of raw milk is legal in thirty U.S. states, although with a variety of restrictions on how it can be sold. Twelve states, including California, Pennsylvania, and Utah, even permit raw milk to be sold in grocery stores, whereas consumers have to go directly to the farms to buy unpasteurized milk in Nebraska, Missouri, and Kansas. But while raw milk activists are lobbying for changes to provincial legislations, it remains illegal to sell raw milk in Canada—in any form, except for unpasteurized cheese.

"Don't you worry about getting caught?" I asked.

"I would—if my milk was for sale," she said with a grin. "But in the world of distributing raw milk, there are a few loopholes. Instead of selling my milk, I've asked people to 'goat share.' For five bucks, someone can own a small portion of Willow, Barley, and the ladies, and in return I provide a weekly supply of milk. It's legal to drink raw milk, if it's from your own goat, or cow. Willow and Barley are community-owned, in that sense. We share ownership and we share the ability to drink raw milk."

Even if Jane wanted to pasteurize her milk, she would be forced to ship the milk off-island, across the Georgia Strait, to

the nearest dairy-processing centre on the mainland of British Columbia. The additional costs of transportation and processing would render Jane's goat milk unaffordable to most young families on Salt Spring Island. The steep cost of transportation was, in part, why a litre of pasteurized organic milk could cost upwards of $10. Dairy products, including cheese and yogurt, were equally expensive.

"Some grocers and farmers are selling a little chunk of cheese for twenty-five bucks!" Jane scoffed. "That's too 'boutique-y' for me. Maybe tourists can afford to pay, on a one-time basis, for novelty food. But who else can afford that? If I sell my milk at that cost, we're not going to be able to keep young families on the island."

Outside, Jane led me towards the barn. She made a long, piercing whistle and the velvety ears of the goats perked up as we approached. A few trotted eagerly towards the gate to greet us with curious, sniffing noses. They cocked their heads at us with expressions of innocence, confusion, and inquiry. "They provide me with such comic relief," laughed Jane, as she bent down and heaved one of the smaller honey-coloured goats into her arms. "This is Willow," she said, introducing me. She pressed her cheek into Willow's coat and closed her eyes, breathing in Willow's musky goat scent. She led me inside the white barn, into the sterile room where she milked the goats twice a day. Jane sat on a low wooden stool and her hands began kneading Willow's full, grayish-pink udder.

"Do you feel supported as a female farmer on the island?" I asked her.

"That's an understatement!" she exclaimed. "Those who are doing it on my scale—that's to say, small-scale—are mostly all women because they're trying to feed their families. The babies are strapped to their backs as they're out weeding in the garden or taking care of the livestock. In such a tightly knit community, we really try to help one another out. It's men who own the larger operations on the island. Some are like the 'talking heads' or the farming gurus that are well known in Canada." Willow's milk began to slowly pool at the bottom of the metal

milking container. Jane looked up and grinned playfully. "But go to their farms and you'll see that it's mostly just women who are doing the work."

I DROVE ALONG a gravel road that cut through an ocean of farmland. Grain stalks from last year's harvest poked up through the nearly melted snow like beard stubble. The farmhouses dotted the landscape. The red-tailed hawks perched on every other power pole lining the road. I watched them swoop low and glide overtop of the grain fields, hunting for the mice and rodents that were suddenly exposed after the long winter snow had begun to melt in the Peace Country, a region located at the 56th parallel in northwestern Alberta.

April was a promising month for people who lived in this sparsely populated region, particularly for farmers who braved the dark, bitterly cold winters that could last for over seven months of the year. As the wild geese and cranes returned from the south, sounding themselves over the fields and stands of spruce, pine, and poplar trees, the farmers emerged from their homes, ready to step into a new seasonal extreme: a three to four month-long summer where the sun shone from 5 a.m. to nearly midnight.

I wondered what it meant to be a woman who farmed on these expansive lands where there were more wild things than people and where the farmer waited out—for over half the year—minus 30 degree Celsius temperatures. If British Columbia's coastal and island communities were considered a mecca for young Canadian women interested in picking up the farming trade, northern Alberta seemed to represent the opposite. To the outside world it was a remote place known for its rugged landscape, limited amenities, and oil, gas, and natural resource development. I didn't expect to find many women at this distant latitude, setting down roots on muskeg soils, and braving the seasonal extremes to grow food and feed their local communities—but I was about to be proven wrong. "If you want to meet

women farmers in the Peace Country," a handful of different people told me, "you have to visit Nature's Way Farm."

Nature's Way Farm was a 600-acre, family-run farm, producing organic pasture-fed beef, sheep, lamb, and pork, located just south of Grimshaw, Alberta. Peter and Mary, a husband-and-wife team who owned the farm, promoted an organic, sustainable agriculture philosophy on the land. Every year, they attracted dozens of young women and men from Canada and abroad who were interested in learning about—and practicing hands-on—organic farming methods. I'd heard about their unique approach to growing food in the north before, but I didn't realize the farm was also an incubator for women farmers.

I arrived at Nature's Way Farm, eager to meet with Mary, her daughter Lisa, a twenty-eight-year-old farmer and food politics activist, and Lilli, a twenty-seven-year-old German agricultural science graduate who had recently decided to permanently put down roots on the northern farm. I sat down at the family's large wooden kitchen table in the main farmhouse. Mary, a slender, silver-haired woman in her fifties, handed me a hot mug of peppermint tea.

"From the time that I was a little girl, I knew that I wanted to be a farmer," Mary recalled, her blue eyes sparkling. She stood at the kitchen counter, slicing mushrooms, mincing garlic, and adding ingredients to a pot on the stove. Born and raised in Canada's eastern Maritimes, Mary was a town girl with the dream to grow and raise her own food. "My mom grew up on a farm in Nova Scotia. She always said, 'Oh no, you don't want to do that!' My family used to tease me about this childhood dream. But later in life, I moved to Alberta, met my husband, Peter, and we began to farm. Finally, I could write home to my family and tell them, Well, I'm now a farmer."

Mary felt passionately about raising their herds of cattle, sheep, and pigs on pastures of alfalfa grass where the animals could live out their animal instincts, grazing, roaming, and forming family groups. "When given the freedom to be an animal—not in a barn, or small pen—you can observe a mother, her baby, and the previous baby together in the field,"

said Mary. "Why are they still together? In the fields, you see they form families. It's made me realize they have so much spirit, so much in them. As farmers, we must respect the animals that nourish us."

Lisa listened quietly to her mother, sipping a cup of strong, dark Cuban espresso. Only a week earlier, she'd returned to the Peace Country from her travels to the Caribbean island, where she visited with Cuban organic farmers. Lisa nodded at her mother's words, pushed her black-rimmed glasses up on her nose, and began to weave her reflections on farming into her mother's story. "I never knew I was going to farm," admitted Lisa. "When I was younger, I wanted to be a doctor. I was keen to work with people, to heal people." Although she always enjoyed working with her mother, father, and siblings on their family farm, she never saw a future for herself in farming. After graduating from high school, Lisa moved six hundred kilometres to the south to study biology at Augustana University in Camrose, Alberta. "In university, I realized it was harder to find good food because I was no longer on the farm," Lisa remembered, which prompted her to seek out locally grown produce at nearby farmer's markets. In her second year away from the farm, she was drawn to attend a variety of talks hosted at the university around the theme of food and agriculture.

"I realized that food is a culture. It's about creating community. These talks would bring me to tears," said Lisa. "I was just starting to ask myself: where does our food come from? What's going to happen when farmland is owned by corporations or foreign ownership? What happens if we don't have access to clean water? I began to realize that I didn't want to be a doctor—I wanted to be a farmer. Slowly, I was understanding that 'food is medicine.'"

In her fourth year of university, Lisa learned about a Canadian farmer who was struggling financially and nearly on the brink of losing his farm. The farmer decided to launch a vegetable CSA, a decision that would save his farm. CSA stands for 'community supported agriculture'. In a CSA, consumers actually

Dawn Boileau carefully weeds her spring radish crop. Boileau is the farmer behind Sunrise Organic Gardens, an organic vegetable and fruit farm in Onoway, Alberta. Over the past ten years, Boileau has innovated with small-scale, intensive organic production, growing her operation from humble beginnings to a thriving operation. Boileau is committed to preserving soil health, growing organically, and nourishing her community. (Photo by Trina Moyles)

pay the farmer *before* the harvest. It's a form of investing in small-scale farmers to provide them with the needed capital early on in the season. Inspired by the man's story, Lisa began to imagine her life back in northern Alberta on the farm. "I wondered, could I start a vegetable CSA in Peace River?" she recalled. "I knew my parents had a fresh spring on their farm and that with water, you have the potential to do anything. Suddenly, a market garden seemed like a plausible idea."

With her bachelor of science degree in hand, Lisa migrated back north to her family's farm to kickstart 'The Veggie Patch', a vegetable market garden CSA, one of the first CSAs in the Peace Country. But from early days of breaking soil and sowing seed, the learning curve for Lisa was steep. "I wasn't just growing

vegetables. I had to learn how to do other things on the farm like how to drive the tractor, how to make hay bales, work with the cows, get out there in the fields and pull calves. It's interesting because even though I grew up on the farm, I didn't learn some of the skills that my brothers would have learned." Lisa paused, reflecting. "I don't know why that happened, but it did. Regardless, I had to learn again."

Lisa's vegetable CSA thrived in the northern community. As her carrots and beets grew fat and full in the organic soils, Lisa was steadily cultivating a loyal customer base in the Peace Country. Every week she drove her van to the grocery store parking lot where she met with customers, face to face, and gave them boxes of leafy greens and root vegetables. Although Lisa sensed she'd found her calling as a farmer, she admitted that it could be exhausting, and at times, frustrating work. "Anytime I'd hit a road block, I'd call Mom," she said, laughing a little. "My mom is the hardest worker I know. People think I'm a hard worker, but I tell them, 'You haven't seen my mom weed!' When I first started, my mom was always there, ready to put in the work. She still has so much energy to be faster and stronger than a twenty-year-old. I think that's phenomenal." Lisa smiled through watery eyes. I was deeply moved listening to mother and daughter. Considering the enormous challenges stacked against growing food anywhere in the world, very few of the women I'd interviewed actually hoped that their own daughters would become farmers. I sensed this was something rare. As Mary and Lisa continued to chat and prepare lunch, I slipped outside the farmhouse to tag along with Lilli—the newest farmer at Nature's Way—who was busy with the morning chores.

"I love that farming is a family business," Lilli told me as we walked towards the cow pasture. "You work hard together all day, and in the evenings you enjoy what you've accomplished. I appreciate the way we farm here—as closely as possible to nature." Lilli first traveled to northern Alberta in 2013 from her home country of Germany. She came to Nature's Way Farm to learn about organic agriculture and fulfill a practicum for her

bachelor's degree in agriculture. After four months, Mary and Peter offered Lilli a permanent job working on the farm. The young German woman accepted, and after her graduation back home, she returned to the north. Lisa had called her a "powerhouse" on the farm, which Lilli humbly laughed off. Her cheeks glowed pink from the icy wind that blew in from the southwest. "Farming forces you to learn so much about yourself," said Lilli. "You're constantly facing different challenges. It takes a long time to learn, but at some point, you'll gain confidence on the land. My advice to other women who want to farm is throw yourself at the biggest challenge – and just go for it!"

Later, the women and I gathered together around the kitchen table to eat. The scent of Mary's creamy mushroom soup and homemade bagels, fresh out of the oven, filled up the farmhouse. The soup tasted of comfort, warming my body from the inside out. As we ate, we continued to talk about farming and food politics.

"Right now, we're in a crazy moment in Canada," said Lisa. "There's an older generation of farmers waiting to retire, and they're trying to figure out what to do with their farms. There isn't a shortage of land right now—there's actually a shortage of young farmers who are ready to farm. People say there's no land, or it's too expensive to buy, but the land is there."

"Oh?" I said, genuinely surprised by Lisa's words, which contradicted the narrative I'd heard, again and again, that farmland in Alberta was becoming increasingly unaffordable and inaccessible, particularly to young farmers. Lisa nodded, continuing: "If you really want to farm today, you can't be set on where you're going to be. You have to be ready to move to where that land becomes available. You have to get creative," she insisted. This conviction is partly what called her back to the north, to her family's farm, a place where she could experiment, grow, and branch out. Recently, Lisa and her partner, Donovan, had purchased an off-grid, homesteader's log cabin on a small piece of land in a nearby rural community. They aspired to transform the land into a productive, small-scale farm, growing and selling vegetables, raising chickens, and experimenting with organic grain

production. They aptly called it 'The Homestead.' To Lisa, the key to farming successfully in Canada stemmed from building relationships with other young women and men who aspired to run viable farming operations. For several years, she'd been involved in young farmer organizations in Canada, including the Young Agrarians, an organization working to support young farmers in British Columbia and Alberta, as well as the National Farmer's Union youth chapter. "We're powering one another up to say we want to farm, but we also want to make this a business, so we can raise and support families."

Mary smiled at her daughter's impassioned words and chimed in. "I see this change in the younger women on the farm," she said wistfully. "They're knowledgeable and independent. I watch them with awe when they're frustrated because they're trying to fix the farm equipment—something I would've never dreamt of doing. These determined women aren't mechanics, but they're trying, and they're learning. It's not only about growing food and animal husbandry. Women are becoming more rounded. I often wonder what Lisa and Lilli will bring to farming in our community," Mary said. Her gentle voice seemed to overflow with love for the two women perched at the table, spooning down hot soup, and gathered together before stepping back out into the cold, but hopeful spring day.

"I see a future in these women."

It was true, I was realizing, that young, educated Canadian women—everywhere, it seemed—were hungry to farm and work the land in new, creative ways. Even on these lonely northern soils, women were starting out, sowing seeds, and striving to feed their communities. As Lilli had summed it up, women were "just going for it", no matter the challenges in store.

CATHRYN PULLED UP on her red bicycle to Café Bicyclette, a patio café in Edmonton's French Quarter. She locked her bicycle to the bike rack and drew a cloth bag full of micro-greens from her front basket. I sat a glass table outside, the mid-May air

slightly brisk on my skin. After six months in winter's lock, it felt something like relief to be outside again wearing only a jean jacket. The buds on the trees opened just slightly, dotting the naked branches with the faintest of virgin green. The months of spring, the warming of the sun and the melting of the last ice, buoyed people's spirits again in Edmonton.

The season's farmers' markets were about to emerge from hibernation. Edmontonians would soon pour onto the streets from their apartments and houses, excited to do their grocery shopping outside again and to have the opportunity to converse with producers face to face. Customers marvelled at how the winter-hardy farmers could stretch out the season, growing varieties of greens under the protection of cold frames and hoop houses, rounded wire farms covered with plastic, which sheltered crops from snow and ice.

Cathryn, a twenty-six-year-old farmer and co-owner of Reclaim Urban Farm, one of Edmonton's first urban farm operations, prepared for the busy season ahead. Cathryn and her colleague grew baby lettuce, arugula, spinach, kale, tomatoes, beans, and squash, on twelve different urban plots scattered throughout the city. Cathryn rode her bicycle through residential neighbourhoods to find vacant residential lots, often weedy, unkempt eyesores in neighbourhoods. She followed the trail of land titles with the city, finding the owners, and asking for permission to repurpose the land into urban farms in exchange for weekly supplies of fresh produce. She and her business partner, Ryan, then transformed these idle yards by ripping up the lawns and layering the space with compost to sow vegetables.

"Our name 'Reclaim' has a lot of meanings," explained Cathryn. "Instead of looking at the city as a series of private properties, we are looking at vacant spaces as opportunities and places where we can grow food for the people who live nearby."

By the end of February, Cathryn had already started the season's tomatoes indoors. She planted the seeds in plastic seedling trays. After germinating, the tomatoes unfurled themselves like tight green fists opening, and sucked up the sunlight from a

Lilli Klamke works as an operations manager on Nature's Way Farm in Grimshaw, Alberta. Nature's Way is an organic pasture operation, raising grass-fed cattle, pigs, and sheep. Lilli loves working closely with the animals, including Cabella, the farm's dairy cow. (Photo by Trina Moyles)

south-facing window in her apartment. These were her grandmother's seeds, a variety Cathryn had not seen anywhere else, shaped like small, fervent red teardrops. "My grandmother is a seed saver. She's always had the biggest garden that's lined with raspberries," said Cathryn. "She could feed a million people," she added with a laugh. That afternoon, Cathryn was transplanting the tomatoes on various plots of land scattered throughout the city. She rode her bike from plot to plot, carrying tools and seedlings in her bicycle basket. The early salad greens were already in production, growing beneath plastic hoop houses. She had brought a harvest of greens for the chefs at Café Bicyclette, one of her loyal customers.

"How did you become a farmer?" I asked her.

"It's kind of in my blood," she shrugged, smiling. "My mom was a gardener, my grandmother gardened, and all of my aunts do, too." She paused. "There's something going on with the women in my family—for whatever reason, we are all very tied to food!"

Cathryn's parents came from farming families in Alberta, though they left the farm after high school, found work in the city, and decided to raise Cathryn and her sister in Edmonton. Cathryn's sister had recently married a grain farmer in Alberta. "My sister and I laugh and say to our parents, 'You're the ones who moved to the city, but somehow you ended up with two kids who are farming.' My aunts and uncles remained on the farm, and all of their kids have moved away from farming."

But Cathryn had no intention of ever becoming a farmer. After finishing a business degree at university, she traveled to South East Asia and Japan. "Traveling was one of the big things that inspired me to get into farming," she said. "I was in Japan for a month. You think of Japan as this very dense metropolis, yet I was surprised to see many urban farms growing fruits, vegetables, and herbs. I wondered, 'What's going on here? Who's gardening here?' Because of the language barrier, it felt like such a mystery. It intrigued me."

In Tokyo, a city of thirteen million people, Cathryn witnessed an array of urban farming techniques, including rooftop

gardens and urban honeybee projects. Retired farmers, many of whom had relocated to the city due to the economic hardship of rural agriculture, had received parcels of land in the city on which to grow vegetables and herbs. With a limited rural arable landmass, the island country had to import nearly 80 per cent of its food. The Japanese government and citizens embraced urban agriculture in attempts to increase their food security. "I've always been interested in how we can work to solve issues of hunger and food insecurity," reflected Cathryn. "I wanted to try to change the food system."

But Cathryn longed to reach beyond North America's tendency to celebrate local food culture and sustainable agriculture without asking deeper, more politicized questions about food access, poverty, and social injustice. She hoped Reclaim could spark a conversation about the history of land in Edmonton, across the province, and even the nation. "It's important to explicitly recognize the historical context in which we're growing food," she explained. "It's important to acknowledge that we are growing food on Treaty 6 land," she said. Treaty 6 refers to the Indigenous land controlled by over fifty First Nations groups in parts of Alberta, Saskatchewan, and Manitoba. Indigenous leaders signed the treaty with the government of Canada in 1876 based on the right to self-determination.

"Due to colonialism and the loss of traditional lands, Indigenous communities are facing much higher rates of food insecurity," stressed Cathryn. "Yet we do not often discuss these topics in public. But we cannot deny what is real in present tense: for example, 13 per cent of Canadian households are living in poverty, but the number is fifteen times higher amongst First Nations in Canada. Everyone has the right to healthy air, water, land, and food. This is why we're reclaiming idle land to grow food for the community."

In her first season as an urban farmer, Cathryn spotted a large empty lot, dense with weeds, near the University of Alberta campus. She researched to find the owner of the land and discovered that St. John's Institute, a low-income housing organization, owned the vacant property. The organizers of St.

John's agreed to allow Cathryn to transform the land into an urban farm in exchange for weekly boxes of produce donated to their low-income housing residents. Every summer Cathryn also hosted groups of youth from St. John's, providing them with tours of the farm and teaching them how to grow food. In late October 2015, Cathryn stood up at a city council meeting in Edmonton and urged councillors to consider changing the bylaws to make 'urban agriculture' an official land-use activity. She was thrilled when the councillors voted unanimously in favour of the bylaw change, which would make urban farming easier.

"Urban farming has been an incredible incubator. People have responded with a lot of excitement about what we are doing in the city. They're interested in reconnecting with growing food. People want to come out, volunteer, and get hands-on with the food they're consuming," said Cathryn. "Sometimes I wonder, could this excitement around urban agriculture revitalize rural agriculture? There has been such a decline in the rural farming community. It's hard to say, but maybe there could be a tie there," she said thoughtfully.

After our meeting, I walked Cathryn to her bicycle, her basket still filled with seedlings from her grandmother's red teardrop tomato seedlings, destined for an urban plot. "I've ditched the nine-to-five lifestyle," she laughed, "and now I'm working the six-to-six!" Off she went, pedalling in the bike lane, hand tools and seedlings in her basket. Cathryn wove her bike through the city streets, watching for empty urban plots—the forgotten spaces that residents passed everyday without a second thought—and reimagined them.

6. INDIA

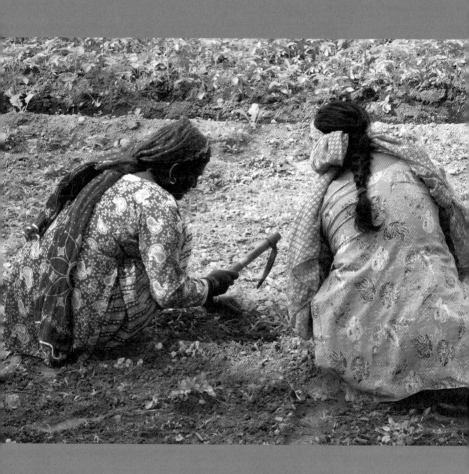

These women are using traditional hand tools to weed crops in the northern district of Dehradun, India. The majority of women-led agriculture in India is small- to subsistence-scale, with women relying on hand tools to plough, sow, weed, and harvest vegetable and grain crops. (Photo by Trina Moyles)

Boys hovered under the streetlamps and lit the fuses on firecrackers before scattering for cover. The fireworks shot violently into the sky, explosions of neon blue and pink light. People down below cheered and the boys raced back to light more. From the rooftop of a thirty-story apartment building, I gazed out at Delhi, a city of ten million living souls, and watched the kaleidoscope sky burn with bursts of colour. The streets filled with smoke.

I arrived in Delhi on the eve of Deepavali, or Diwali, meaning the "Row of Lights," one of the largest Hindu festivals in the country that celebrated the victory of light over dark, good over evil, and knowledge over ignorance. The festival spanned four days, honouring important Hindu gods and goddesses with offerings of food, flowers, rituals, and light. Lakshmi, the deity with the face of a lotus and one of the most important goddesses in the Diwali festival, embodied prosperity and abundance. Inside cities, women prayed in Lakshmi's name for money and material wealth. In the countryside, where the majority of over a billion people eked out their existence, female devotees prayed for a good harvest. In rural India—the Old India—I would come to meet women who decorated their hands with red henna ink and set tiny oil lamps outside the shadows of their front doors so Lakshmi would bestow her grace on their homes. They needed her luck these days.

I had come to a continent, a country, where over 60 per cent of rural Indian women were farmers and farm labourers. They grew rice, millet, and pulses. They milked cows and buffalos, and herded goats. They picked baskets of tea leaves on massive plantations. They sold red bananas on street corners. Who were the women who fed India? What were their names? What were their struggles? I was eager to leave the congested city where affluence and poverty lived side by side. Contradictions filled Delhi's streets, with modern condos and shiny high rises next to sprawling slums. People packed together like sardines, sleeping on the road dividers, while waiting in an impossibly long queue for access to the public hospital. The city's elite visited shopping malls while the poor bought their food from vegetable carts.

At the stoplights, silver sports cars idled next to bridled nags pulling passengers in carts. I could barely see the sun through the dense cover of smog and pollution. The rivers thickened with waste: plastic and human.

In Delhi, I met a young surgeon whose words would remain with me as I traveled to the southern tip of the continent.

"Women in agriculture?" he inquired, after I told him about my writing and the journey ahead. He rubbed his chin in contemplation, then his eyes flicked up at me.

"That's a dark subject," he said finally. "It's very dark. Women in India are facing tremendous challenges related to growing food these days. The markets exploit them. Actually, they're not even farmers—"

"They're labourers," I answered.

"Yes, exactly."

"I guess it's a book trying to explore the dark and the light," I said a bit wistfully.

"But what does the light even look like?" asked the surgeon.

He pointed out how increasing numbers of small farmers across the country were committing suicide to escape their poor harvests and the debts that accumulated like disease. Staggering numbers of men died after drinking the very same pesticides they couldn't afford to pay for. Farmers comprised more than 10 per cent of suicides in India. In 2004, a record-setting eighteen thousand female farmers were widowed by suicide. Extreme climate change struck India in the way of fervent heat, lashing rain, and destructive winds. Farmers in the northern Himalayan foothills hadn't seen *jeriya*, a drizzling rain, for years. *Jeriya* sank slowly into the soil, saturating seeds. The rain these days crashed against the soil and ran off. The sun beat down on the Indian continent.

"It's becoming so hot that even the roads are melting," the surgeon said. "What about the crops?" He shook his head. "What does the light for farmers even look like?" he repeated.

All night the fireworks continued to light up the black canvas of the sky. The smoke thickened its chokehold on the city. By morning, I could barely breathe and I felt the relief of

leaving Delhi behind. The surgeon's words followed me south like a stray.

"RICE WITHOUT RAIN is impossible," said one of the female farm-workers. The women stood at the edge of the paddy and the sun poured down, spilling onto the electric green landscape that covered the southern province of Tamil Nadu. On the land, the women were growing pulses, okra, sugar cane, and coconuts. But since the monsoons had returned to southern India, they were planting rice again. The women stood ankle-deep in water that reflected the blue and the white of the sky. Earlier that morning, I left the city of Madurai and drove along a pencil-thin road through the green paddies. I couldn't count the number of women who were working in the fields. Their brightly coloured saris sharply contrasted with the emerald green paddies. The women worked with bent backs and wore baskets tied around their waists. Plunging their hands into the baskets, the seeds cool against their moist skin, they pulled out fistfuls of rice. They saw their tired reflections in the muddy water. The seeds slipped through their hands like quicksand, sank, and the women whispered gratitude for rain.

In southern India, Hindu women celebrated the *navadhanya puja*, offertory rituals in which believers worshiped nine sacred grains. They gave wheat to the sun and rice to the moon. They used the nine cereals—Bengal gram, horse gram, green gram, black gram, chickpeas, white beans, sesame, rice, and wheat—to express their deep gratitude for the nine heavenly bodies that influenced the elements and life on earth, including the rain and the sun. But the rain had become foreign to them. Four long, scorched years passed without the heavy, pregnant rains they needed to grow rice. From June to September the sky used to swell and descend on the land in a thunderous collapse. Rain penetrated the cracks in baked earth. The rain poured down until the streams flooded their beds, the ground grew soggy, and the paddies filled to their banks' lips. When the skies cleared, water evaporated from the oversaturated earth and

farmers emerged from their homes, hopeful. Drought meant hunger and hardship. Rain meant rice.

During the 1960s, India became a laboratory for agricultural experimentation and reform. When the country was pushed to the brink of a massive drought and famine, the Indian government partnered with USAID and the Ford Foundation to test what Westerners were touting as 'modern' agriculture. The Indian government imported genetically modified (GM) wheat seed from the International Maize and Wheat Improvement Centre. This seed promised robust yields to soothe the ache of hunger. But the seed had been born in a sterile laboratory, not a field of varying soil and weather conditions. The seed required precise measures of chemical pesticides, synthetic fertilizers, and more water than the indigenous seeds, which had survived over centuries of cultivation. The seed took root in northern India and slowly spread, covering the skin of the country. "It is not a violent Red Revolution like that of the Soviets, nor is it a White Revolution of the Shah of Iran. I call it the Green Revolution," boasted William Gaud, the former director of USAID, in 1968. But only the politicians and economists who watched the numbers of the gross domestic product accumulating would call the revolution "green." Over the years, the agricultural revolution darkened into an ugly stain on the country's six hundred million farmers, half of them women. Only a fraction of farmers had access to modern agriculture: those with capital, affluence, and the privilege of social caste.

The women who worshipped the nine grains didn't reap the benefits of the green revolution. Five days of the week they gave themselves to the land and the tasks of larger farms and wealthier farmers. In a country of over a billion people, more than 80 per cent of women worked the land for a living. Shrinking numbers of them were farmers and a growing number were labourers. The land that was theirs, land inherited through their husband's lineage, barely yielded enough food to both feed the family and generate income to cover the rising costs of living in India: the modern seeds, the pesticides and fertilizers, their children's school fees, their daughters' dowries.

Every day they rose before the sun and returned after dark. They sweated and slaved in the fields for seventy rupees a day, no more than a dollar. Landowners preferred female labourers to male labourers for one reason: they could buy women's labour for 30 per cent of what male labour costs.

"They say men work harder than women," said Maya, a woman who stood taller than the others. She wore a strand of gold around her neck and a gold stud in her nose. "But the men stand around like they're supervisors, like they're the real farmers. We women do the same amount of work with the same speed. Maybe we're even faster."

In the fields, their hands flew and their backs ached. At home, they cooked, swept, and washed. They slept when the moon was already old against the sky. And when they closed their eyes, worry set on them terribly: for rain, for food, for hunger, for the security of work. Worry for the sex of their unborn children. Awake against the night, their bellies as big as gourds, they yearned for boys the same way they yearned for rain.

For poor farmers, to give birth to a daughter symbolized hardship, but to give birth to more than one daughter felt like a curse. After a girl's birth, parents began saving for her dowry to secure marriage and kinship. Being a girl represented a heavy debt, a living tax that must be paid. When they saw her wriggling newborn flesh, some of the fathers looked away, ashamed at what they would have to do. A girl was something to bury in a hole behind the house on a night with no moon. "A single grain of rice is placed at the back of the baby's throat to make her choke," said a professor I met in Madurai. Unknown numbers of female infants had been suffocated and poisoned in India. Women forced out the female fetuses, ejecting them from the womb. Over the course of thirty years, scholars believed the number of aborted girls in India had reached twelve million.

People buried girls like seeds, hiding them beneath the surface of the land on which their mothers laboured. In the rice paddies, the women worked with bent backs and, in the reflection of the water, they saw the faces of their daughters.

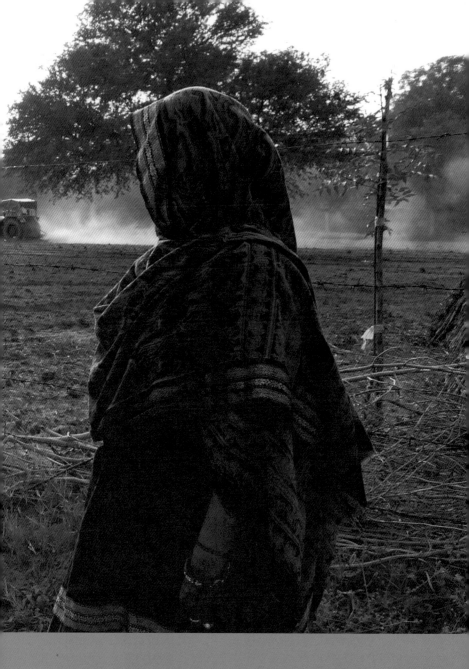

Most women in India are engaged in small-scale, or subsistence, agriculture, and they rely on hand-tillage methods or tillage by the use of oxen teams. In this village in the Rajasthan district, in north-central India, farm families rent tractors to plough their land. "Do women drive tractors?" I asked the female farmer in this photo. "No, no," she laughed, amused at the question. "That is work for men only." (Photo by Trina Moyles)

THE PEOPLE OF NAYAKKAN built the road only wide enough for an ox cart. Sugar cane grew in the ditches, sucking up the moisture and maturing to a height that completely blocked the view beyond the road. Up ahead, an old man herded goats with a long stick. His legs were skinny sticks, the flesh loose and wrinkly as the skin on an old peach. The bells around the necks of the goats jangled and the two of them trotted forward. The vehicle slowed, following the man and his goats into Nayakkan, a village of less than five hundred people. A dog with ribbed sides scurried in front of the vehicle. Children heard the hum of the engine and poked their heads out of the wide-open doors of their homes. They crumpled their fingers at their lips, hiding their smiles. They looked at one another with excited eyes and spilled onto the street, chasing behind. The houses were low concrete boxes painted colours like watermelon flesh and aquamarine, and roofed in ceramic tiles. The Hindu temple was in the centre of the village. Concrete steps led up to a pillared platform, and men dressed in white draped themselves on the steps. They cast unbothered glances at the small parade of children before retreating to their conversation.

A group of women walked gracefully in a single thread along the side of the road, while they balanced urns full of water on their heads. The women belonged to a social caste called Dalit, a word that translated into "broken" or "oppressed." To be born Dalit was to be born poor and ostracized: their villages were built separately from the dwellings of higher social castes. Historically, they couldn't drink from the same well as higher castes. They couldn't eat from the same plate, they couldn't marry across caste, and they couldn't be touched. Indian society used to call them the Untouchables.

The Hindu caste system, known as *Varna*, had prevailed for thousands of years in India. According to Hindu religious thought, the Creator gave birth to four varnas. From his mouth sprung the Brahmin priests. From his arms came the Rajanya warriors and kings. From his legs were born the Vaishya landowners and merchants, and from his feet emerged the Shudra artisans and servants. The fifth varna, the Dalit, were born

external to the Creator's body and marginalized from the priv-
ileges and order of the caste system. As outcasts, society tasked
them with burying the dead, disposing of dead animals, and
emptying latrines. Following India's independence from British
rule in 1947, the government made the restrictions against the
Untouchables illegal.

India had taken strides to reserve economic and social
opportunities for the Dalit. But centuries of oppression and
inequality wouldn't be easily undone. Representing 15 per cent
of the population, the Dalit were amongst the poorest demo-
graphics in the country. They formed the majority of the agri-
cultural workforce as subsistence farmers and landless labourers.
Fifty per cent of them lived below the poverty line.

Generous yards of cloth draped over the women's bodies,
anchored at the shoulders and wrapped around their midsec-
tions. Although modest, the fabric sang with hues of red and
orange and blue. The gold jewellery at their necks, noses, and
ears glowed in the sun. I followed Selvi, a woman wearing
a scarlet red sari, into a concrete building that served as a
meeting space and as storage for grain. We sat cross-legged on
the cool floor.

"I've been a farmer since the day I was born," said Selvi.

Outside, the children knocked on the door and chatted
excitedly. Their hands were silhouettes against the white opaque
plastic that covered the windows. Selvi's voice echoed in the
mostly empty room. A few large grain sacks were heaped in the
corner. She gestured with her hands as she spoke.

Selvi never finished primary school, but she knew how to
measure the skies and sow a rice paddy before her tenth birthday.
Upon her fifteenth birthday, Selvi's parents arranged her mar-
riage to an older man in an adjacent village. She didn't ride
into the wedding on a painted elephant, nor did her husband
arrive on a white horse adorned with gold. The wedding lacked
the opulent rituals of a Brahmin, or higher caste, affair. She
was bound by the custom of dowry, a cultural practice where
the bride's family gave the groom's family gifts of appreciation:
gold, jewellery, money, livestock, and land. Traditionally, dowry

served to safeguard a girl's financial security in her husband's home so that if she needed support, she could draw from this pool of wealth. But the practice had evolved over the centuries into a payment to the groom's family. Dowry secured relations across social castes and economic situations. Most Dalit women would never 'marry up' the social ladder. In India, the poor married the poor. Farmers married farmers. Selvi moved into the home of her husband's parents and worked under the demands of her mother-in-law, cooking, cleaning, grazing livestock, and working in the fields. Their land was less than two acres, but when the rain was plentiful and flooded the paddies, they sowed the sacred grains—rice, gram, chickpeas, and wheat—and sold the surplus in the local markets.

"I worked alongside my husband in the fields, although he tended to do the heavier work. He drove the team of oxen to plough the earth and I sowed and weeded," she said. But her husband was a decade older and, after years of farming, his bones grew thin. "He's too weak to take to the fields these days," she said with resignation in her voice. He had become one of the elderly men dressed in white, sloped along the steps of the temple.

"My worry these days is saving for my daughter's dowry," she said. "She was the last born. We've been saving since the day she was born."

"How much is a dowry?" I asked her.

"We could never afford what the rich pay," she said. The higher social castes in India negotiated dowry gifts of up to $15,000. "But even for the poor, it's expensive—it's more expensive than my sons' college tuitions, combined."

She touched the gold chain around her neck and the dozen old rings in her sagging earlobes. A woman's worth was measured in gold. In the 1960s, the Indian government outlawed the practice of dowry, making it a criminal act. "We don't have a word for 'dowry' in our dictionary anymore," said a Brahmin man whom I met in New Delhi. "We prefer to call it a 'gift' nowadays." He suggested that the practice was losing importance in 'modern' society. The way people talked about dowry

was changing, but the cultural expectation of a dowry payment remained.

Selvi was saving everything they had of value: jewellery passed down through their families, one or two of the oxen, goats, and a stack of worn bills with Gandhi's face on them. The money and goods would reach a value of one lakh, or $1,500. On her two acres of land, Selvi couldn't provide enough food and profit, so she joined the other women in her community and sold her labour to richer farmers. She rose at four in the morning and worked until the sun reached the middle of the sky, then she returned to tend to her own fields of grains and her animals. More important than food, Selvi was farming to secure a place in society for her daughter. Her labour, like a cotton fabric pulled and stretched taut, was becoming threadbare and scarcely covered her family.

"Small farmers are struggling everywhere," she said. "How can we grow enough to eat and develop ourselves in society? I want my sons to study. I want my daughter to marry. How can I provide for them and grow as a farmer? I have tried and I cannot."

Under the pressure of a changing climate, the rain offered little and the sun beat the earth. The heat, often exceeding forty degrees Celsius during the dry season, scorched crops in the field and even melted the black tarmac on roads. Extreme weather events such as heavy, monstrous monsoons drowned out life in the fields and displaced Selvi, not only from her farm yields, but her work as a labourer as well. Too much sun spoilt entire fields. She stared into the abyss of long days with nothing left to weed or busy her hands with. Selvi looked to what larger farmers in the region were doing to adapt. They had equipment for groundwater irrigation: pumps, hoses, and sprinklers. She lived close to a major hydroelectric project located outside the city of Madurai. She wondered if she could invest in groundwater irrigation, or purchase more land so she could increase her yields. She walked from Nayakkan to the highway and took a taxi into Madurai, hoping to apply for credit. "At the bank, they asked me for collateral. But what could I tell them? The land is

in my husband's name!" said Selvi, her voice becoming shrill, exasperated. "I went home empty-handed. I am not alone. I've spoken with other women who say the same thing."

Banks refused to approve credit loans to those without proof of assets, or land ownership. No matter that women's efforts in agriculture outweighed the work of men and oxen combined, only 10 per cent of women owned farmland in India. Throughout most regions of the country, boys inherited farmland from their fathers, although in 2005, the government amended the Hindu Succession Act to legally allow women to inherit agricultural land. But ten years after it had passed, very few women were claiming their rights to register for land. As with the legislation on dowry, the deep roots of culture dictated more than the written law.

"Have you thought of signing your name to your husband's land?" I asked. Selvi tilted and wiggled her head to the right to signify her affirmation.

"My husband forbids it," she said. "He says that the land is for our sons, not for his wife. It is not appropriate for a woman to own land—not yet. Maybe it will be different for my daughter's generation." She shook her head, the gold hoops around her ears jangling.

There seemed to be a sixth, unmentioned class in India. If men were born from the mouth and hands and legs of the Creator, Dalit women were born from underfoot. They were the skin of the earth. They were millions of invisible bodies upon the land, digging, improvising, saving, and sacrificing to grow food. Selvi's body in the fields of 'modern' agriculture represented all women labourers who sacrificed their labour to nourish the country. If men were the mouth, women were the dirt underfoot from which sprang sustenance.

PERIYACHI SAT on a low stool by the cow's udder and her fingers worked as though she were kneading bread. The milk came in long spurts and made a pinging, echoing noise as it squirted into the metal bucket below. She squeezed one teat at a time,

Yashwanti, a female farmer in a village in the Rajasthan district of north-central India, collects dried manure from the water buffalo paddock. Women use the manure from livestock as fuel for cooking fires. Yashwanti milks the buffalo daily for sale in her village, and for her family's consumption. The milk is processed into yogurt and ghee. (Photo by Trina Moyles)

the drooping pink skin emptying and expanding with milk. The cow stood docile, lowering her head so her neck sagged in bunches. Periyachi milked quickly, the level of milk sloshing back and forth in the container and rising a full inch as I watched. She pushed her stool to the next cow, sat low, and pressed her thumbs into the warm udder to begin her rhythmic work anew.

She rose at three o'clock in the morning and milked until the bones in her hands felt as though they'd been run over by an ox cart. By nine, her husband loaded the large, metal milk containers into a cart and drove his team into Madurai to sell the milk to a processing centre. Periyachi milked all of the cows in the village of Karugappillai—forty in total—every morning. After milking, she returned to her acre of crops and worked for the rest of the day until the sun plunged low to the west. Near sundown, Periyachi returned to the udders of the village's cows for another round of kneading her fingers into the warm teats. "I barely sleep. My life is my work," said the thirty-nine-year-old

woman. She spoke plainly, matter-of-factly, without a trace of exhaustion. The pencil-thin woman didn't have time to feel tired.

Under the days of the old monsoons, when the rain came in the way that was meant for growing rice—full-bodied, but without the force that would cripple rice seedlings—Periyachi and her husband were able to grow enough, and earn enough, to care for their two sons and daughter. When the full grey skies denied the monsoon, refusing to rain in Tamil Nadu, Periyachi's crops suffered. She left her fields in pursuit of additional labour to save for her daughter's dowry and discovered that she could earn a living milking other people's cows. The other villagers paid her a meagre amount of money for her services, but at least it provided a steady income—not like the uncertainty on the return of crops in the market.

"It's becoming exceedingly difficult to farm today," said Periyachi. "It makes me wonder if our children will be able to carry on with how we've lived with agriculture for so many years. I think my own parents would be sad because they see it's not realistic anymore."

Many farmers were selling their few acres of land to agribusinesses, companies with millions of acres, tractors, and the capacity for large-scale irrigation. Periyachi's struggles stemmed from market injustices. In India, imported grains from the United States and Canada cost less money per weight than the Indian farmer's traditional grains. The global market drove down the worth of her own food crops. How could she compete? International trade policies, including the World Trade Organization (WTO), established in 1995, and the Trade Facilitation Agreement (TFA), signed in 2014, restricted the Indian government and other developing countries from providing sufficient subsidies to farmers. Ironically, the United States didn't have to adhere to the same restrictions as developing countries. It continued to funnel billions of dollars in subsidies to American grain farmers. In India, this resulted in the greatest of hypocrisies: Indian grain farmers were buying and eating grains grown by American farmers.

In 2000, five years after the WTO came into effect, Periyachi had ceased growing the nine sacred grains, though she hadn't entirely given up the labour in her fields. Instead, she planted other local vegetables, including snake gourd and okra. Local farmers called okra "ladyfingers" for the shape of the crop's slender, elegant fruits, delicate as a woman's finger. Snake gourd was a kind of long, white squash, streaked with greenish lines. Both crops endured the lack of rain and the wicked heat. Her husband sold the drought-tolerant vegetables in the market when he delivered the milk every morning.

"I've changed the way I farm to keep up with the changes in the fields and the markets," said Periyachi. "Though certainly not for want, but necessity. I suppose I've done everything I'm supposed to do as a mother. I've been able to send my sons to college and pay for my daughter's dowry. I'm not happy with the reality we face, but I'm proud of my work."

Later I would learn about the sacred meaning of her name. When she was born, her mother named her after the goddess, Periyachi Amman. In the Tamil language, *amman* meant "the woman who became a mother." According to her legend, in the early 1400s Periyachi was working as a midwife in southern India and attending to the wounds and grievances of the ill. She gained a reputation for her wisdom and abilities to help women through complicated pregnancies and deliveries. In 1406, opposition forces violently deposed King Vallalan IV from this throne. Vallalan fled into the dense forest, raiding and terrorizing nearby villages. When his pregnant wife, Kaar-kuzhali, went into labour, Vallalan's soldiers captured Periyachi and dragged her back to the forest. Being a superstitious man, Vallalan believed the unborn child was possessed by evil spirits. He ordered Periyachi to deliver the child without it touching the ground, for fear of a dark omen coming to cover the land. The midwife obliged and delivered the child on the top of a large boulder. Upon hearing the newborn's shrill wail, Vallalan leapt to kill his son with a sword. Instinctively, Periyachi drew a spear from beneath her robes and intercepted Vallalan, piercing him directly in the heart. Kaarkuzhali tried to strangle

the child, but Periyachi drew a dagger across her throat. The midwife cradled the baby in her arms and fled into the forest to raise the child as her own.

The story of Periyachi's bravery spread throughout the region. When she died years later, women came to kneel at the ground of her temple and to pray for the health of their sick babies. Those who were unable to conceive touched their heads to the ground and prayed to Periyachi for fertility. But six hundred years later, the name and memory of Periyachi were slowly disappearing from people's lips. Only a few dilapidated temples remained to honour the goddess and her struggle. Some speculated that her temples of worship were isolated to clandestine forest shines. People were forgetting about the woman who defeated the murderous king and protected a child at all costs. But sitting across from Periyachi and listening to the subtleties of her life's joy and suffering, she seemed to embody the fierce qualities of the forgotten goddess.

"After my daughter married, she struggled to conceive," explained Periyachi. "After she miscarried for the third time, her husband threatened to leave her for another woman. 'What good are you to me if your womb is hostile?' he asked her. She came to me. She was desperate for help."

Her daughter's in-laws refused to pay for her fertility treatments. "They told us, 'This is your daughter and if she cannot produce, she has no place in our family. You, as her parents, should be the ones to pay.'"

In Madurai, an hour's drive away from Periyachi's village, clinics charged over $400 for a single cycle of in vitro fertilization. Periyachi consulted with her husband and they agreed that they couldn't abandon their daughter at a time when she risked losing her husband, her security on the land, and the respect of the community. The stigma of being a barren woman would enclose her like a shell. In the eyes of everyone in her world, she had failed utterly in life for her inability to fulfill the greatest obligation of being a woman and a wife.

"We couldn't leave her to suffer alone," said Periyachi. "We sold part of the little land that we had to pay for her treatments."

For a family that barely earned fifteen hundred American dollars in a year, the cost of in vitro fertilization drained them of savings, security, and sustenance. Periyachi lost vital land for growing vegetables. To compensate for the loss of her vegetable sales, Periyachi knocked on the doors of other farmers and begged them to permit her to milk their cows in exchange for a small fee. She found some customers, and the hours of kneading accumulated. Her muscles cramped and the bones in her hands hardened. In the city, her daughter received four cycles of fertility treatment. On each visit, she lay on her back while the physicians transferred the fertilized eggs into her uterus, sowing them as they used to cast the fine rice into water. Periyachi waited and prayed and wondered how much longer her hands could draw milk before giving way to fatigue and pain. And finally, as though the goddess she was named after heard her unspoken worry, the seed inside Periyachi's daughter germinated.

"Nine years after she was married, my daughter was able to give her husband and his family a child," she said. A slight smile flickered across her face.

"Was it a boy or a girl?" I asked.

"A girl," she said. And the smile dissipated at her lips.

I wondered: was it enough? Was a baby girl enough for Periyachi's daughter to preserve her marriage, to secure her fragile ties to the land?

"We'll try again," Periyachi said plainly.

She turned back to her work, kneading the cow's udder while I sat in contemplation of what she didn't say, listening to the sound of milk squirting into the container.

"MY SON," said the man with a silver moustache, fastening his hands on the shoulders of his adolescent son and thrusting the boy of fourteen years forward like a gift. "Good translator." The boy smiled widely and his white teeth flashed. His whole face seemed to smile. Even his sandy-coloured eyes smiled. He nodded and wagged his head back and forth in greeting. "Hello, miss," said the boy. "I am most happy to be helping you

Displaying a henna design on her open palm, a young woman stands in her ginger field in the Dehradun district of northern India. Women decorate their hands and bodies during Diwali, an important celebration that honours light over darkness, good over evil, and enlightenment over ignorance. (Photo by Trina Moyles)

today." I eyed the room nervously. Half a dozen men dressed in white cotton sarongs leaned back in plastic chairs positioned in a semi-circle and conversed amongst themselves, while the women sat cross-legged at their feet on the tile floor. The man with the silver moustache motioned to an open seat next to him. I awkwardly obliged and mustered a gracious smile. I felt deeply uncomfortable towering above the women, who all sat on the floor. Their creased faces revealed their age. Many appeared to be my mother's age, or older. I nervously looked down at my notebook and the list of questions I'd prepared for the women's farming group in Nattipatti. *What challenges do women face? Should women own land? Do you think dowry culture should be*

stopped? I hadn't anticipated interviewing the women as their husbands watched on. My questions felt like explosives. Were they too political? Too dangerous? I didn't want to risk aggravating any tensions between men and women in the village. I closed my notebook and opted for safety.

"What crops do you grow? What agricultural techniques do you apply? Where do you sell your products? How are the prices?"

I asked technical questions, neutral questions, questions that would generate stock answers, the same answers that I imagined could be found in a high school agriculture textbook. As I spoke, I looked into the faces of the women sitting cross-legged on the floor. The pimply-skinned boy translated my questions into Tamil and the men's voices erupted at once. They turned to one another, deliberating. Their voices reverberated off the concrete walls. The women murmured amongst themselves. They could not compete with the volume of the men's dialogue. The men's voices occupied the room. The man with a silver moustache spoke the loudest. His son looked to him eagerly and translated his words into English.

"We grow sugar cane, coconuts, and okra," he said. "We buy fertilizers and pesticides in the market," he translated. "Each farmer takes his harvest and sells it to markets in Madurai," the boy replied, his voice sharp as a parrot. "The prices are good, miss."

I nodded and smiled politely at every response and the men looked at me with expectant faces. They were enjoying the exercise of ask and answer, ask and answer. As their voices lifted in excitement and volume, my frustration, a hot sensation in my chest, began to creep up my throat. I swallowed the feeling down and sat and listened uncomfortably to the men. I hated the place of privilege the men had given me as a white North American woman, seated above the women whose voices and experiences I came to learn, and cared so deeply about. In trying to be a gracious guest, I felt myself colluding with the same forces that kept women seated on the floor, that kept their voices mute, irrelevant to the thoughts and opinions of their husbands.

Why had I traveled so far to southern India to listen to women's silence? Suddenly, I felt the words leaping out of my mouth.

"How is farming a different experience for men and women?" I asked. Instantly, I regretted the biting, accusing quality of my question.

The men's voices became louder and more intense, and it seemed as though they were arguing. The women turned to one another and spoke inaudibly. I longed to desert my chair and sit beside them and lean into their quiet conversation below the men, but I sat frozen in my chair and waited for the boy's stock response. I could have guessed what he would say.

"Miss, there is no difference to be man or woman. Farming is the same."

"Can you please ask the women what they think?" My voice sharpened like teeth.

"But I just told you, miss," said the boy, bewildered by the question.

"You told me what the men said," I said, struggling to mask my exasperation. "But I am curious to hear what the women have to say. I want to hear their words."

The boy turned to his father and spoke in Tamil. The man with a silver moustache barked an order at a woman seated in the centre of the women. She appeared to be in her fifties. Her maroon sari with elaborate gold embroidery at the hem shone. Multiple gold earrings hung from her ears. She smiled and nodded to the man, acknowledging his words, and she rose up, towering overtop the women around her. Her voice filled the room, while everyone listened quietly to her. The man with a silver moustache nodded, and she retreated to her position on the floor. Later I would learn she was his wife.

"She says it is no different," said the boy. "That being a farmer is being a farmer. That women and men, they face the same difficulties of no rain and too much sun."

With resignation, I nodded and withdrew to my role as gracious guest. I longed to probe and pick at what existed, even without language, in the room of men and women. The women's silence was a high-pitched scream that drowned out the

chorus of male voices. I felt the irony of having come to interview women only to end up enduring how their husbands controlled what was said and what wasn't said. I looked down at the women and wondered if they could sense my frustration and helplessness. In my plastic white seat, I sat mutely and listened to the men dominate the conversation as though it were a kite. They reeled and pulled and prevented the dialogue, fragile as a paper kite, from being blown away by the wind.

An hour later, I left the meeting feeling defeated, unable to scratch below the surface of things. As I bent to do up my sandals, a voice, birdlike, freed me from my thoughts.

"It is different," said the voice. "It's different to be a woman," she said.

Surprised, I looked up into the face of a young woman with large amber-coloured eyes, nearly the same colour as an agate held up to the sun.

"My name is Savanya," she said. As she pronounced the syllables of her name, they slipped off her tongue like water. Her voice was youthful and bright. I hadn't noticed her at the meeting, but she told me she sat at the back behind her mother, who was a member of the women's farming group. Her father had also been there.

"When I was younger, men did most of the work in the fields to grow food," said Savanya. She was only twenty years old. "But today men migrate into the city for work and women are left alone on the land. Although men would be quick to say they do all the work, it's women who have most of the responsibility on their shoulders."

Savanya's mother sowed and harvested an acre of grains and vegetables. She also worked as a day labourer, planting and weeding for wealthier farmers, generating income to help pay for her daughter's university tuition.

"I am a civil engineering student," said Savanya. She was about to enter into the final year of her degree. During the semester break, she returned to her parent's home in Nattipatti. She worked alongside her mother on their land and on the land of other farmers as well.

I looked into her earnest face and saw the face of the new India.

In Savanya I recognized the faces of other young women gathered together outside a university campus in Madurai, clustered in semicircles, seated in the lotus position with their notebooks out before them, heads bent in study. "Education is changing everything for women," said an economics professor whom I met in the city. "It's part of why we're seeing a significant decrease in the practice of female infanticide and feticide." The professor explained how parents were beginning to see the value in raising and educating their daughters. Educated daughters could, after completing their studies, if they were lucky, find work to support themselves and their families. If Savanya had been born two or three decades earlier, she might not have lived longer than a day. *A single grain of rice is placed at the back of the baby's throat.*

In her moon-shaped face, I glimpsed the face of Selvi's daughter and the face of Periyachi's daughter. They lived the lives of daughters whose mothers laboured in the fields to send them to school, to pay for their tuition, to help them study to become teachers, lawyers, and medical doctors—but not farmers, anything but farmers. I recognized the same pattern in developing countries I had visited in Central America and East Africa. An older generation of women, farmers who worked with the word daughter branded upon their minds. They didn't want their daughters to become farmers. The women of India, the world's largest labour force for growing food, didn't want their daughters to suffer the way they were suffering against unjust markets, patriarchal traditions, and the increasingly real threat of climate change. Why would they wish this kind of weight on their daughters? Many women longed for a new order in India for their daughters.

And yet, Savanya stood before me, with her face bright as a coin, confessing to me that she longed to study agriculture and return to her mother's fields to share knowledge like seeds, to help the women grow rice and the eight other sacred grains again.

A woman carries harvested mustard greens from her garden to her home, walking in a village in the Rajasthan district of north-central India. (Photo by Trina Moyles)

"I wanted to study agriculture in university, but my father wouldn't allow it," Savanya revealed. "He said, 'Choose a faculty that will give you a future.' If I had the freedom, I would have chosen agriculture. I wanted to bring knowledge back to my mother's fields. Growing food is what we have always done—it's a part of who I am."

"Where will you work after graduating?" I asked her.

"I don't know," she said, pausing with uncertainty. "I will likely return to the house of my parents. I should stay close to my parents."

"Will you get married?"

"That is a decision that only my parents can make," said the young woman.

I nodded and forced a smile.

Although Savanya would soon have a degree in civil engineering, she faced more questions, and the greater uncertainty of dealing with other societal expectations. Where would she

work? How would she put her civil engineering degree to use? In India, only 25 per cent of women participated in the workforce. What alternatives did she have? The international community often played education like a golden horn, championing it as the most important solution to gender inequity. But how would Savanya's degree actually aid her when so few employers hired women for what were considered men's jobs?

Even a daughter in an increasingly modernizing India, even being a woman with the courage to recognize and speak aloud the words "It's different for women," Savanya was still tethered to a larger society that denied her equality in social, economic, cultural, and political spheres.

Like Savanya, Jyoti Singh, a twenty-three-year-old woman, had also been a daughter of a farmer. Her story, which shocked and horrified the world, became a powerful symbol for gender equality and justice in India.

Jyoti's parents, both farmers, had raised two sons and one daughter in Delhi. Her father sold his ancestral land to be able to afford to send his daughter to medical school. "It never entered our hearts to ever discriminate," he said in an article written by *The New York Times*. "How could I be happy if my son is happy and my daughter isn't?" Jyoti's father explained how he recognized early on his daughter's love for school. He worked at an airport, loading suitcases on and off airplanes, to pay her monthly tuition fees.

Jyoti had just finished her final semester of medical school when, at nine o'clock on the night of December 16, 2012, she and her male friend, Awindra, boarded an off-duty charter bus whose driver claimed to be heading back to where they lived. In celebration of the end of the semester, they had just watched *Life of Pi* at a movie theatre in south Delhi. When the bus driver shut the doors and deviated from the way home, the friends quickly realized they had made a mistake to board the bus. The five other passengers on the bus—men who were in their twenties and thirties—suddenly approached the couple, demanding why they were out together at night. The men beat Jyoti and Awindra unconscious with iron bars. They dragged Jyoti to the

back of the bus. She screamed, kicked, punched, and lashed back at her attackers, but they overpowered her. The men proceeded to rape her, repeatedly, one after another. The men later admitted to using a rusty wheel-jack handle to penetrate her. One of men later recalled how he felt something like a wet rope in the dark. The men dumped the bodies at the side of the road. By eleven o'clock that night, a passerby stumbled upon Jyoti and Awindra and called the Delhi Police, who rushed them to the hospital. Jyoti barely survived the vicious assault, her vagina and uterus were badly damaged. Her intestines were hanging out of her. She died from her injuries on December 29, 2012, at a hospital in Singapore. Awindra suffered from multiple broken limbs, but survived.

Jyoti's death sparked protests against violence against women in cities and towns all across India. Thousands of men and women took to the streets in New Delhi, demanding justice. Activists declared hunger strikes. More than six hundred women joined hands and strength to protest in the streets of Bangalore. In Kolkata, thousands of women walked silently through the city with their mouths taped shut. They urged the government to take rape cases and violence against women seriously. That same year, women filed seven hundred rape claims with the police in Delhi, yet only one rapist was convicted that year.

Following the arrest of the five perpetrators, including the driver, who was a minor, the public demanded that they be hung for their crimes. In a highly controversial BBC documentary, *India's Daughter,* one of the men's defense lawyers, M. L. Sharma, attempted to justify the gang rape: "A female is just like a flower. It gives a good-looking, very softness performance, pleasant," said Sharma. "But on the other hand, a man is just like a thorn. Strong, tough enough. That flower always needs protection. If you put that flower in a temple, it will be worshipped. If you put that flower in a gutter, it is spoilt."

One of the perpetrators died in jail. Four of them died by hanging in March, 2014. The minor received only a three-year sentence. But Jyoti's death catalyzed the mobilization of

A woman uses a woven basket to hand-winnow peanuts outside her home in a village in Tamil Nadu, a district in southern India. She wears heavy gold earrings on her nose and ears. Traditionally, when a woman marries in Tamil Nadu culture, her parents must pay the groom's family a dowry, often paid in gold. When a baby girl is born, her parents must start saving money and gold to see that she is one day married. Due to pressures of poverty, girls can be seen as an expensive burden to families. Historically, the issue of female infanticide plagued communities in Tamil Nadu, although through education it is becoming less pervasive. (Photo by Trina Moyles)

women's rights groups across the country. The way the men viciously dehumanized her body brought to the surface issues and root causes of misogyny and crimes against women. Immediately following her death, the government organized a judicial committee to consider more than eighty thousand suggestions from the public for changing laws to better protect women and prosecute sexual offenders with more efficiency.

"They literally ate our daughter," said Jyoti's father, who vowed to continue fighting for gender equality and justice in her name. "She was always our strength," said Jyoti's mother. "Now she will be the strength and inspiration for many girls."

The story of Jyoti had taken on new meanings and symbols in India. After the tragic incident, the media and public could not reveal her real name due to an Indian law that withholds the identity of rape victims. Instead, they called her *Nirbhaya*, the fearless one. They called her *Damini*, a Hindu word that meant lightning. In a society that upheld female deities like Lakshmi and Periyachi, the media lifted Jyoti's image from the horrific violence and placed her on the pedestal next to these same goddesses. Society extended the symbol of the goddesses' nobility to the young woman, but at the same time they shrouded her true identity, her womanhood. Some critics called it a convenient guise, consistent with how Indian patriarchy elevates women to noble status, yet also denies them true autonomy.

"It is easier to idolize than it is to introspect," scholar Tunku Varadarajan, wrote in a letter to the editor published in *The Indian Express* three years after Jyoti's death. "In ceasing to be 'Jyoti Singh,' and in becoming 'Nirbhaya,' Jyoti lost her personhood," he said. "She was effectively dehumanised. Not in the way that she had been dehumanised by her attackers—who took from her everything they could, including her life—but it was a public, collective stripping from her of her personality, and identity."

On December 16, 2015, the three-year anniversary of the night the men brutally attacked and gang-raped Jyoti on the bus, her mother spoke publicly in New Delhi and said the name of her daughter aloud, so the whole country and world could hear. "My daughter was Jyoti Singh and I am not ashamed to name her," she said with a trembling voice, fighting back tears. "Whoever has suffered should not hide their name. It is the offenders who should be ashamed and hide their names. I want to tell everyone that my daughter's name was Jyoti Singh. From today, everyone should know her as Jyoti."

SAVANYA REPRESENTED a new generation in India. She was the daughter of a female farmer who had given her life wholly to the land. Savanya's mother longed for a new reality for her daughter: access to education, employment, and a chance at living a dignified life.

Voices of a changing India criticized and questioned the reduction of womanhood to the idea of a flower to protect, a dowry to pay off, and a womb to impregnate. Savanya would continue fighting to find a way to fulfill her dream of studying agriculture, working the land, and supporting other women farmers. I hoped that society would recognize her contributions as equal to and as important as those of men, while untangling her from the chains of dowry and the expectation of producing male offspring.

Savanya's dreams and the dreams of women around her were more than wombs and hands. She faced dark circumstances, but the voices of the country's women and men, dissenting, demanding justice for girls and women, gathered in strength and volume.

Where was the light amidst so much darkness?

Her light flickered like a *diya*, a tiny oil lamp lit and placed near the door of her house, a tiny light in the dark. It wasn't much, but it offered solace. Being a farmer kept her from forced migration to the city, where migrant workers slept in large, sprawling slums, or along the long, concrete meridians in the middle of busy roads. She didn't have much, but she had the knowledge of a farmer, the hands of a farmer, the strength of a farmer. She grew some of what she ate. The humble satisfaction of her labour and ability to eke sustenance from the earth gave her feelings of pride she did not have the name for. On the land, she mattered.

She was surviving, struggling, even fighting. Amidst the darkness, her tiny light danced. In a culture that sought to swallow her in darkness, her hands continued to work, cultivating the light.

7. THE NEW CONGO

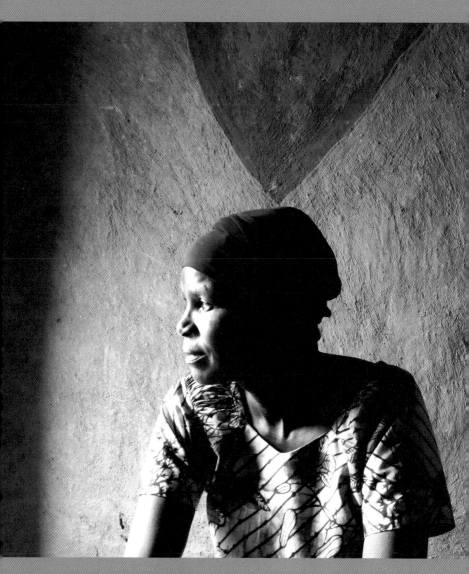

A woman sits in her small home in the New Congo, a predominantly Congolese neighbourhood in Nakivale Refugee Settlement in southwestern Uganda. She, like thousands of other women from the Democratic Republic of Eastern Congo (DRC), has fled to the New Congo after enduring persistent conflict and violence in her home country. Although life in the refugee settlement has severed her from land, she still tends a small plot of farmland, growing maize, beans, and groundnuts. (Photo by Trina Moyles)

The dirt road off the highway led to a military checkpoint with two wooden barricades. A black rubber strip with sharp metal spikes lay across the road like a massive python. Several Ugandan soldiers sat under the shade of a tree, their legs spread wide and their arms resting on their knees. One approached the vehicle, dressed in loose steel-grey-and-blue fatigues and high black boots. An AK-47 strung around his shoulder, the barrel of the gun pointing down.

"Identification, please," he said, his face unsmiling.

He flipped through the pages of my passport and glanced down at my photo and then back up at me. He saw the colour of my skin and the name of the country on my passport. To the officer, I looked like yet another foreign face: a relief worker, doctor, missionary, or journalist. Hundreds of people had come before me. Conducting his routine inspection, his eyes searched the empty backseat of the vehicle. Satisfied, he handed back my passport and motioned to his comrades to open the barricade and pull back the heavy rubber strip. He gestured at the road ahead. "Nice time," he said casually, sauntering back to the shade under a huge umbrella tree, seeking relief from the sun that scorched and blistered the skin. I breathed a sigh of relief as he waved me forward.

Nakivale Refugee Settlement, the oldest and largest refugee camp in Uganda, spread out over a swath of savannah that stretched over one hundred kilometres east to the border with Tanzania. Since 1959, more than seventy thousand refugees from Rwanda, Eastern Congo, Burundi, Kenya, Somalia, and Central African Republic had sought refuge in Nakivale.

On the horizon, low, crooked trees and coral-like cacti dotted the yellow grasslands. Lake Nakivale shimmered blue in the distance, buffered by a ring of papyrus that proliferated in the lake's shallows. Cattle and goats grazed at the edges, appearing on the landscape as tiny brown specs. Anthills rose up in strange red humps.

Geographers had carefully omitted Nakivale from the maps of Uganda for good reason: the camp bordered on Lake Mburo National Park, a major tourist destination. In the minds of

officials at least, the presence of the camp would deter tourists, it was something to look away from, so it was omitted entirely from Uganda's geographical representation. Every year thousands of foreign tourists visited the area to snap photographs of herds of zebra, golden impalas, and hippopotamuses from the pop-up tops of their 4×4 safari vehicles. I wondered: how many tourists realized that only a few kilometres to the east lay a mass concentration of makeshift houses to shelter seventy thousand men, women, and children?

Nakivale became a camp in 1959 following an outbreak of violence between the Hutu and Tutsi ethnic groups in Rwanda, a country bordering on southwest Uganda. In Rwanda, Hutu farmers and Tutsi cattle grazers had lived amicably together, relatively speaking, since the fifteenth century. In the late 1890s, the German state claimed colonial control of Rwanda and created a classist, racist system that favoured the Tutsi, the small and minority elite who, at the time, ruled over the Hutu, who comprised the majority of the population. The Germans claimed that Hutus were inferior to the Tutsis, whom they classified as more "European" based on their Hamitic origins in the Horn of Africa. In 1922, the Belgians assumed control of Rwanda and reinforced the Germans' racist system, deepening the tensions of resentment between Hutu and Tutsi. They created an identification system, registering Rwandans as either Hutu or Tutsi, and requiring that each group produce identification, for example in the streets, at job interviews, and on university applications.

By the late 1950s, Hutu leaders, infuriated because, with few exceptions, only Tutsis held positions of power in Rwandan institutions, incited retaliation against Tutsis. They orchestrated attacks on Tutsi communities, killing entire families and setting their homes ablaze. As a result, in the span of a month, more than thirty thousand Tutsi Rwandese flooded across the border into Uganda, fleeing for their safety. The Ugandan government settled the displaced Rwandese in the Nakivale savannah.

More than fifty years later many of the same Rwandese refugees remained in Nakivale, living where Ugandans would

not, where the sun was harsh and robbed moisture from the soil, causing the crops to perish. The Tutsi feared returning to Rwanda where the racism between Hutu and Tutsi festered, incited by Hutu government propaganda. The refugees had reason to worry. In April 1994, hatred between the Hutu and Tutsi heightened to the point of genocide. In less than one hundred days, the Hutu government and its ragtag teams of youth militias murdered close to one million Tutsi people, slaughtering them like animals.

By August 1994, a Tutsi-led militia group advanced on the Hutu regime in the capital city of Rwanda and, at last, put an end to the genocide. In the days that followed, however, the violence shifted and spread like wildfire into parts of Eastern Congo, Burundi, and Tanzania. More than two million Hutu Rwandese fled across the borders, including former Hutu government officials and the *génocidaires*, genocide perpetrators. The influx of Hutu Rwandese in the Eastern Congo began to incite and fuel a much larger, more complex war that would span twenty years and involve at least a dozen rebel groups and government militias from several countries, all of which thirsted for political and economic power. The faces of oppressors and victims blurred together until they were ambiguous and often indistinguishable. Scholars called the war the bloodiest since World War II. The war in Eastern Congo, raging from 1996 to 2013, claimed the lives of more than five million Congolese and resulted in one of the largest forced exoduses of farmers in world history. The war internally displaced over three million Congolese. Two million more abandoned their farmland and escaped across international borders, including into Uganda.

Over the course of the war in Eastern Congo, more than forty thousand Congolese refugees flooded into Nakivale Refugee Settlement in southwestern Uganda, the largest concentration of Congolese refugees in the entire country.

Driving along a straight, flat, red dirt road, I passed their gardens: fields of rows of stunted maize, shrivelled and weakened from the oppressive heat. Women in the fields bent at

the waist, weeding around the low-lying groundnuts. On the shoulder of the road, they carried monstrous bundles of firewood on their heads as they walked towards the New Congo, their bold *kitenge* cloths tied at the waist and fluttering above their ankles. The dust on the road dyed their feet red. I passed them slowly, careful not to shroud them in dust. They looked straight ahead, their necks steady, accustomed to the weight.

We continued along the dirt road to the place they called the New Congo, a huge tract of land in Nakivale Refugee Settlement where the farmers-turned-refugees, those displaced by the three decades of violence and conflict in Eastern Congo, lived and farmed and prayed for rain. The New Congo did not exist on the official maps of Uganda, but it should have: more than forty thousand Congolese farmers dwelled there, hardened by war but not without hope.

FOR THIRTY-FIVE YEARS Anne, a Tutsi-Congolese woman, lived on the lush green hillsides that rolled from North Kivu to South Kivu in Eastern Congo. Her mother gave birth to her in a village in Busanza, a township in North Kivu, and taught her how to be a farmer and how to be a good woman: to always share part of a harvest with neighbours whose crops failed, to always serve her guests porridge made from cassava and millet flour. As a young girl, Anne could run up and down the hillsides with other village kids without effort, or breaking a sweat. She could never have predicted how she would long for her ancestral land, to taste again the cool fog that pooled in the chasms of the hills, to feel the mist on her skin.

At sixteen, Anne squatted down the same way her mother had birthed her and her eight siblings, and, holding a plastic washbasin beneath her, she delivered her first child. Anne placed her newborn son in the washbasin and cut the umbilical cord with a razor blade. She gave birth to four other children the same way.

Her husband carved a foundation into the hillside and built a home for Anne and the children out of pine trees, rocks, clay,

and sand. The land amply provided generous harvests of cassava, their staple food crop. The long, white root vegetable grew for twelve to fourteen months. Every tree produced a cassava along each of its multiple, tumorous roots. In Eastern Congo, they ate cassava at every meal: roasted whole, fried, stewed, or cooked into doughy bread for dipping into groundnut sauce. Anne dried the large roots in the sun until they were hard as rocks. Using a heavy, flat stone, she ground the cassava, by hand, into flour. Then she added the flour to a pot of boiling water on the fire and stirred it with a long wooden stick until it became a giant, starchy mass. Life depended on cassava, but Anne grew other crops too, including maize, groundnuts, beans, bananas, and vegetables. The forests of trees that surrounded the fields drew rain into the ground and farmers could therefore enjoy at least two growing seasons, even three during a lucky year. While Anne farmed plots terraced into the hillsides, Anne's husband grazed a herd of cattle and goats on the bald hilltops. A rooster and a flock of laying hens gave them eggs and meat. They rarely went to sleep hungry.

Anne remembered life in Busanza with a hardened ache.

In August 1994, the Rwandan Patriotic Front (RPF), a Tutsi-led rebel group led by Paul Kagame, overtook Kigali, the capital city of Rwanda, and the Hutu government and *génocidaires* fled the country in the masses. Two million Hutus crossed the borders into surrounding countries, including the Kivu provinces of Eastern Congo. The sudden incursion of refugees into Eastern Congo drastically changed the lives of the Congolese, including the lives of Anne and her family. Lacking adequate shelter, food, and sanitation facilities, the Hutu refugees began stealing resources from the Congolese: trees for firewood and building, food crops and seeds for planting, along with chickens, pigs, and goats. Cholera broke out and besieged the refugees, resulting in hundreds of thousands of deaths that reached even beyond the immediate camps and into the villages in Busanza.

Rumours surfaced in the camps that Kagame's RPF soldiers were marching from Rwanda to launch an assault on the

refugee camps in Eastern Congo and the Hutu *génocidaires* they knew were hiding there. In retaliation, the Hutu *génocidaires* in the camps launched a campaign of hatred against the Tutsi-Congolese. They called them invaders and *inyenzi*, a word that means cockroach. The soldiers started organizing young, hungry Hutu men into brigades to pillage the surrounding villages, to avenge the loss of their homeland on the Tutsi-Congolese families. In a lust for power, control, and revenge against the ethnic Tutsis, Hutu men raided villages, raped mothers and daughters, and chased the Tutsi farmers and cattle herders from their land and livelihoods. In 1996, over thirty-four thousand Congolese-Tutsi abandoned their gardens and homes, and, in their haunting memories, the blood of loved ones still spilled before their very eyes.

Throughout human civilization the horrid nature of war and conflict—the violent tearing apart of communities from daily routines and relationships with food systems—has devastated the way food is grown, processed, distributed, and consumed. War has forced mass migration, decapitated food production, plagued populations with famine and poverty, robbed farmers of traditional seeds and access to land, and traumatized culture, often prohibiting the flow of traditional knowledge through generations.

Nowhere has the negative consequences of war on food systems and farming communities been more pervasive than in Eastern Congo, where, before the conflict began in the mid-1990s, more than 80 per cent of the population grew food for a living. Decades of conflict, displacement, and illegal resource extraction by rebel groups have forced the Congolese remaining in the region into abysmal living conditions. In 2015, Eastern Congo received the lowest ranking out of nearly two hundred countries in the United Nation's Human Development Index, and over six million Congolese were reported acutely malnourished and food-insecure. The average Congolese in Eastern Congo would only reach the age of forty-five years old, and nearly 20 per cent of babies born would never reach their fifth birthdays.

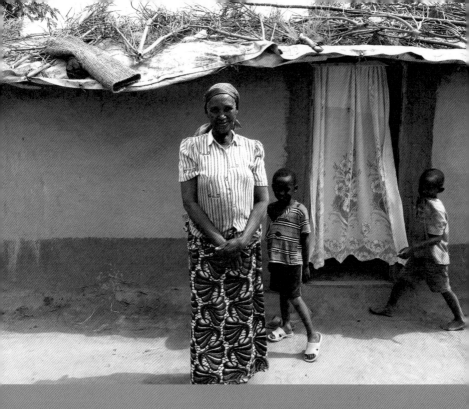

Some women have been living in the New Congo of Nakivale Refugee Settlement for decades. This woman was forced to flee her home in Eastern Congo in 1996, following a period of instability and violence that was, in part, sparked by the Rwandan Genocide of 1994. She crossed the border into Uganda alone with two small children. Her husband was killed in the violence. In Nakivale, she continued to farm and raise her children. "I'll never go back to the Congo," she said. (Photo by Trina Moyles)

I met Anne eighteen years after she had fled her village in Eastern Congo. The tall, slender woman waited for me outside the front door of her home: an adobe-built house with a white-and-blue United Nations tarpaulin for a roof. Several rocks and shredded car tires lay on top of the plastic to prevent it from blowing away. The neighbours' homes, the same square brown buildings, were packed together like loaves of bread, differentiated only by the objects—tree branches, rusted scraps of iron sheets, broken cinder blocks—that weighed down the roofs and prevented the wind from peeling back the plastic membrane that protected them.

Anne stood a few inches taller than the walls of her house. Her silver coiled hair peeked out around her temples from under her blue-and-purple headscarf. She beckoned me inside her house, lifting a delicate lace curtain, which hung in the doorway. I ducked my head and entered. Against the mud-smoothed wall, I sat on a wooden bench in a small room that measured two metres by two metres. Anne sat across from me on a low bench made from mud.

"I fled from Busanza in the middle of the night with my neighbours," she began. "They killed my husband and two of my oldest sons. We moved from refugee camp to refugee camp before we were finally transferred to the New Congo."

She escaped the Eastern Congo alone, carrying her four-year-old son, Eric, on her back and pulled along her five-year-old daughter, Rebecca. Eric, her son, had grown into a handsome man with a head of loose black curls. At twenty-three, he stood taller than his mother. He entered the house, crouching under the low ceiling, and sat down beside me. He listened quietly to our conversation and barely spoke. At times, his gaze drifted up to the ceiling, or down to the hard-packed floor.

When Anne reached the New Congo in Nakivale, the UNHCR administration assigned a house to her, along with a standard parcel of land that measured sixty metres by twenty metres, less than an acre, a tiny shard of what she used to farm in Busanza. Every family who came to Nakivale received the same amount of land. The camp administration gave Anne a hoe, a bag of maize, and bean seeds for planting.

"In Congo, I had so much land to farm. But here in Nakivale, I've gotten used to planting only one or two crops on a single plot," she said.

She gazed out from beneath the white lace curtain which draped from the mud-packed house. Outside, a group of young boys laughed and chased one another around on the compound. They giggled and squealed with the pleasure of their game.

Anne raised her children on the small harvests she painstakingly lured from the land. Nakivale felt so far away from the cool, temperate climate in Eastern Congo. In the refugee camp,

the bean limbs turned a crisp yellow and produced three or four beans in a pod, in contrast to the long curling beans, twelve to a pod, she once grew in Busanza. The maize stunted, failing to turn the deep green shade Anne remembered. The crops stood in the field like withered crosses. Like the other refugees, Anne and her family depended on food rations. The UNHCR distributed six kilograms of beans and maize monthly for every adult and child in the household, along with a small plastic soda bottle filled with cooking oil.

"It's not enough to get us through the month," said Anne.

She reserved a portion of her small harvest to sell to the Ugandan middlemen who came to the New Congo every season to buy crops from the refugees. The New Congo had become a new agricultural market in Uganda, although the middlemen, with their trucks and ability to transport produce to larger markets in Mbarara, Masaka, and Kampala, held the upper hand in transactions with the refugees. Anne earned enough only to cover her basics: salt, low-grade black tea leaves, sugar, and, perhaps, onions and tomatoes to add flavour to the beans and porridge.

When her children were younger, she bought them one notebook per semester, along with a pencil and eraser each. They attended primary school in the camp, learning alongside a sea of other refugee children: four hundred students to one teacher. Eric and Rebecca had to elbow their way to find a spot near the front of the room, so that they could at least hear the teacher's voice. They learnt the local language, Runyankole, and spoke their mother tongue, Kinyarwanda, only with their mother in the dark privacy of their home. When the children completed primary school, Anne worked to secure spots for them at a secondary school in Isingiro, the nearest town centre to Nakivale. They both studied until the tenth level. Eric had applied, through the UNHCR, to emigrate to a Western country. He spent his days waiting outside the UNHCR's compound with other young men and women who had applied, dreaming of what life would be like in the United Kingdom, the United States, Canada, or maybe Norway.

"It's like waiting around all day to find out if you'll win the lottery," Eric told me. He shook his head in frustration. "I'm one of thousands of young people waiting to find out." The odds of leaving Nakivale were stacked against him, but at twenty-three, he had a lifetime of waiting ahead of him. The employment opportunities in the New Congo were few.

"Do you think you'll ever go back to your land in the Congo?" I asked Anne. Eric stood up abruptly, as though my question struck a nerve, offending him. He pushed through the lace curtain, retreating from us back into the midday sun. Outside, he hushed and scolded the children, who shrieked like the long-beaked ibis. I sat, ashamed, and waited for Anne's response. She fell into long and heavy silence that burned on my conscience. I considered what Anne had not told me about her story. How she watched the rebels kill her sons, murder her husband; what happened along the path of her exodus into Uganda. How she mustered the strength and will to sow seeds for such an uncertain future. My heart weighed.

"I can't even think of going back," Anne said at last. She locked eyes with me. "The problems in Eastern Congo, to me, they are the same as they were since the day I left."

Anne would probably never leave the New Congo. She would continue to swing the hoe into the hard, reluctant ground until old age. She would subsist on monthly aid rations and the handfuls of beans, maize, and groundnuts harvested from her garden. She prayed that Eric and Rebecca could win the lottery, travel to the UK, to anywhere else, and find a way out of the suspended existence as a refugee.

SCHOLARS AND JOURNALISTS often refer to the periods of fighting and violence in Eastern Congo as the first war (1996 to 1997), and the second war (2003 to 2005). But the war never truly let up for women living in the Kivu provinces of Eastern Congo. They could not predict the pattern of gunfights and bullets ripping across the sky, tearing their world into pieces. The fear of violence never left them. The internal war ravaged on. In

their fields, sowing seed, the weather, the rain were the least of women's worries. They lived in terror of what could happen: death, rape, pillage, and fire dancing on the thatched roofs of their homes. The tragic stories they heard from friends, the attacks they witnessed on neighbours or on people in the markets, paralyzed them with fear. Fear occupied their minds and bodies and threatened the women, even during what the scholars called peaceful times, with the imminent possibility of violence.

In Eastern Congo, Senu's five children knew war the way they knew the colour of the sky before it rains. Her sons learned to walk during the first war. Her daughters married and moved to their husbands' land to farm during the second war. They lived in Bunagana, a township located in the Rutshuru territory of the North Kivu province. In Bunagana, Senu sowed seeds into a carpet of black, volcanic soil on the hillsides of the Virunga volcano range. Her land dwelled on the edges of the Masisi forests, where the lush land ripened with nourishment: timber and copious rain, and minerals, including gold, silver, nickel, and coltan, a black metallic ore used to make the world's supply of smart phones, laptops, and other electronics. These riches attracted rebel groups in Eastern Congo like vultures. Rebels smuggled diamonds and coltan out of the country. Their profits fuelled their ability to take violent action against one another and everyone else that stood in their way.

Senu, her husband, and children were Congolese-Hutu, although their descendants came from Rwanda during the 1930s as part of a Belgian colonial policy that forcibly relocated 175,000 Rwandans to Eastern Congo to work on the colonialists' cattle ranches and plantations. The Bembe, an indigenous ethnic group in Eastern Congo, immediately despised Senu's ancestors, who slowly began to occupy the land available for farming and herding livestock. As the availability of arable land shrank over the decades, the Bembe continued to blame the descendants of Rwandans for their hardships. Their anger towards Senu and her family had simmered, ready to explode, for decades.

From a brightly painted church in the New Congo, a neighbourhood in Nakivale Refugee Settlement, the voices of women ring out in harmony. Congolese women, many of them survivors of horrendous acts of gender-based violence in their home country, gather to collectively pray, grieve, heal, and rebuild their lives. (Photo by Trina Moyles)

In 2006, Laurent Nkunda, a Congolese-Tutsi rebel leader from North Kivu, led the Congrès national pour la défense du peuple (CNDP), an armed rebel group, in an attempt to seize power in Bunagana and in the larger Rutshuru territory. The CNDP sought justice and revenge against the Hutu-powered Forces démocratiques de libération du Rwanda (FDLR), a rebel group connected with the perpetrators of the 1994 Rwandan genocide. The CNDP wanted the Hutu, including Senu and her family, to suffer the way Tutsi-Rwandese suffered during the genocide. It did not matter that Senu had nothing to do with the Rwandan genocide. The CNDP considered all Hutu connected to the mass slaughtering of Tutsi. They wanted Senu

and her neighbours off the land. The riches under their fields of cassava and maize would fund their ethnic cleansing campaign. "An eye for an eye," said the CNDP's leader, Nkunda.

They attacked Senu's home in Bunagana late one afternoon. A gang of young men burst inside the house. They flashed *pangas* at Senu and her husband, and stuck the long barrels of AK-47s into their ribs, ordering them outside on the family's compound. Two men pinned Senu to the ground. One of the men held her head against the earth with his boot, making it impossible to look away from their violence. Three of the men hacked her husband's body into pieces. The rebels ransacked what was left over from their harvest, the dried cassava and maize, the sacks of beans, and bolted into the forest.

For hours, Senu lay on the earth, unable to move. She stared at the bloody remains of her husband until one of her neighbours pulled her body off the ground and together they fled from Bunagana under a moonless sky. They crossed the Ugandan border, collapsing with exhaustion when they reached a transit refugee camp in Kisoro. At the camp, Senu reunited with her eldest son and daughter and their families. She received the devastating news that three of her adult children were murdered in Bunagana. Devastated, she slept away the month under a plastic tent and forgot to count the number of days that passed. Eventually, UNHCR officials transferred Senu and her children's families to Nakivale in southwestern Uganda. Her neighbours from Bunagana would be relocated to another camp to the north of Nakivale. For Congolese women, the war blew the severed threads of their former lives to distant camps on unfamiliar lands.

In Nakivale, I found Senu outside her home in the New Congo, preparing wild spinach the same way she once did in her home country, pounding the leaves with a large pestle in a tall wooden mortar. Senu held the mortar steady by fastening her feet on either side. She rhythmically beat down with the long pestle. During the war, rebels used the same pounding technique to crush the skulls of infants. These horrific acts were meant to live and fester inside the surviving witnesses, to torture them for a lifetime.

"*Karibu*, welcome," said Senu, using Swahili, a language commonly spoken in East Africa.

Though her mother tongue was Kinyabwisha, a dialect of Kinyarwanda spoken in Eastern Congo, many people preferred the versatility of Swahili in the refugee camp, and the anonymity it gave them. The mother tongue gave away clues to ethnicity, offering information about their hidden selves. People kept quiet in the New Congo.

Senu led me inside her house to talk. She used a technique from the Congo to insulate her house against Nakivale's heat, applying a paste of cow dung, mud, and water to the walls. She harvested black sand from Lake Nakivale to create a black border around the edges of the walls. Senu had dipped her fingers into the black sand mixture and patted out a large, asymmetrical heart on one wall. As we sat down, her five-year-old grandson tottered into the room and pressed his body against her thighs. He leaned close to her face to whisper something. Her face lit up and she patted him on the back. She disappeared into another room and emerged holding a yellow plastic jerry can. Senu handed it to her grandson and gently pushed him outside. "He's going to fetch water for our lunch," she explained with a faint smile.

Senu's two adult children lived nearby in the New Congo. The three households had received three plots for growing food. Every morning, Senu and her daughter walked a kilometre to the gardens. They did the bulk of the work: sowing the maize seeds; weeding around the base of the maize stalk; planting groundnuts beneath the maize, or beans to climb the maize stalk; and harvesting the crop to sell to the middle people, who came with trucks to the market. Senu longed for her fields in North Kivu, for the black volcanic soils, and for the steady, generous rain.

"What did you grow before, in Eastern Congo?" I asked.

She cocked her head slightly and reached back into memory. She recited the names of crops as though murmuring her favourite hymn.

"Cassava . . . maize . . . yams . . . bananas . . . sweet potatoes
. . . " she said slowly, lingering on the name of each food and
the memory it evoked. "I used to grow so many vegetables, like
eggplant . . . pumpkin . . . carrots . . . onions . . . and celery."
She smiled weakly. "Before the war, the land and rain were
plenty in the Congo. I used to be able to sell in the market.
Slowly by slowly, I was increasing my production. I used to
hire other people to help dig on my land and produce even
more," she said. "But here, the land is hot and infertile and I
can barely grow maize and beans. The challenges for a refugee
are too many."

Hunger, she confessed, was one of them. She stretched out
six kilos of maize and beans over thirty long days. Senu ground
the maize into flour and mixed it with boiling water to make a
thick, tasteless porridge that kept the stomach full during the
long mornings she worked on the land. She ate beans for one
meal a day only. Her minimal harvests covered the costs of
soap, salt, and seeds for the following season.

Senu heard bits and pieces of news about her former neigh-
bours. Eight years had passed since they were separated into
different truck beds and moved across the country. She heard
rumours that some had left the camps, provoked by the cramp
of hunger that plagued the refugees there. They crossed the
border to Bunagana and back to the fields and the ashes of
their homes, which the rebels had burned to the ground. But,
as they quickly discovered, they had to choose between living
with hunger or violence. Senu had heard that when her neigh-
bours had returned to Bunagana, violence greeted them, the
rebel groups still vying for control of the mineral-rich land.
The UN estimated that over six thousand rebels remained in
the Eastern Congo, fighting to control mining, illegal log-
ging of the Virunga forests, and even agriculture. The bullets
flew more irregularly, but they still tore the skies into shreds.
By remaining in the refugee camp, Senu's friends had chosen
hunger over danger and left their land for the second, third,
and fourth times. They returned to the food rations that

would never satisfy their physical hunger. Trauma created an insatiable hunger: a hollow, burnt-out pit of loss and suffering.

"I will never go back," Senu said, her voice shaking, "I can't forget what I saw there."

"Do you think your grandson will return one day?" I asked.

He was so young, I thought. I wondered if one day he could be reconciled with the land that belonged to his grandmother and late-grandfather, where his mother had been born. But Senu couldn't fathom it. She shook her head, certain of its improbability.

"There is no one left. I don't know what's happened to our land. Why would he go back to a place that he doesn't know and doesn't know him?"

Her grandson returned from the well, lugging the jerry can with his whole five-year-old body. Water splashed from the opening and stained the dry earth. What would he grow up to remember about his family's history and culture in Eastern Congo? Would he inherit the stories his mother and grand-mother told him? Would he inherit the stories they didn't tell him? Trauma passed like blood between mother and child, a substance of grief, rage, and despair.

The war in the Congo had put a knife to the things that held Senu's life together: family, land, and farming. As the Nigerian author, Chinua Achebe once wrote, "things fall apart."

DURING THEIR DAYS in the refugee camp, Congolese women tended the fields, fetched water, and scoured the land for firewood. Men grazed long-horned Ankole cows and goats around Lake Nakivale, the only place in the camp where the grass grew green. The men with silver hair, humped backs, and brittle spines went to the trading centre, a row of shacks strung together, where people converted their assigned homes into small stores. They sold cooking oil, onions, tomatoes, soap, plastic bags of fried chips topped with grated cabbage, and home-brewed alcohol. Outside the stores, women swept the hard-packed floors at the front entrances with bundles of long

dried grass; shaky old men sat on wooden benches with cups in their hands; and kids ran and played, spinning rusty wheel frames around with sticks. Some of the children went to school; others ran in packs, playing soccer with balls made from dried banana leaves and plastic bags tied with twine.

On the surface, life in the camp appeared the same as in other villages in Uganda. But looking more closely, I saw a myriad of people going about their daily routines together. Somali girls, wearing bright yellow-and-turquoise-coloured *hijab*, fluttered by like butterflies. An Ethiopian woman with honey-coloured skin and loose, curly, black hair bought tomatoes from a vendor. A few Sudanese boys draped their long limbs over one another, crowding together to watch a game of cards. One boy slapped down a card and threw his fist into the air and the others laughed and cheered. Languages reverberated like music: Swahili, Lingala, Kinyarwanda, Runyankole, Luganda, French, and English.

But outside Miriam's home, silence hung in the neighbourhood.

"Come," she said. "Let's come inside and talk."

We could have sat under the shade of her small house. But Miriam seemed to prefer to talk behind the closed doors of her small, dark home. The New Congo sheltered tens of thousands of Congolese-Hutu and -Tutsi men, women, and children. They came to the refugee camp to escape the war and some of them stayed and began to put back together the pieces of their lives, but memories of the homeland taken from them, the fire, the bloodshed and the many costs of war, also followed them. Eyes and ears were everywhere in the camp. Some of the refugees were victims, some perpetrators, and others were both. Life had stabilized, even normalized, for many refugees in the New Congo. But they still searched the faces of their neighbours, the vendors, the men drinking at the pubs, and people they met in church and at the market. People whispered information from the past only in dark places.

Inside her living room, Miriam sat next to her seven-year-old daughter, Janet, who clutched her mother's hand and eyed me

shyly. She smiled, revealing tiny white teeth and pink gums. She was nearly the same size as her mother. Miriam only reached five feet and she moved like a bird, barely occupying even the small space of her home. Her blue-and-maroon *kitenge* was too large for her tiny shoulders.

I wondered what happened to Miriam's eyes. One pupil hugged the inner corner of the eye while the other shot off in the opposite direction as though to look at someone who had suddenly burst through the front door. A deep scar curved like the cusp of a new moon under one eye.

"I am Banyamulenge," said Miriam.

The word Banyamulenge, when uttered by some ethnic groups in Eastern Congo, turned vile, transformed into a hateful thing. *Bor,* the Bembe people of South Kivu called her. They hurled the word, meaning penis, like they would a rock. The history of bitterness between the two ethnic groups traced back to the mid-1880s when the Banyamulenge, formerly Tutsi pastoralists who grazed their cattle in Rwanda, crossed over into Eastern Congo and scaled the Itombwe mountain range. They settled in a village called Mulenge and, shortly after, the Bembe farmers, native to the land, christened them with the name Banyamulenge. But tensions between the two groups grew over the years, as the population of both ethnic groups increased and the land available for farming and herding decreased. The Bembe referred to the Banyamulenge as invaders, even two hundreds years after they settled in Eastern Congo. By the turn of the twenty-first century, the debate over rights to land, resources, and citizenship continued to rage between the Bembe and Banyamulenge.

"I was born in the Minembwe highlands in South Kivu," explained Miriam. "My father grazed the long-horned cattle and my mother grew crops. I married a Banyamulenge man and that's where our five children were also born."

In 2006, Minembwe became a recognized territory in Eastern Congo. The drawing of lines around Minembwe stirred anger and controversy among the surrounding communities. The Bembe refused to see the Banyamulenge as Congolese. To

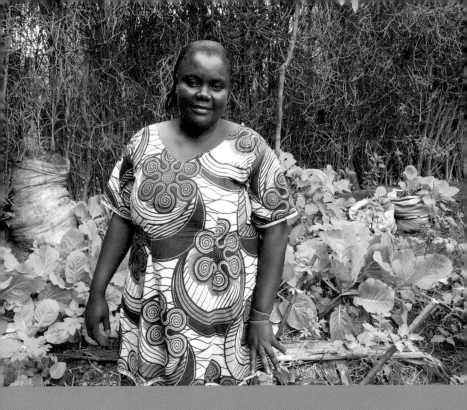

A Congolese woman stands in front of her backyard vegetable garden in the New Congo of the Nakivale Refugee Settlement. She, like other women refugee farmers, is making use of small spaces to grow vegetables and raise livestock. From potato sacks she has made raised beds to cultivate cabbage. She also dug a small hole in her backyard, which fills with rain water, to serve as habitat for the ducks she raises. (Photo by Trina Moyles)

them, the invaders spoke Kinyarwanda, the same language Rwandans spoke. Even their physical features mirrored the Rwandan Tutsi: tall, slim, brown-skinned, with slender noses. The Bembe would never accept the Banyamulenge as Congolese, and therefore they had no right to the ground on which they grazed their cows, planted seeds, and built their homes.

During the second war in Eastern Congo, rebel groups capitalized on the Bembe's hatred for the Banyamulenge. They recruited adolescent boys from the Bembe to join their cause against the Tutsi, even those with distant ancestral roots, such as the Banyamulenge. The FDLR, the Hutu rebel group,

thirsted to exterminate the Tutsi ethnicity. They employed the same hateful language used by architects of the 1994 Rwandan genocide, calling the Tutsi "cockroaches," "scum of the earth," "invaders." Some of the Bembe joined voluntarily, but others were forced by the threat of violence. The conflict in Eastern Congo made murderers and rapists and child soldiers out of thousands of Congolese youth. The FDLR promised youth, particularly youth from poor families, money, opportunity, and power if they took violent action against the Tutsi families in Eastern Congo. The rebels forced young men to set their neighbours' homes on fire and to drag women and young girls into the forests to gang-rape them. The conflict swallowed youth whole. "Eat, or be eaten," said a Congolese proverb. Some of the boy rebels could barely carry their loaded weapons.

Months later, a group of rebels attacked Miriam's village in Minembwe. They crept into the village under the cover of darkness, their bodies weaving silently through the banana plantations, their long knives reflecting bits of the silver moon. Before Miriam told me the story, she bent and whispered into the ear of her daughter. Janet left obediently. I saw her outside through the curtain that hung from the door. She pulled laundry from a wire hung between their house and the neighbour's house. The sun burnt like an ember in the sky. Their clothes hung stiff. Janet piled them high in her arms.

"The rebels burst into our house and dragged my husband out onto the compound," Miriam began, concentrating on her clasped hands on her lap. She spoke evenly, without emotion, as though she had told the story many times before. As I listened, my breath slowed.

"They bound my arms behind my back and tied my feet together, so I couldn't move and then they killed my husband right in front of me, cutting him into pieces. They held my head and forced me to watch him die. He did not die quickly."

"Then they raped me," she said. "Six of them."

Rebel groups and soldiers frequently used rape as a tool of war against women's bodies in Eastern Congo. It had many aims: to humiliate men, to exterminate ethnic lines, to cause

pregnant women to have miscarriages, and to strike fear into women, to prevent them from gathering firewood, sowing seeds, and fetching water. The perpetrators raped women in horrific, dehumanizing ways: using broomsticks, the long barrels of their guns. At times, they took young girls captive and enslaved them in forest camps. Some rebel soldiers claimed that the act of rape gave them strength and power to overcome their enemies. Other soldiers admitted they were just following orders, that their superiors would kill them if they did not rape their victims.

By 2010, the UN reported, over forty women were raped daily in South Kivu. "It's become more dangerous to be a woman than a soldier," said Major-General Patrick Cammaert, a former commander of a UN peacekeeping force in Eastern Congo. By the following year, the UN believed that close to two million Congolese women were victims of rape in North and South Kivu.

Miriam did not know who her attackers were. They had come at night to steal everything good in her life: her husband, her parents, their crops, and their cattle. She did not have names or faces to attach the violence to.

"I remember the words of one of the men. He screamed at me: 'You're Rwandese! Get out of our country!' But I was born in Congo. My parents were born in Congo. How could they say that I was Rwandese?"

It took her one hundred days to reach the New Congo. She fled the region with thousands of others, carrying her daughter on her back. She crossed into North Kivu, to the internally displaced camps, before arriving at the Ugandan border. Along the way, she suffered from separate bouts of malaria and typhoid. She struggled to fall asleep at night. She had no idea what had happened to her five older children. They had fled into the forest on the night of the attack. The images of her daughters being turned into sex slaves, her sons into rebel fighters, tormented her. She received no word from them.

When Miriam arrived in the New Congo, the camp officials gave her seeds and a fragment of land. On the land she

bent over the hot, hard earth and worked, her mind numb. The heat burned the seeds, while in the sky deceivingly grey clouds rolled. The sky promised rains and she and the other farmers waited, but nothing happened. Miriam felt dead inside. One day, as she worked in the field, she looked up and saw the face of her eldest daughter. She nearly collapsed in the field. Her five other children had managed to escape South Kivu and make their way to the refugee camp in southwestern Uganda.

The whole family lived together in the New Congo: seven bodies squeezed together on two beds in a two-room house made out of mud and sticks. Miriam and her daughters walked an hour to reach the small patch of land where they grew maize, beans, and groundnuts. She sold part of the crops to pay her children's tuition fees for the nearby primary school. Her eldest daughter, now eighteen years old, longed to study nursing.

In the fields of the New Congo, Miriam met other women from South and North Kivu. Slowly, the women began to help one another, as they would have helped their mothers, sisters, neighbours, and friends in Eastern Congo. Miriam and her friends formed a farming group to share labour, seeds, tools, and ideas.

"These women are not simply farmers who offer advice of when to plant, or how to remove pests," she said. "They are also my friends."

Together, the women recalled the past with one another, speaking in their mother tongue. Language swept them back to memories before the war, during the days when they planted their crops in rich, mineral soils, harvested cassava, and shared food with their neighbours and friends. Together, Miriam and her friends mourned those who were killed in the war. In the fields the women worked and grieved, sometimes without saying anything at all.

MY TRANSLATOR, Gloria, spoke six languages fluently: English, French, Swahili, Lingala, Runyankole, though she preferred her mother tongue, Kinyarwanda. Gloria's soft, musical voice

created bridges between English and the variety of languages spoken by the women in the refugee camp. Many of the women grew to recognize the sound of Gloria's musical voice before they saw her coming, slowly, down the road, her large body swinging side to side as she walked. *Agaandi! Bonjour! Hodi! Muraho! Mbote! Hello!* The women we passed along the way greeted her in six different tongues.

"We are going to interview one more woman," said Gloria, clutching her white plastic purse under her doughy arm. She wore a forest-green-coloured *kitenge* patterned with tangerine flowers. She shuffled along in her leather sandals.

"What is her name?" I asked.

"Gloria," she said, casting a sideways glance at me. "I also have a story to share. Women carry stories the way we carry children. My story is also important."

For most of her life, Gloria had intimately known the weight and worry of war. She grew up in a farming community on the slant of the Virunga mountain range in a village along the Eastern-Congo and Ugandan border in North Kivu. Her mother's family had farmed for generations, and so she and her mother had an intuitive ability to cultivate lush fields of tall cassava, rust-and-orange-coloured sorghum, and pink and purple flowering peas, which fed her brothers and sisters. Gloria's father tended a small herd of cattle and shaggy-necked goats. For the first thirteen years of her life, she sloped down to the stream to fetch water without fear at her back. When the war broke out, for every walk to the stream and forest, hunting for fallen branches for firewood, for every kilometre on the way to school, fear accompanied her. The possibility of violence was always a step behind her.

"The war would be coming and then go quiet," she said. "It was coming and then quiet, coming and then quiet. And then the war was coming again."

After her sixteenth birthday, Gloria went to college to study social work and began working for a non-profit organization that supported Congolese families living in a camp for internally displaced persons. There, she met her husband,

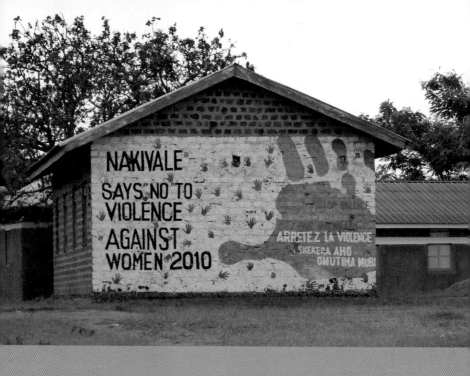

This mural was painted by the UNHCR, the UN Refugee Agency, in Nakivale Refugee Settlement. Many of the Congolese women living in Nakivale today are survivors of sexual violence and gender-based violence who fled the persistent conflict in Eastern Congo. However, a sad reality is that violence has followed them into the refugee settlement, as well. The UNHCR is working with communities to promote healing and reconciliation, although girls and women continue to face high risks of gender-based violence within the camps. (Photo by Trina Moyles)

a handsome Congolese-Tutsi man, who had just finished his law degree. Despite the flying bullets and war that continued to unfold in the forests around them, Gloria became pregnant. She cultivated her husband's land, planning for the season the way her mother taught her: watching for signs of rain, the clouds thickening like maize porridge, the wind kicking up and shaking the banana leaves like gentle maracas. She watched for the weather the same way she watched for the war.

Meeting with her years later in the New Congo, Gloria introduced me to her children. She had three daughters: thirteen, seven, and five years old. She called them into the living

room where we sat on bright pink plastic chairs. Gloria's daughters filed obediently into the room.

"You're welcome," said Joan, the eldest daughter. The second-born pulled on the hand of her older sister, her polyester trousers drooping at the waist, two sizes too big for her seven-year-old frame. The youngest dashed into the room, halted right in front of me, then scampered back out of the room, giggling. Wordlessly, the older girls shook my hand and returned to their chores on the hot compound, one stirring a small saucepan of groundnut paste over a charcoal stove.

"Do you see the difference in age between my first born and the second?" Gloria asked and I nodded. "The war has taken so much from women. For me, it took my sons."

In 2008, the last Gloria remembered of peace was preparing a fire to cook lunch. She organized the twigs and sticks among three large cooking stones. She struck a match, held it to the kindling, and the wood smoked before it began to burn. Then Gloria heard her mother-in-law's cry. She rushed through the house to see her husband lying on his stomach, pinned down to the earth, a large black boot resting on his neck. The rebels had come: a group of many men, too many for Gloria to count, surrounding their home. Her father-in-law and mother-in-law and her two sons, eight and nine years old, clutched at one another on the ground, a rebel holding them at gunpoint. "Go!" her husband cried, in a muffled voice, unable to twist his face to look her in the eye as he mouthed the words.

"Go, run!" he cried to her.

The soldiers tied her husband's hands behind his back. Two men pulled him up on his feet. Dirt clung to the side of his face. They stabbed his back with the long black nozzle of an AK-47 and forced him to walk along the path that led away from their home. He locked eyes with Gloria for a moment before he disappeared on the road. The remaining rebels pushed Gloria's in-laws and her two sons into a round, grass-thatched hut. Her sons clung to one another with thin limbs and trembled with fear. The men doused kerosene on the hut and closed the door.

A young rebel emerged from the back of the main house where Gloria had lit the fire.

Horrified, she watched as he carried the stick, a red, burning ember at its tip, and without hesitation, plunged it into the roof made with the husks from last year's harvest. The roof caught fire and crackled. Her sons screamed. Her mother wailed a prayer. She watched helplessly as the fire consumed the house and her children were reduced to a thick white ash that floated in the sky.

Following the attack on her family, Gloria fled with her three daughters, crossing the border into Kisoro, Uganda. There, she slept in a church on a wooden pew, her infant daughter burrowing into her chest. Her husband came, at last, two months later. The rebels forced him to work as a mule, carrying cargo from camp to camp in the forests. One night, he and other Congolese men and women who had been kidnapped managed to escape the camp. When Gloria saw his face, she wept rivers. A month later, the UNHCR assigned them to the Nakivale Refugee Settlement and they boarded a passenger bus with other men and women from Eastern Congo to travel to the camp.

For seven years, Gloria and her family had gradually rebuilt their lives in the New Congo, sowing seeds of sustenance in the vast plains surrounding the camp.

"Come," she said. "Let me show you my garden."

Gloria led me through the back door, past her daughters who stirred at the groundnut paste, and into the backyard where she tended a vegetable garden. The intense green of Gloria's garden against the white, glaring sunlight startled my vision. A cluster of banana trees sprung from the earth, slumping under the weight of the full, green banana bunches. Spiky carrot tops, an explosion of leafy green cabbages, and white-stemmed Swiss chard sprouted up from a series of raised beds. A few ducks waddled beneath the banana grove, their tail feathers wagging back and forth. Gloria showed me how she mixed together ash, vegetable peels, and animal manure to make organic soil. She had also dug a metre-deep pit to collect rainwater from a folded piece of metal that ran off the roof of the house.

"The garden is my utopia," she said, gesturing at the greenery. "Women have carried with them too much sorrow here. We came with nothing in our hands and everything on our backs. But we can't do anything to change what happened to us."

In the fields, Gloria met other women who were also survivors. She heard their stories and grew to know the names of their surviving children. In the faces of the women's sons, Gloria saw the image of the sons she lost in the war.

"Today they would have celebrated their tenth and twelfth birthdays," she said.

On Sundays, following the church service in the New Congo, Gloria volunteered as a social worker, offering counsel to Congolese girls and women. The UNHCR reported that over half of the women living in Nakivale Refugee Settlement— nearly ten thousand women—had survived brutal assault and rape in Eastern Congo. Many other women witnessed horrific, dehumanizing crimes, which had been inflicted on the bodies of their husbands, children, parents, and neighbours.

"Trauma is like a snakebite," said Gloria. "The snake bites you and leaves the venom running through your body. But you cannot kill the snake to take away your pain. Even if you kill the snake, you will live with your suffering. So you must learn how to live again."

Despite the war, women in the New Congo had not given up on living or growing food. Every season, they dropped seed in the refugee soils and prayed for rain.

"Work is the best medicine. It saves us from being idle, and idleness is fertile soil for sadness," Gloria said softly.

At a small church in the New Congo, Gloria and other Congolese refugees gathered every Sunday to sing and pray and mourn the ghosts of their former lives. The women told stories from the past, wept, and threw their arms around one another. They beat empty jerry cans, making a rhythm. They had not forgotten how to dance.

8. CUBA

A woman sells her produce at El Pimenton's kiosk stand in a neighbourhood in Sancti Spíritus, Cuba. The kiosk is connected to an *organopónico*, an urban farm, where she and her husband grow vegetables, herbs, and fruits to sell to the neighbourhood for a subsidized rate. The rise of *organopónicos* in Cuba was a food security response to scarcity faced by Cubans following the collapse of the Soviet Union in 1989. (Photo by Trina Moyles)

"Count the number of old tractors and harvesters we pass in the fields," Fernando suggested, his eyes twinkling with playfulness. On an eighteen-hour bus journey across Cuba, from La Habana to Santiago de Cuba, I sat beside Fernando Funes, a Cuban agroecologist and one of the founding fathers of Cuba's sustainable agriculture revolution. "Just try to remember the number!" he cackled mischievously, taking off his straw *guajiro,* cowboy hat, the brim curling like an upper lip, while he ran his hand through his silver hair.

Moving eastwards along the skinny highway that cut through the fields of endless green *caña,* sugar cane, I followed Fernando's advice and watched for the old farm equipment that lay destitute on the land. *Unò,* a rusted-out tractor, parked beside an old barn in disrepair. *Dos,* an abandoned sugar cane combine from the 1960s. "It's one of the Soviet models," explained Fernando. *Tres,* a gutted state factory where workers once processed sugar cane for export. Fernando called the farm relics "evidence" of the failure of modern agriculture in Cuba. "Let them rot in the fields," he said. "Let them be a reminder of how an agricultural model that requires machines, petroleum, fertilizers, and pesticides is not a sustainable agriculture."

Cuba's former agricultural system—large-scale, mechanized, and "modern"—had relied on a steady flow of resources from the Soviet Union. But, since 1989, mammoth pieces of Soviet farm machinery had lain rusting in the fields, alongside ghost factories, both scarring the green landscape like strange carcasses. Before 1989, the Soviet Union sent vast amounts of agricultural supplies, including petroleum, pesticides, fertilizers, and livestock vaccinations, to fuel Cuban production of cash crops such as sugar cane, tobacco, coffee, and bananas. The Cuban government prioritized the export of cash crop products and imported 80 per cent of what the country consumed: rice, beans, grains, and vegetables. To the north, the United States enforced *el bloqueo,* an economic blockade against Cuba first established in 1960, prohibiting the flow of goods, including food and medicine, to and from the socialist island. When the

Soviet Union collapsed in 1989, severing the supply of food and farming supplies, Cuba woke up to a major economic crisis.

Without food imports to stock the grocery store shelves, how would Cuba feed eleven million people? How would Cubans till the soil without diesel to run the tractors? How would they transport farmworkers to their jobs without fuel to power the public transport system? How could farmers stimulate yields without synthetic fertilizers? How would they keep livestock fat and healthy without grain and imported vaccinations?

Agricultural production plummeted dramatically. Between 1989 and 1998 milk and egg production dropped by 60 per cent. State farms and factories shut down. Livestock perished. Precious cash crops rotted in the fields and, as a result, revenue from exports crashed. The government slashed the national food ration program to one-fifth of what it had been before the crash. Since 1962, the program had provided every Cuban citizen with guaranteed access to food, but after being cut off from the Soviets, the government's reserves dwindled. Between 1989 and 1994, the average Cuban's daily caloric intake dropped from 3000 to 2000 calories.

Fidel Castro, the ruling leader of the communist state, referred to the economic crisis as *El Período Especial*, or the Special Period During the Time of Peace. He urged the Cuban population to work resourcefully with the meagre supplies they had. Remarkably, people did just that: they began to grow vegetables and herbs in pots and containers on rooftops, to plant avocado and mango pits in their backyards, and to raise smaller, more efficient meat sources such as rabbits and guinea pigs. The Cuban state responded to the domestic food crisis by once again giving precedence to food crops over luxury cash crops like sugar cane and coffee. Without heavy-duty machinery to plough the soil, the state needed a younger generation of the *guajiros*, peasant farmers, to till the land using the *buey*, long-horned oxen, so it created government schools to teach these older techniques.

"Heavy-duty machinery compacts and breaks down the soil structure," explained Fernando, "whereas animals tread much more lightly on the soil. It's more sustainable."

From 1989 to 1994, alternative agriculture was transformed from fringe ideology to reality in Cuba. The Cuban government called upon the country's academics, researchers, and sustainable agriculture technicians, including Fernando, to provide expertise on local, organic, and resourceful methods of growing food, not only in rural locations, but also within marginal spaces in towns and cities. They supported existing farmers and new farmers to raise fish, chickens, guinea fowl, and ducks, and to grow more fruits, vegetables, *viandas*, potatoes, and grains. At national research centres, they experimented with developing new pasture grasses with higher levels of protein for cattle. Across the country, agroecologists encouraged farmers to use large numbers of red wiggler worms to convert organic waste into nutrient-rich compost to distribute to farmers. By the late 1990s—due to the efforts of state policy and, more importantly, the cumulative work of old and new farmers alike—the rate of food production gradually climbed again, the population's nutritional intake improved, and the food crisis abated.

"The crisis forced us to revolutionize the way we grew food in Cuba," said Fernando somewhere on the highway between La Habana and Sancti Spíritus. "Our agricultural system is more diverse today because of the crisis. It's not a perfect system and there's a lot of work that remains to be done. But what the Special Period taught us is that agricultural diversity is essential to adapting to disaster. We need many ways to grow food—not only one."

"Have Cuban women been involved in the sustainable agriculture revolution?" I asked.

"My dear wife, Marta, worked for thirty years as a biologist and an agricultural researcher. We worked together, every step of the way," responded Fernando, his voice wavering with emotion. "She was the love of my life; I was the love of her life. We had a deep love for agriculture and for our country. Marta was the other half to my orange, my *compañera* in everything."

Fernando reached into his briefcase under the bus seat and pulled out a manila folder filled with clippings from newspaper

and magazine stories about his wife's life and work at an influential agriculture research station in Cuba. Marta had passed away the year before. Fernando's eyes grew watery as he flipped through the stories about his late wife. They had been married for nearly forty years and had had two sons. Their skin grew weathered from work and age, but they had never tired of their love of supporting farmers and advocating for sustainable agriculture.

"I miss her more and more every day," Fernando confessed. "I did not know it was possible to love someone as I loved Marta. So, to answer your question: *sí, sí*, Cuban women have participated in the sustainable agriculture movement every step of the way."

His words caught me off guard: I could never have expected such vulnerability from a perfect stranger, from a man whom others referred to as a Cuban leader and one of the founding fathers of the sustainable agriculture movement. I felt deeply moved by Fernando's reverence and respect for his wife's work in sustainable agriculture. I took his hand gently and sensed emotion springing to my own eyes. Outside, the farmland blurred green.

FOR MANY WOMEN, the Cuban Revolution of 1959 symbolized a "revolution within a revolution." These famous words belonged to Fidel Castro, excerpted from his speech at a gathering of the Federation of Cuban Women in 1966. "Prejudices against women have existed, not just for decades, or centuries—but for millennia," Castro argued. "Under the forces of capitalism, women are doubly exploited and doubly humiliated. A poor woman, whether a worker, or belonging to a working-class family, was exploited simply because of her humbler status, because she was a worker."

Before 1959, Cuba boasted one of the richest economies in Latin America, entertaining foreign investment in sugar cane production, nickel mining, and tobacco industries. The island nation, however, also had one of the highest disparity rates between the wealthy and impoverished. The vast majority of

the working poor endured the uncertainty of seasonal labour in *la zafra*, the sugar cane harvest: slashing, harvesting, and hauling the sugar cane to the processing centres. Farmworkers, typically only men, laboured for only five months of the year in the sugar cane industry, and often went without work during the seven months that followed. Although half of Cubans lived in the rural countryside, 70 per cent of the farmland in Cuba belonged to only 8 per cent of the population: wealthy American investors and the national elite.

In the days leading up to the revolution in 1959, Cuban women, as a whole, suffered from a much bleaker reality than men. Fulgencio Batista, a Cuban businessman with close ties to the United States, ruled Cuba from 1940 to 1944, and again from 1952 to 1958. Batista neglected the social welfare of Cubans altogether: by 1953, the average Cuban lived less than sixty years, while 8 per cent of newborns did not survive their first month. Cuban women bore the brunt of Batista's regime, particularly black or mixed-race women, due to racial discrimination. Twenty per cent of women older than ten years were illiterate, only 2 per cent ever graduated from high school, and a mere one per cent of women received post-secondary education. Only 12 per cent of women worked outside of the home, typically as domestic and sex workers.

Women in Cuba faced abysmal social conditions and therefore began their struggle for gender emancipation in Cuba well before the 1959 revolution. Non-Cubans typically associate the faces of Fidel and Raúl Castro, and Che Guevara, with the Cuban revolution. But in fact, women, including Celia Sanchez, Vilma Espin, Haydee Santamaria, and Melba Hernandez, amongst many others, fought and struggled shoulder to shoulder with their male colleagues in the armed rebellion against Batista.

In the days that followed the revolution, gender equality became entrenched in the legal constitution and was enforced through political bodies such as the Federation of Cuban Women (FCM), which created universal daycare in Cuba in 1961 and advocated for gender equality in employment, education,

healthcare, and political participation. As a result, nearly sixty years after the revolution, Cuba now demonstrates some of the best gender-equality indicators in Latin America. Women now represent the majority of Cuba's high school and university graduates, and comprise nearly 50 per cent of the National Assembly.

While *machismo,* cultural patriarchy, still existed in Cuba, the 1959 revolution had helped women achieve and fulfill many rights to education, health, reproductive rights, and full participation in society. How had it affected women's abilities to participate in traditionally gendered occupations such as farming and agriculture? I wondered if Fernando's words were true: were women keeping up with men, step for step, in providing local food for the population?

I HAILED A TAXI from a street corner in Sancti Spíritus. *"Whoa, whoa, whoa!"* groaned the driver, pulling back on the leather reins, slowing his engine: a chestnut-coloured horse pulling a passenger cart rigged up with two wooden benches and a yellow plastic roof. The cart had been outfitted with a makeshift sound system, a small radio and two speakers tied in the corners just under the plastic roof. It wasn't a gimmick for tourists. Following the Soviet collapse and the oil crisis that ensued, horse taxis became an increasingly common mode of accessible transportation: cheaper to fuel and maintain than cars, with the added benefit of producing organic waste. A folded rice sack hung beneath the horse's rump, catching the manure before it fell on the streets. Twice a day, the driver unloaded his horse's waste at various composting collection sites set up in Sancti Spíritus. As I boarded the passenger cart from the back, a romantic *bachata* song played on the radio. The driver flicked the reins and the cart bounced along the street, the sound of the hoofbeats clomping rhythmically to the music—*uno, dos, tres, cuatro,* one, two, three, four.

We passed through the colourfully painted residential areas that surround Sancti Spíritus's *plaza.* People sat outside their

Following the 1959 Cuban Revolution, Fidel Castro recognized that gender equality would be critical to the health of people and the economy in Cuba. As a result, today Cuban women have the highest rates of literacy and of academic and professional titles in Latin America. Following the economic crisis of the 1990s, women were an integral part in revolutionizing the way food was grown and distributed in the country. (Photo by Trina Moyles)

homes on the pillared verandas, hovering over games of dominoes spread out on low tabletops and leaning back in wooden rocking chairs. Kids played *béisbol*, baseball, Cuba's beloved national sport, on the street with broomsticks for bats and rubber balls. Only ten minutes away from the main square, the driver murmured to his mount and rolled to a halt beside an urban farm bordered by apartment buildings. The large sign out front read *Linda Flor*, Beautiful Flower, and the farmer, a woman named Edith, waited by the roadside, waving warmly at me.

Edith's friends called her *La Chiquita*, the small one, because she barely reached five feet. She wore her carroty-coloured hair

cropped short to just beneath her ears. Her orange hair clashed with the screaming hot-pink colour of her shirt, which read FEMME FATAL in rhinestones. The fifty-year-old farmer wore her stylish, skin-tight outfit with black rubber boots and a pair of miniature cloth work gloves that enclosed her small hands. Aside from farming, she later confessed, she loved dancing. She seemed to be dressed to do both at once: weed, prune, plant, and shake her hips to bachata, salsa, meringue, and rumba.

I leaned down into her warmth; she grabbed my shoulders and kissed both my cheeks in greeting. *"Bienvenido, mi vida,* welcome," she said, using the Cuban term of endearment, 'my life.'

Wedged between the cotton-candy-coloured residential buildings, Edith's urban farm spanned two acres and was packed with long, concrete, raised beds where she grew a combination of flowers, vegetables, herbs, and medicinal plants. She specialized in propagating and experimenting with growing flowers. "They feed my soul!" she sang passionately. "Nutrition isn't only about feeding the stomach, it's about feeding the soul."

Fifty different kinds of flowers cascaded over the edges of the beds: pink hibiscus, big-headed sunflowers, various shades of roses and carnations. The flowers rose up out of the vegetables, punctuating the sea of green with reds, oranges, blues, pinks, and yellows. The farm contrasted sharply with the cubic, concrete apartment buildings, built in the uniform Soviet architecture, but made Cuban with the choice of canary yellow, turquoise, and lime-green paint. Residents hung their laundry on the balconies to dry in the hot sun and gazed down at Edith's long beds of food and flowers.

"Can you believe that, over twenty years ago, this farm was a garbage dump?" asked Edith. "We started the farm from *nada,* nothing. There wasn't even an inch of soil to grow from! People used to deposit and burn their garbage on this piece of land. Today they ask me, 'How did you ever think it would be possible to transform garbage into food and flowers?'"

During the 1980s, Edith lectured as a biology teacher at a high school in Sancti Spíritus. She remembered the harsh

impact of the Soviet crash in 1989: the bare shelves at the food markets, the exhausting wait times at the food ration stores, and the urban population's frenzied search for the minimum basics, such as vegetables and grains. Edith felt as though they were living through a war: enduring long power outages, or waiting for hours on the street corners just to catch a bus or taxi. She grew accustomed to going without meat, milk, and eggs as the large-scale state farms dropped off in production, some closing altogether. The government cut back on the ration system. People innovated, frying up root vegetables instead of pork and grinding split peas to add to the limited amount of coffee that was available. During the Special Period, the average Cuban adult lost from ten to thirty pounds.

In the 1990s, in response to the nutritional crisis, the Cuban government invited Edith and teachers from across the country to participate in a series of workshops on food production. "At those workshops, I fell in love with farming," gushed Edith. "I began volunteering on a part-time basis at a government vegetable farm in Sancti Spíritus. There, I learned the art of seed saving and seed propagation techniques. I loved the challenge of selecting the hardiest vegetable seeds, and breeding different flower varieties."

By 1994, Cuba's minister of agriculture, Raúl Castro, recognized the potential for institutionalizing food production in cities across the country. During the Special Period, the state struggled to produce high volumes of food on the former state farms and plantations, and to cover the fuel costs of transporting products to the cities. As a solution to the food crisis, Castro founded the country's urban agriculture program, enabling Cubans to identify empty, marginalized spaces in their towns and cities that could be transformed into *organopónicos*, or urban farms. Castro aspired to convert enough urban land to provide every city resident with five square metres of farmland, which would yield, every day, three hundred grams of vegetables. Cubans from different professional backgrounds, including teachers, lawyers, and nurses, became farmers overnight and began to grow root vegetables, leafy greens, fruits,

herbs, medicinal plants, animal feeds, and to produce meat, eggs, milk, and honey. The urban farms included small kiosks where farmers could sell their products, heavily subsidized by the government, to people living in their neighbourhoods.

In Sancti Spíritus, Edith walked through the neighbourhoods, searching for abandoned land. "Somehow," she said, shaking her head in wonder, "somehow I dreamed that I could, one day, turn an area of waste and neglect into *this!*" After receiving approval from the Cuban government, Edith enlisted the support of her father, a veteran rebel fighter who fought in the revolution, and a small team of retired Cuban men. "They were the only ones willing to help me," she recalled. "Everyone else, including my son and daughter, thought I was crazy. *'Ah Mami,'* they said to me, 'you're going to hurt yourself doing all of that heavy work. Look at your hands, look at your hair! Look at what you're putting yourself through!' But I was determined to do the work."

The biology teacher realized that she would have to build from the ground up and make her own organic soil. She knocked on every door of the residential buildings surrounding the land to recruit support from her neighbours. Inspired by Edith's resolve to grow food in their neighbourhood, people gave her their organic waste, including kitchen scraps, and paper and cardboard products. At the manure composting centres in Sancti Spíritus, she collected bags of horse manure from the taxi drivers. She layered massive heaps of the materials. Slowly, microorganisms broke down the organic material, turning the waste into black, nutrient-rich humus. She spread the compost on the soil in the beds, and watched seedlings push their green heads through the soil and tight buds unfurl themselves with brilliant colour. Linda Flor became increasingly productive. Her employees pushed food and flower carts throughout the city, selling directly to the public, as well as through the street kiosk. She hired more of her retired neighbours to help on the farm.

By 1999, Edith and other urban farmers in Sancti Spíritus were producing around fifty tonnes of vegetables and fruits for the local population, exceeding by far Castro's goal of three hundred grams of vegetables, daily, for every person in the city.

The majority of urban farmers in the city were male, but Edith's passion for food, and her strong work ethic, earned her respect amongst her colleagues. "Sometimes I've had to work against the current of thought that a woman does not belong in agriculture, or in the leadership of agriculture," Edith admitted. "But I've continued to struggle and work against that mentality. I make decisions and lead by example. I believe that I am seen—and appreciated—by my society, and even my government."

After her fifth year farming at Linda Flor, Edith received an official visit from representatives of the Ministry of Agriculture. She explained to officials how she worked with the community to collect their waste for composting and showed them the small workspace where she selected, saved, and propagated seeds. Impressed by her ingenuity and resourcefulness, the ministry granted her an additional acre of land adjoining her current plot.

In 2004, Edith attended a workshop organized by a local cultural and environmental foundation in Sancti Spíritus. The workshop focused on applying permaculture, a sustainably designed system, to Cuba's cities, farms, and urban farms. She fell in love with the theories of minimizing waste, using local resources, promoting diversity, and increasing efficiency. Edith began lending her teaching skills to the local organization, volunteering to share information with Cubans living in both rural and other urban areas. Hundreds of students from Cuba, Mexico, Ecuador, Canada, the UK, France, and Sweden traveled to Sancti Spíritus to tour through Edith's stunning farm and learn from her organic composting techniques.

"I used to feel so confined by teaching in a classroom. But teaching outside on my farm, I feel more alive and my students feel more alive. I think they are more attuned to listen, learn, and absorb information," said Edith thoughtfully. "It's true that a garden is also a classroom. I feel very blessed to be a Cuban woman, a farmer, and a teacher. I wake up early, I spend all day on the farm, working hard, managing the workers, planting, harvesting, selling, teaching—I do all of this out of love for my work. My work is my life."

FOR OVER A DECADE, Ismar worked as an agricultural technician on a tomato farm outside Sancti Spíritus. Every morning, she inspected the underbellies of leaves and examined the hairy stalks, looking for miniscule clusters of translucent aphids. She walked down the monocrop rows of tomatoes, searching for yellowing, wilting crops—signs of nematodes. A handful of soil could contain thousands of nematodes, microscopic parasitic worms that devoured root systems. Ismar monitored the tomatoes as they ripened from green to shades of golden yellow, blood orange and cherry red. Every few days, she mixed together a few capfuls of powdered herbicide into twenty litres of water in a yellow plastic spray pack. She heaved the pack onto her strong shoulders and walked up and down hundreds of rows of tomatoes, spraying and shrouding the crops in a fine mist.

"I handled chemicals on a daily basis," said Ismar. "It was my job to inspect and spray, inspect and spray. The herbicides and pesticides exterminated the pests, along with everything else in the soil. I never knew about the consequences of pesticides on soil and environmental health, let alone my own health. Before the economy crashed in '89, that's what they taught us in university: encounter a problem and spray, spray, spray."

She paused and counted aloud on her fingers, *uno, dos, tres, cuatro* . . .

"Four," she said. "That is the number of miscarriages I had while working there."

Ismar and I sat on wooden stumps under the cool shade of her banana trees, looking out at her *organopónico*, El Ranchón, a fifteen-hundred-square-foot plot situated in a neighbourhood in the city of Sancti Spíritus.

"I love my three daughters dearly," Ismar continued, "but I lost a son after carrying him for seven months. When he died, I quit the tomato farm. I swore that I would never touch pesticides ever again."

From a series of raised beds, Ismar grew rows of electric-green lettuce, green beans and peas, carrots, beets, and green onions. Ismar and her husband, Roger, lived in an apartment building adjacent to the urban farm. They sold their vegetables in front

After the economic crisis of the 1990s, Cubans began innovating in their own backyards. Farmers recognized the potential of breeding rabbits for meat sources. Rabbits are high in protein, low in saturated fats, and reproduce quickly. Rabbits are raised in elevated cages, where farmers can collect their manure for organic fertilizers in the gardens. (Photo by Trina Moyles)

of the *organopónico* at the *punta de venta*, a sales kiosk that faced onto the street. Customers came daily to buy green onions, tomatoes, and beets to supplement their rations of rice and beans. Ismar also sold her produce at a subsidized rate to a nursery school, adhering to the Cuban government's requirements that *organopónicos* provide healthy, accessible food to the urban population.

Twenty-five years had passed since Ismar worked on the tomato farm, spraying chemicals into the soil and onto the crops. When the supply of pesticides from the Soviet Union halted in 1989, Cuban agriculturalists had to learn alternative methods of controlling pests. They turned to practices that

had been employed for years by *guajiros*, peasant farmers, who could never afford the expensive pesticides sold in the market, but instead maintained traditional techniques of tilling the land with teams of oxen, mixing animal manure into the soil, and rotating crops to minimize pests. Mimicking the ways of the past, many Cuban farmers, including Ismar and her husband, returned to organic practices, applying organic manure, rotating fields of crops, and polycropping, a technique of planting compatible, mutually beneficial crops on the same plot of land. During the 1990s, after the urban agriculture movement began in Cuba, public health officials banned pesticide use in urban areas. The wind could easily blow toxic residues into people's homes and workplaces.

"Chemical pesticides kill everything, even the worms and microorganisms that are essential to soil life," explained Ismar. "If we kill the soil, we're killing *la vida*, life, also. We must learn to grow food in harmony with nature, not against it."

She pointed silently at a cerulean-blue-and-lime-green chameleon, slowly edging its way along the stalk of a banana tree. We watched the chameleon transform to blend in with the black-and-green banana stalk. It froze for a few seconds before its pink tongue darted out of its mouth, snagging a lazy fly, and, like a slingshot, recoiled back into its mouth.

"*Mira*, look," she said. "The chameleon is a small part of the farm and the balance of nature. The chameleon hunts for insects and, by doing so, she helps to keep the insect population in balance. But when we plant only one crop and spray pesticides, we create a hostile environment. We chase away the chameleon. We prevent nature from taking its course."

Ismar guided me along the rows of the *organopónico*, pointing out how she and Roger were using biological methods for pest control. They planted sunflowers along the edges of the vegetable beds. "The sunflowers grow taller than a person and their bright yellow petals and seeds attract pests that would otherwise attack the crops," she said. The scent of potent herbs wafted towards me. Ismar intercropped medicinal, aromatic herbs like *hierba buena*, the good herb, a variety of Cuban mint,

and oregano, throughout the *organopónico*. "They are natural pest repellents," Ismar explained. Inside the vegetable beds they grew a multitude of different vegetables. "Diversity," she said, "diversity is a farmer's greatest tool for building resilience against pests. Never try your luck on one crop alone. It's risky."

Ismar and her husband, Roger, grew to be recognized as leaders in the urban and sustainable agriculture movement in Cuba. Ismar took pride in sharing her knowledge about organic practices for pest control. She traveled throughout different parts of the country, imparting ideas and offering counsel to Cuban farmers. "I begin a workshop by telling people my story," said Ismar. "When you share something about yourself, that is a real teaching opportunity. People think agriculture is only about the science, the technique. But it's also very personal. It's about the love you feel for your profession, the love that motivates you to grow food for your community."

Recently, Ismar returned from her first 'mission' to rural Venezuela: in 2012, the Cuban Ministry of Agriculture selected her to fulfill a year-long posting in Guanayén, a small, farming community, as the leader of a team of agricultural consultants. "*Claro*, of course, I said yes. It was a tremendous honour," Ismar recalled. Few people know about Cuba's legacy of sending teams of agricultural specialists to live alongside small-scale farmers. The program, *Campo Adentro,* Inside the Countryside, had placed thousands of Cuban farmers with poor farming communities around the world to build relationships and trust, and to offer support and expertise for improving yields.

During her first week in Guanayén, Ismar joined a group of Venezuelan farmers, all men of varying ages, to broadcast maize and wheat in the fields. She worked alongside them, sowing the seeds, sweating under a blistering sun, and enjoying a brief *siesta*, rest, beneath an acacia tree. The men shared with her a tin cup of hot *cafecito,* sugary coffee, and a piece of sweet fried dough. She shared stories with the men about her family and urban farm in Cuba. She asked about their lives. They joked about the differences between the Venezuelan and Cuban Spanish dialects. "The men told me 'You eat your words,

Cubana!'" recalled Ismar. The men pointed out how Cubans casually dropped the 's' sound at the end of words, or the 'd' sound altogether. Instead of saying, *"Estoy cansado*, I'm tired," Cubans skipped over the 'd' and said, *"Estoy cansao."* "Are you tired, or something else?" the Venezuelan farmers teased her. One afternoon, while working in the fields with the farmers, Ismar glanced up to see a truck slowing alongside the road. A group of male farm labourers peered out curiously at her, the only woman doing the work that typically only men performed. *"¡Oye,* hey, Cubana!" one of them hollered at her. "How much is the owner paying you to work?" Ismar wiped the pooling sweat on her brow. *"Nada,* nothing," she replied. "I didn't come here to make money." The man responded, incredulous, "How can you be making nothing? We earn one hundred *bolivars* [fifteen American dollars] every day to work in the fields." "I didn't come here to make money," she said, repeating herself. "I came to live here in Guanayén, to work alongside the community, to share with them. I came for the *amor,* the love, of agriculture and to help the community grow more food!" "Okay, Cubana," said the man, surprised, but nodding his head in acknowledgement. The truck rolled away.

In the Venezuelan fields, Ismar worked with male farmers. Over time, the Cubana gained their trust and friendship. She felt they respected her, but she recognized her privilege as a Cuban, professional woman. Venezuelan society exempted her from adhering to its traditional gender roles. Women in rural Venezuela rarely worked in agriculture; they either sought employment in town or were *amas de casa,* housewives. Interestingly, the men listened to Ismar as she spoke about integrating organic production techniques into their farming. Often, they sought her advice. But when she attempted to weave social issues, including gender equality, into their conversations, the men shrugged off her words and retreated from further discussion.

"The men in Guanayén were very *machista,*" she explained. "Women had to do what their husbands told them to do. Some women were illiterate, having dropped out of school when they

were girls. Women didn't have the same independence we have in Cuba. In Guanayén, men would have three women in the same town. That was normal."

Ismar befriended the farmers' wives in their homes, drinking coffee with them, showing them photographs of her three daughters, and confiding to them the difficulty of working so far away from her family and community in Cuba. She encouraged the women in Guanayén to plant vegetables and medicinal plants in the small patches of land surrounding their simple clapboard homes.

"I would say to the women, 'Why do you waste your little money on food when you can grow your own? You will never be rich if you're buying your food.'"

Typically, Ismar's visits with the women transcended providing advice on what to grow in their gardens or solving specific problems about growing various vegetables. She also offered counsel to the young women, many of whom faced challenges in their relationships and marriages. Ismar told me about a twenty-year-old woman named Elsa, a mother of a one-year-old daughter, whose husband refused to allow her to return to her job at a hardware store in town. When her daughter reached her first birthday, Elsa was supposed to return to work after maternity leave, but her husband forbade it, insisting that she stay at home.

"I told Elsa, 'You need to convince your husband to let you go back to work, and to have your independence. If you lose your job, how can you ensure your daughter's security? What if your husband also loses his job? What if your husband leaves you for another woman?' Women cannot only depend on men," added Ismar.

Ismar had spent a year in Guanayén, integrating herself into the Venezuelan farming community, getting to know the lives of the men and women, and opening herself up beyond the limitations and privileges of her position. Her work extended beyond gardens, composting, and crop rotation. She shared her personal stories and opinions about many things with the farmers. When her mission in Guanayén came to a close, she

hoped that some of her ideas, particularly about gender equality, would take root in the minds of both men and women.

A year after she returned to Cuba, Ismar received a phone call from Elsa. "She called to thank me," recalled Ismar. "Elsa said to me, 'No one has ever advised me like that before. Not my mother or my sister. Nobody.'" She bent to pluck the weeds that grew around the young lettuce seedlings. Her long, shiny, black ponytail, held beneath a baseball hat that read *Te quiero, Cuba*, I love you, Cuba, caught the sunlight. She smiled through her joyful tears.

"I'm not rich. I don't have money," Ismar said thoughtfully, "but when I think about what I've done with my life—I feel like a millionaire." Ismar tossed the weeds on top of a compost heap and slowly moved through the rows of her produce to the sale kiosk, where a woman leaned casually against the counter, patient, her hair full of pink plastic curlers.

ODALYS NEVER WANTED to be a farmer. She wanted to be a sculptor, a painter, or a poet. She grew up in the epicentre of Cuba: in the capital city, La Habana, which some Cubans simply called *La Ciudad*, the City, as though it were the only urban centre on the island that truly mattered. The country's most important artists converged in La Habana, congregating at cafés, shaking their hips at the *Casa de la Música*, and strolling along the Malecón, an eight-kilometre seawall that separated the city from the turbulent, leaping waves of the Atlantic Ocean. At university, Odalys specialized in art history. She wove herself into a vibrant movement of young Cuban artists, and upon graduation she fell in love with a young man named Hector whom she met at a poetry reading. Hector recited the poems of José Martí, a Cuban poet and political revolutionary of the nineteenth century. Hector also worked at the Ministry of Agriculture and dreamt of being a farmer. Hector sang of land, seeds, and the image of the humble *guajiro*, the peasant farmer, with poetic reverence.

"Come with me to Matanzas," Hector begged his young, aspiring art historian *novia*, fiancée. "Let's create a masterpiece

Edith is one of the female urban farmers leading the way in the sustainable agriculture movement in Cuba. Over twenty years ago, Edith transformed an urban garbage dump into a productive *organopónico*, an urban farm. At her farm, Linda Flor (pretty flower), she grows flowers and vegetables, which she sells to the local population. Edith also teaches permaculture principles and organic soil building methods to Cubans and international students and visitors. (Photo by Trina Moyles)

on the land." And so Odalys abandoned the city, following Hector back to the land where his *guajiro* ancestors once toiled on the earth. Slowly, she later confessed, she grew into *"una campesina con la conciencia"*—a farmer with awareness.

"When I followed my husband to the farm, I felt as though I was somehow regressing back into worn-out traditions," Odalys recalled. "I felt far, as far away from La Habana as I could possibly get. I was so disconnected from media, music, and art."

"So I invited the city's artists to the farm," she said with a melodic laugh.

From the city of Matanzas I traveled east along the single-lane highway through a sea of sugar cane. The *caña* stood swaying

at over seven feet tall, ready to be cut and harvested. Nearly a kilometre in the distance, I saw Odalys's sculpture, the distinguishing landmark that set their farm apart in Cuba: a colossal farmer built out of large, stacked rocks. The giant faceless rock figure reclined beside the highway, drinking in the sun. I pulled into the driveway, through a wooden archway with a sign that read *La Conciencia*, Awareness. Odalys, a thin wisp of a woman with a bouncy, black bob haircut, waited outside her peach-coloured home. More of her creations lined the patio in front of the house: large ceramic vases sculpted with wide "O" mouths and painted with the images of Picasso-esque women and fluid fish. A giant silver ceiba tree cast shade over the ceramic-tiled roof. Fruit trees and tightly knit stands of bamboo were scattered throughout the yard, along with more abstract sculptures: human-sized chess pieces, wooden masks, and a ceramic statue of a Cuban *abuela*, a plump old grandmother, holding up a basket of food. Odalys and her husband maintained several acres of mixed-food forests, relying on techniques of agroforestry; they grew *guayabas*, or guavas, mangoes, avocadoes, a tiny sweet variety of bananas, orange-fleshed papayas, and trees to harvest for timber. Odalys also maintained a large garden for growing staple crops, including sweet potatoes, varieties of yellow and green oblong squash, and other vegetables and herbs to flavour her cooking.

"For women, farming is double the work," said Odalys. We sat at a small table under the shaded veranda behind her house. She had laid out plates of sliced pinkish *guayaba* and long, quartered sections of papaya. I palmed a papaya and scooped out the soft, sweet insides with a spoon, listening to Odalys talk. "When my three sons were younger, I did all of the cooking and cleaning in the home, yet I also worked outside with my hands in the soil, and not to mention my ceramics workshop." She let out a high-pitched laughed. "*Bueno*, well, for me, farming is triple the work."

On a pottery wheel powered by a foot pump, Odalys spun mounds of red clay into bowls, cups, and mugs. She hand-sculpted ornamental urns and decorative sculptures to hang on

the wall. From as far away as La Habana, Cubans journeyed to the farm to buy Odalys's ceramic creations. The ceramics workshop generated another source of income for their farm, and enabled her sons and their wives, her daughters-in-law, to inherit her craft in ceramics, along with agriculture.

"What do you prefer most?" I asked Odalys. "Being a farmer or an artist?" She laughed her sing-song laugh, and corrected my oversight.

"Agriculture is also a form of artistic expression," insisted Odalys. "They call it agri-*culture* because it makes us human. We're not practicing agriculture only for commercial purposes. We plant to feel happiness and to feel joy for what's growing on our land. Growing food is a form of art. It's the supreme art. Nature paints what no painter can achieve."

The earth under her feet provided a canvas, a vast landscape for creating works of art through food and sculpture. She invited artists from La Habana to use the land to bring to life their creations. We walked through her sprawling vegetable garden and I saw how she integrated ceramic sculptures amongst the leafy crops. Odalys stopped in front of one of the abstract sculptures of a round, faceless woman.

"What do you call this one?" I asked her.

"*La Matriarca,* the Matriarch," she said. "I draw much of my inspiration—as an artist and a farmer—from the work of women. I admire women that are involved in agriculture. It's a profession that beats you to the bone."

She reached out and ran a hand through a stand of bird of paradise flowers. The petals unfurled themselves dramatically, coloured as deeply as an orange sun, low on the horizon. "But this contact with nature—*tocando la tierra*, touching the soil, *luchando por su familia*, struggling for your family—it cleans the soul," Odalys said.

"It has added immeasurable beauty to my life."

As I continued along my journey towards Santiago de Cuba, I thought about the powerful relationship between art, agriculture, and feminism. Odalys had chosen to become a farmer the same way she had decided to dedicate her life to art and

expression. An upbeat folkloric song on the radio filled the bus with the sound of a flute and steel drums. The words made me laugh aloud in my seat as I moved east to the second-largest urban centre in the country:

> *Hay mujeres en el campo, hay mujeres bailando,*
> *En el patio de la casa, ella tiene calabaza,*
> *Y en la primavera, cosecha el boniato,*
> *Hay mujeres en el campo, hay mujeres trabajando*

> There are women in the fields, there are women dancing,
> On the veranda, she has squash,
> In the spring, she harvests sweet potatoes,
> There are women in the fields, there are women working.

NILDA HANDED ME a glass of *pru oriental,* a fermented refreshment that originated in eastern Cuba. I took a tiny sip of the molasses-coloured drink. The chilled liquid sweetness rushed to my brain. *"¡Qué rico!"* I cried, surprised by the intensity of the flavour. Nilda's lips, painted shiny eggplant, grinned widely, pleased with my passionate reaction. Years ago, Nilda resurrected the recipe for *pru* from her mother's cookbooks. After she mastered the art of making *pru,* Nilda went a step further by planting the ingredients—an array of obscure roots and trees—behind her house on the outskirts of Santiago de Cuba, located on the eastern tip of the island. Nilda insisted I write down the recipe for *pru* in my notebook.

"*Mi niña,* my child," she crooned, affectionately calling me 'my girl,' no matter that we met only hours earlier. "To make *pru* you have to harvest China root, *palo de jaboncillo,* pepper leaves, and bark from the cinnamon tree," she said, counting the ingredients off on her manicured fingers, her nails painted the same purple shade as her lips. "Then you pour the mixture into a bottle, add *un poquito,* a little bit, of brown sugar, and set under the sun for the whole day. When you turn the bottle cap and hear that '*Fzzzzzz*' sound, that's how you know it's done!"

On my first afternoon in Santiago de Cuba, an aggravatingly hot coastal city, I could already taste what the rest of the country knew it for: a *mejunje*, a mix, of Spanish, African, and Haitian cultural influences in the flavours of food, the rhythm of music, and the way people moved their hips while dancing. I had traveled here to meet Nilda, a proud *Santiagüera,* a university mathematics professor, PhD student, poet, and self-professed *campesina.* "¡*Soy campesina*! I am a farmer!" exclaimed Nilda. Her hand fluttered on top of her heart, dramatically tapping her chest, as if to show me where her passion stemmed from.

"I come home every day from the university, take off my high heels, and head to the garden to work," said Nilda in a matter-of-fact voice. "Sometimes people wonder why a female professional is interested in farming. Sometimes my colleagues make fun of me for being a farmer. They call me "*campesina*" as though it's a dirty word. They try to make me feel small, but I'm a proud farmer."

She arched her shoulders back dramatically and stuck her hands on her hips with an air of play and defiance. The Santiagüera in her tangerine blouse and bright orange bob glowed under the rays of sun that shot through the heavy, humid clouds. A smile drifted to my lips. How could anyone ever call Nilda *small*?

In her childhood Nilda traveled to help on her grandfather's ranch, which was just outside the city. She loved calving season and watching the slick four-legged creatures slip out of their mothers, enclosed in sticky membrane, their eyes blinking, full of wonder. At a young age, Nilda possessed a propensity for agriculture, for nurturing life out of the earth, but she never pursued farming as a topic of study or career. Many years passed without Nilda *tocando la tierra*, touching the soil. After graduating from university, the Cuban state assigned her to a teaching position in mathematics and physics in Santiago. Nilda married and gave birth to a daughter whom she named Gloria. She felt satisfied with her life in Santiago. Her husband had a kind heart: he cooked meals and helped raise Gloria into

Edith collects organic waste—kitchen scraps and scrap paper—from her neighbours in a residential area in Sancti Spíritus and composts the materials to produce organic soil for her flowers and vegetables. (Photo by Trina Moyles)

a young woman. At the university, Nilda enjoyed the challenge of helping students to discover unique pathways to solve their mathematics and physics problems. She found success in the home and workplace, completing a master's degree, watching her daughter graduate from college and, eventually, give birth to a daughter of her own. After her forty-eighth birthday, Nilda desired another challenge in her life, so she applied for a PhD program in mathematics.

And then, out of nowhere, the unthinkable happened.

After midnight on October 25, 2012, Hurricane Sandy raged over the Sierra Maestra mountain range, moving at over two hundred kilometres an hour, heading straight towards Santiago. The hurricane unleashed itself on the surrounding agricultural area, uprooting plantations of orange, grapefruit, and lemon trees, tearing up hundreds of acres of coffee, and ripping millions of sugar cane shoots, strong as bamboo, clean out of the earth.

"It felt like a nightmare coming to life," recalled Nilda.

Sandy struck Santiago full on: in the city, the wind tore the roofs from houses, offices, factories, and apartment buildings. Nilda woke to the sound of a mango tree crashing through the roof. It was too dark to see the effects of the hurricane, how it had picked up cars and thrown them back down, how the debris turned about as though inside a drying machine. She remembered the sound of shrapnel whizzing by. Nilda, her daughter, and granddaughter evacuated their house and raced to seek shelter with the neighbour in an old concrete pig barn. The storm lasted for over six hours. When light finally filtered into the morning sky, they witnessed the damage wreaked by Hurricane Sandy. Only the concrete foundation of her house remained: the wind had claimed the roof and four walls. The furniture and personal possessions that filled up the spaces of the place she called home were all gone.

"We did not have anything, not even clothes or shoes to wear," said Nilda. "I was totally broken. The morning after the hurricane, I felt as though I had hit rock bottom."

Nilda's home was amongst twenty thousand other homes severely damaged by Hurricane Sandy. Eleven people in the city perished that night, killed by the flying debris or crushed under the collapsing buildings. The city officials pulled bodies out from the piles of wreckage in the days that followed. Hurricane Sandy disrupted and destroyed agricultural production throughout the province of Santiago, uprooting nearly thirty square kilometres of banana plantations and destroying thirty tonnes worth of food. The storm hit fifty food distributing centres, one hundred grocery stores, ninety bakeries, and forty food markets, as well as food-processing centres in Santiago. Within days, crates of beans and maize and other aid items arrived from Havana, Venezuela, and Red Cross International.

Following the hurricane, Nilda spent her days standing in long line-ups at emergency centres, trying to get her hands on whatever food items she could: typically quantities of dried beans and maize, maybe potatoes, if she got lucky.

The Cuban government took months to repair and rebuild the damaged infrastructure in Santiago, but it provided basic food and healthcare services to the afflicted population. It also established a loan program to help the families who lost their houses. Nilda successfully applied to the program, which enabled her to purchase construction materials for 50 per cent less than their market value. Slowly, she and her family rebuilt their house, replacing the four damaged walls, and erected a new roof. Life went back to normal, yet Nilda could not help but brace herself for another disaster.

"The hurricane shook me," she said, her lips trembling with emotion. "Those days I spent searching for food, it was an enormous stress—physically and psychologically speaking. Even after the hurricane went away, that same stress stayed with me."

A year after Sandy, Nilda seized on the opportunity to attend an educational workshop at her church on the subject of sustainable agriculture. She had never heard the word 'permaculture' before, but she fell in love with its philosophy of transforming waste into productive agricultural systems. The presenters showed her photographs of home gardens and food

production systems from other parts of the country. Inspired, Nilda returned to her family's home and stood outside, reimagining the landscape surrounding the house. She put her ideas down on paper, mapping out in detail where she wanted to grow varieties of vegetables in raised beds, plant banana suckers, dig a pond for raising tilapia and ducks, and grow the strange roots and trees that yielded the ingredients to make *pru* and other traditional drinks and dishes from her mother's cookbooks. Nilda marvelled at her design on paper and set to work. She traded in her sparkly heels for black gumboots, her tight jeans for loose-fitting cargo pants, and dug in, determined to see her plan on paper come to life.

Three years after the hurricane, I came to Santiago to see Nilda's permaculture garden, a quarter-acre property on the edge of the city. She took my hand and led me through the garden. Trees towered above us: mango, avocado, and cinnamon. She pointed out the low-lying China root, an essential ingredient for making *pru*. In the banana plantation she grew food at all levels: on the mulch-strewn ground, *boniato*, white sweet potatoes; hanging off the trees, bunches of green bananas; and upwards, in the branches of avocado trees, the unripe, leathery fruits, hard as rocks.

Closer to her kitchen, Nilda designed a series of raised garden beds, which took the form of a large mandala. We walked around the mandala, the beds loaded with carrots, beetroot, different varieties of leafy greens, and wispy green onions. She knelt to show me her experimental plants, including the reddish-purple Jamaica flowers, which she cultivated for making juice and drying for tea, along with yellow string beans, green sugar snap peas, and purple lettuce.

"I love to experiment," Nilda enthused. "It keeps *mi amor*, my love, for the land, and it diversifies what my family eats. I take great pride in knowing that my work on the land feeds my family, particularly my little granddaughter."

Nilda fed her two-year-old granddaughter a plethora of garden harvests: steamed squash and carrots, mashed sweet potatoes and avocadoes, fresh bananas, mangoes, and eggs

from the carefree hen, which ranged and rooted throughout the garden, turning over the soil with its leathery talons, digging for grubs. The Cuban state provided a portion of the staple food items, including rice, beans, cooking oil, milk, and pork. Nilda lamented over the growing cost of different fruits and vegetables in the markets in Santiago.

"Food is expensive in Cuba," she said, "Just as it is expensive in world markets."

The inner walls of Nilda's home echoed the colours of the gardens. She led me inside a tiny kitchen, painted buttercup yellow with turquoise trim.

"Welcome to my laboratory," she laughed heartily.

Nilda had decorated her kitchen as garishly as a Mexican shrine on *Día de los muertos*, the Day of the Dead. She adorned the walls with small bundles of bright cloth flowers and large black-and-white family portraits in gold frames. She lined the cupboards with small wooden mortars and pestles and cloth dolls. A *guajira* doll wearing a straw hat smiled back at me with red embroidered lips. Her cupboard shelves burst with canned creations: pickled beets, carrots, and garlic, and vinegars made from mango and pineapple, cherry, and guava jams and jellies. Nilda had labelled and dated every jar in her blue, cursive writing.

"Many farmers are facing the challenge of food waste," explained Nilda. "Especially here in the tropics, fruits and vegetables rot quickly in the humidity, and most of us lack storage options. How do we get the most out of our harvests?"

Nilda found books in the university library, spoke with *viejas*, older Cuban women, and experimented with food preservation techniques. At the turquoise tiled countertops of her kitchen, she pickled carrots and string beans, used fruit peels to concoct vinegars, and collected bruised mangoes to slice and dry in the sun or blend with other fruits into juices, jams, and jellies.

"We throw out many parts of foods that could be reused to preserve other foods. Food waste is an issue everywhere in the world," said Nilda. "So I'm hosting workshops in my garden and kitchen to teach my friends and neighbours how to grow

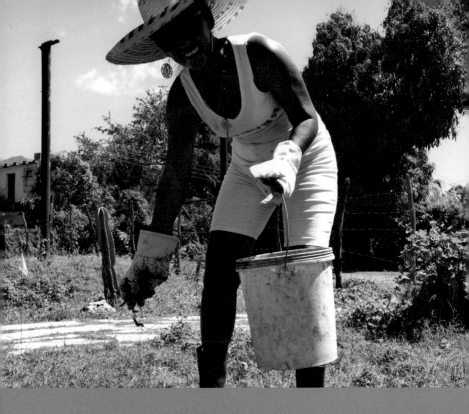

A woman hides beneath a wide sombrero while working in a permaculture garden in Santiago de Cuba. The temperatures soar in eastern Cuba, reaching 40 degrees Celsius. Using principles of permaculture, women grow a variety of vegetables and fruits, often under the shade of fruit trees, to feed their families and communities. (Photo by Trina Moyles)

their own food, but more importantly, how to get the most nutrients and value out of what they grow."

Hurricane Sandy had shaped Nilda into a farmer. The disaster catalyzed Nilda's recognition of her vulnerability, which she had transformed into action. She wisely assumed control and provided her family and her community with security by planting and preserving food, and by sharing knowledge with other people. "I feel in control on the land. I feel like I'm the owner of my own person," Nilda confessed passionately, as though reciting the lyrics of a poem or folksong. "I have sovereignty, *como mujer*, as a woman, I grow and consume what I want. *I eat what I love*."

Before I left Nilda's home in Santiago, she walked me through the garden and I glanced above at the sign she had hung overtop the arch of the main entrance.

"EL RENACER," read the sign, meaning, The Rebirth.

"*Mi niña,* my child," she said, taking hold of my forearm with her warm palm, "after the hurricane, I was reborn again. As I rebuilt my house, as I planted the seeds of the garden, I was reminded to *luchar, luchar, luchar*—to struggle, struggle, struggle. In the garden, I was born again."

BEFORE I LEFT Santiago de Cuba, I gave a presentation to a small gathering of male and female farmers, sustainable agriculture technicians, and social workers on the topic of gender and agriculture. I shared stories from my travels and research throughout communities in North America, Central America, East Africa, and South East Asia. I talked about the slow struggle for women's land ownership in southwestern Uganda. I showed them photographs of the cacao forests in the rainforest region of Nicaragua, and the deep red and purple ears of maize from the Mam communities in Guatemala. I spoke about the trauma of war on women's bodies and the resilience of women who kept planting in refugee camps. I described the way I witnessed women carrying the burden of a changing climate. I talked about how the injustices of the global food market discriminated against female farmers in particular and usually resulted in women eating last.

After the presentation, one by one, women rose up out of their seats and spoke.

"What's different in Cuba is that if a woman's husband leaves her for another woman, or to migrate elsewhere for work, she doesn't suffer alone in poverty," commented a social worker.

"Our government has supported women with equal access to jobs, childcare, food, education, healthcare, and the freedoms to participate in society," said another.

"My husband knows my worth as a woman and a human being," said a soft-spoken woman in her forties. "We are both farmers and we are both worthy of working on the land and

receiving the support to grow food." The man seated next to her—her husband—nodded and smiled.

"It's shocking to think violence against women and *machista* attitudes towards women still exist in this century," commented an agricultural technician. "Where women are not recognized by society, they are not fully valued. I wish I could travel to the fields and farms of the women you met. I wish I could tell them the ways we are growing food in Cuba and how deeply joyful we feel when we are working."

I stood before the women and men, listening to their passionate reflections, the hairs on my arms standing electric, on end, tingling with excitement. Emotion crept to the corners of my eyes. I felt as though I could cry, as many of the Cuban women had cried in front of me, baring their lives, their work as farmers. Their work gave them immense joy.

And then a Cuban man stood up and spoke. I swore I would never forget his words.

"Quite simply," he said, "achieving a sustainable agriculture system—one that will serve our needs today and the needs of our children and grandchildren tomorrow—is impossible without gender equality. Women's freedom is a part of the work. It's what men and women, and our larger societies, must strive for."

The women and men before me nodded their heads in acknowledgement, murmured *"Sí, sí, sí,"* and smiled at one another. I felt the hot liquid in my eyes, the gravity pull of a joyful tear, spilling over the edge of my eye, dampening my skin like rain on the earth.

MANY OF THE CUBAN WOMEN I met had inherited the social benefits of the 1959 revolution: equitable access to basic food, shelter, education, employment, childcare, and healthcare. Their bodies had softened with age, some had watched their children give birth, bounced grandchildren on their knees, and spoiled them with sweet mangoes from the garden. A few of the women ventured closer to what Cubans called *el tercer ojo*, the third eye,

and the age of wisdom. But what about the generation of Cuban girls and women born decades after the revolution? Would they embrace the values of food, family, community, and culture the same way their mothers and grandmothers had? Were they willing to sacrifice individual materialism for the wellbeing of the greater society?

In 2015, the two presidents from Cuba and the United States—Raúl Castro and Barack Obama—shook hands and announced to the rest of the world their commitment to reconciling political and economic relationships between the two countries. What social and economic changes would occur in Cuba? How would they affect women and farming? Cuban feminist scholars, including Norma Vasallo, president of the Women's Studies Department at the University of Havana, warned that the "updating of the economic model" in Cuba could negatively affect gender equity in the country. By eroding government support to women in the form of basic food guarantees, childcare, education, and employment, would Cuba's future generations of women thrive the way their mothers had?

"Everyday I'm alive, I'm trying to impart what I know to be good with my three daughters," Ismar had shared with me. "I want them to know how to plant, grow food, and love the land they're on. To watch them cultivate their own relationships with the earth and with agriculture—this gives me tremendous satisfaction."

As I boarded the airplane and flew away from Cuba, the tiny island located only twenty-five kilometres from the American fingers of the Florida Keys, I wondered whether the new economic influences that would surely come to Cuba would enhance or hinder women's participation in the sustainable agriculture movement. Would society continue to recognize Cuban women as equal agents of change—in schools, universities, governments, and the rural and urban fields of crops? Furthermore, would sustainable agriculture survive, or would it give way to the American model, which includes heavy-duty machinery, petroleum, pesticides, fertilizers, and an emphasis on growing and exporting cash crops instead of food crops?

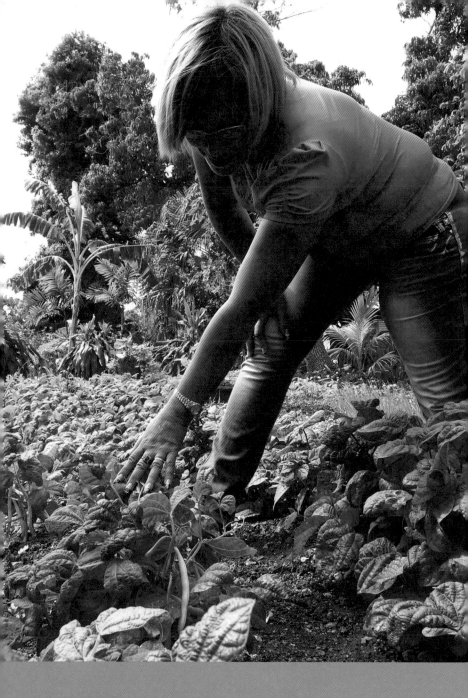

Nilda, a university professor of mathematics and urban farmer in Santiago de Cuba, reaches for a crop of yellow beans. In her backyard, Nilda is growing over thirty varieties of vegetables, herbs, medicinal plants, and fruits. After Hurricane Sandy swept through Santiago de Cuba in 2012, Nilda's home was completely destroyed. She picked up the pieces and planted a permaculture garden, which she calls El Renacer, The Rebirth. Today she teaches her neighbours and other community members about food processing, making jams, juices, dried fruits, vinegars, and other food items. (Photo by Trina Moyles)

Five months later, I stumbled upon an article in *The Guardian*, entitled "The Farmer Who's Starting an Organic Revolution in Cuba." As I read more closely, I saw a photograph of Fernando Funes Monzote—the son of Fernando Funes, the man who spoke so passionately about his wife and her contributions to the sustainable agriculture movement in Cuba. The journalist captured the story of Monzote, an agronomist in his forties, and his work on a twenty-acre farm, applying the principles and practices of sustainable agriculture. On the land, he used organic methods, agroforestry, permaculture, and polycropping. He planted more than sixty varieties of fruits, vegetables, and grains. As I scrolled through the article, I admired the photograph of three women at work, with their hands in the black organic soil. A pitchfork stuck out of one of the raised vegetable beds. The women laughed and draped their arms around one another. The photograph captured the energy, passion, and conviction of the Cuban women I had also met in fields and urban farms across the country.

The article about Monzote and his work inspired me, but I knew that the journalist had overlooked the deep, emotional meaning behind the namesake of the farm. When I read what the young man had decided to call his *finca*, farm, a smile surfaced instantaneously on my lips.

He named the land after the woman who brought him into the world, who fed him, nourished him, and fought alongside his father to bring about the sustainable agriculture revolution in Cuba. *Finca Marta*, he called it. He named the vast stretch of organic farmland in honour of his mother.

CONCLUSION

For three years I traveled across three continents and eight countries, journeying into remote, rural places on roads that were hardly roads but really crude strips of dirt and dust and rock, penetrating fields of rice, wheat, maize, beans, squash, vegetables, and fruit trees. I longed to meet the *abahingi mukazi*, the women who dig, women whose contributions to farming, growing, processing, and distributing food—ultimately feeding the world—was undervalued, misunderstood, and largely ignored by their own communities and the larger global one. I wondered why so many cultures around the world have been so reluctant to perceive and call women what they actually are in the truest sense: not women who dig, not farmwives, nor farmers' daughters, but *farmers.*

Feminist scholars have often referred to women's work as 'invisible work': work that occurs in domestic and community spaces, work that is always underpaid and often unpaid, work that remains unaccounted for in national and global economic figures. But at the end of these long, skinny roads—mostly hidden away from urban centres where wealth is concentrated, resources consumed, markets controlled, knowledge authorized, and political decisions made—I found the stories that global statistics fail to capture and communicate. I saw through a lens where women gave meaning to the word 'work.' I met female farmers and farmworkers dedicated to the tasks in their fields, on the land, inside and outside of their homes, and at markets, and organizing in the name of food, family, and community.

Although their farming contributed tangibly to the public good, somehow society perceived their efforts as meagre in comparison to those of the male farmers operating tractors, combines, and threshers. But looking beyond the statistics for yield tallies, women emerge; they, on average, sowed and cultivated fewer cash crops per acre of land than male farmers, yet they grew a wider diversity of food products—like vegetables, herbs, medicines, eggs, meat, and wild mushrooms—on the same piece of land. It could be argued that these women were, in fact, more productive than their male counterparts, particularly if crop and food diversity is valued as an important

outcome. Of course, on a global scale, women own less farmland then men, but collectively women farmers are feeding the majority of Earth's 7.4 billion inhabitants. Their products may not travel thousands of miles, or traverse oceans in cargo crates to wind up in Wal-Mart's produce aisle, or in the feed bins on sprawling factory farms, or on the ingredient list of high-fructose products. Instead, the food these women grow remains close to the place where they sowed and harvested it. The efforts of women farmers tend to be localized: feed the family, feed the community, and steward the land.

Tragically, the women farmers I encountered along my travels also faced tremendous barriers to growing food. Particularly in Latin America, Africa, and South East Asia, girls and women had fewer pathways to study agriculture formally in the classroom and encountered greater obstacles when trying to acquire credit at the bank. They struggled to move their product from field to market and earned less on the dollar than their male counterparts, yet they persevered to nourish, clothe, and educate their children and their community. In North America, the skyrocketing cost of farmland and farm equipment—anywhere from tens, to hundreds of thousands, to upwards of a million dollars—undoubtedly prevents young, passionate women from accessing land and shaking up the male stereotype that persists in North American culture. Across borders, I saw how women toiled in their fields to be able to send their sons and daughters to school, to build financial security for their families, to eke out their own version of success. Steadfast, they swung their hand hoes, bent with hands in the earth, weeded until their backs ached, and watched their work germinate before their eyes. Despite the scorching sun and pounding rain that beat down on them, as one Ugandan woman had remarked, they toiled, mostly without recognition, on the land.

Every woman I met, across three continents, no matter how difficult her situation, expressed joy and gratitude for her work, thanking the earth for what she could harvest from it and pass into the hands and mouths of her loved ones. I admired the women's courage and commitment to providing themselves

and their communities, as much as possible, with food they grow themselves. As 'La Cubana,' the Cuban farmer Ismar, would attest, the most important quality a farmer could possess was *love*. Love for watching seeds unfurl themselves and rise through the soil like tiny green fists. Love for nurturing the young of cows, sheep, pigs, poultry, and goats, and for harvesting their eggs, milk, and meat. The women's love of their work filtered into every mundane, exhausting task that farming entailed. Reflecting on her experiences as a farmer moved Ismar to tears. How many people could express the same depth of emotion for their life's work and purpose? To feel that joy and love emanating from so many women across many borders deeply moved me. I witnessed again and again how farming meant significantly more to women than yield sizes, profits, and public praise.

I will keep forever pressed in my mind the image of Mam women in northwestern Guatemala, dressed their brilliantly coloured traditional woven skirts and blouses, standing up to the riot police and Guatemalan military, in protest against the Canadian-owned gold mining company, Goldcorp. With their bodies, the women fought for their land, forests, clean water, and for preservation of the sacred. Every day Mam women defied Goldcorp's wish that they would sell their land and disappear by working rebelliously in their fields, by continuing the legacy of farming and herding sheep on their cultural lands, and by hanging their ancient maize seeds, sparkling tangerine, magenta, and ruby red, to dry in the sunlight. These seeds, though their origins trace back through multiple generations, are ever adapting to a changing environment and climate: they represent the past and the future of farming.

With seeds in their fists, women are armed to resist forces of the global food industry that seek to standardize and monopolize control over seed distribution and preservation. Presently, there are three corporations vying for domination of the global seed market: Monsanto, DuPont, and Syngenta, who collectively account for nearly 50 per cent of the worldwide seed market. Surely then, the act of sowing, selecting, and saving

ancient varieties of seeds has never been a more powerful act of defiance than it is today. Women farmers are collectively propagating and protecting the genetic diversity of foodstuffs for generations to come. They also harbour and keep safe the names and uses of the wild plants that naturally spring from the slants of mountainsides, within the depths of tangled rainforests, across desert plains, and along porous coastlines. They will pass their knowledge of wild herbs, mushrooms, roots, and plants—much like seeds—onto their daughters and granddaughters, who will face the challenge of growing food in a rapidly changing and unpredictable world.

And changes to the way we grow food are, certainly, on the horizon.

Nowhere had women farmers experienced change so sharply, so painfully, as had the Congolese women I met on the sun-dried, desolate soils of Nakivale Refugee Settlement. Three decades of war and conflict had brutally severed women and their families from their ancestral agricultural lands in the Democratic Republic of Congo. The memories of the land that they were forced to abandon—remembering the soft, black, volcanic soils that nurtured a wide diversity of vegetables—would not fade as their years as refugees in Nakivale accumulated. They longed for those lost soils. Yet, incredibly, the unthinkable violence women had endured during the conflict in the DRC, and the physical and psychological events that branded and scarred their bodies and minds, had not immobilized them, nor deterred them from their commitment to dig. Sowing seeds into the scorched soils, the women told me, was far preferable to idly sitting by, waiting around for rations from the United Nations. The rhythm of digging, the dropping of seeds, and gathering with other women in the fields calmed women's minds and slowly began to alleviate the memories of war that they carried everywhere, like heavy loads of firewood on their heads.

Farmers in many conflict regions face uncertainty as to whether or not bullets will fly across their fields of crops today or tomorrow—or the day after that. But what I saw in Nakivale Refugee Settlement taught me that, in the face of mass

displacement caused by political and environmental instability, women are playing a key role in recovering from crisis, building security, and redefining healthy communities by returning to the earth and growing food. I learned from the Congolese women farmers that it is possible to grow hope anywhere, even on refugee soils.

Global political and environmental crisis will, tragically, continue to displace women and men from their land and livelihoods as farmers. By June 2016, the number of people displaced from their homes, worldwide, had reached a new high: the United Nations estimated 65.3 million people have been displaced due to war, conflict, ethnic oppression, and environmental disaster. I wonder how many of those people had been farmers and, specifically, female farmers. How many women would lose their land and connection to growing food? How many women would no longer sow their traditional seeds as a result? How many would be forced to live undocumented or illegally in another country where they'd toil as a farmworker on a larger, corporate venture?

What does the future hold for women farmers around the world?

Farming, in general, has never been so uncertain or precarious, particularly for small farmers whose yields cannot compete in global food markets with the yields of factory farms and the rapid expanse of agribusiness. Many of the women whom I met confessed to me that they did not wish for their daughters to become farmers. Why wish that kind of burden or struggle upon their lives? Women recognized how different political, economic, and cultural systems had been stacked against them. They wanted their daughters to have options, freedom, and power—not to endure the poverty and powerlessness that many small farmers, particularly women, are battling against today.

But other women, including the Mam women from Guatemala, felt that land and their knowledge of growing food would give their daughters and sons security, not only in terms of sustenance, but in terms of cultural and spiritual identity. This belief is what fuelled their decade-long fight against Goldcorp and the

gold mining projects on their ancestral land. They are defending their right to remain on the land they intend their children, one day, to sow and harvest. I recalled the words of an elderly woman named Juana Maria. "I will live a farmer and die a farmer on my ancestral land," she told me passionately. "And I hope my daughter and granddaughters will be able to do the same." As she spoke, the sounds of heavy-duty equipment and explosives rang in the distance, sounds from Goldcorp's latest efforts to uncover and exploit the long veins of silver that ran through the Mam's mountains. I remembered the words of another Mam woman who lamented, "You can't eat gold." Would political leaders ever recognize the sacrifice of agricultural lands, water, and forests due to the world's unsustainable, unquenchable thirst for mineral resources? Just as you cannot eat gold, neither can you eat oil and diamonds in order to survive.

In the face of political instability and climate change—leading to heightened global food insecurity—it's timely for world leaders to recognize the efforts of small farmers, particularly female farmers, and the collective roles they play in providing global sustenance, caring for soil, water, and forests, and building healthy, resilient communities. If political and economic systems actually supported women farmers by investing in small-scale agriculture (and not only in the large-scale production, which is dominated by male farmers), women could exponentially increase their contributions to society. To uphold the rights of small farmers, governments must curb the flow of cheaper imported crops into local communities, and thus create access to fair markets. In countries where women do not have the legal rights to inherit, co-own, or buy their own land, it's time to demand changes to these patriarchal laws. As I hope I've demonstrated, a woman farmer's ability to grow food is directly linked to her security on the land. Similarly, policymakers must begin to link domestic and gender-based violence to food productivity and sovereignty, and to recognize that a successful harvest also depends directly on a woman's right to live a secure, safe existence—free of violence and oppression.

Fortunately, some political leaders and global development specialists are speaking out in defense of women farmers and the distinct ways in which they grow food and feed communities. "Global agricultural policy needs to adjust. In the crowded and hot world of tomorrow, the challenge of how to protect the vulnerable is heightened," said Hilal Elver, United Nations Special Rapporteur on the Right to Food, in her first public speech in September 2014. "That entails recognizing women's role in food production—from farmer, to housewife, to working mother, women are the world's major food providers." Elver called on world leaders to transition towards an "agricultural democracy" that would empower small-scale rural farmers— many of them, of course, women farmers and farmworkers. In 2013, the United Nations published a report entitled *Wake Up Before It Is Too Late: Make Agriculture Truly Sustainable Now for Food Security in a Changing Climate,* which advocates that small-scale, organic agriculture will be better positioned than large-scale, industrial agriculture to survive and adapt in the face of continually rising temperatures and the impending scarcity of rainfall and groundwater irrigation. Women, of course, are leading the small-scale organic movement in countries all over the world, and particularly in developing nations.

Will world leaders heed the UN's advice and begin to empower small-scale agriculture, a model of farming preferred by the world's female farmers? Will they recognize what the men in Cuba whom I met had also recognized, that "a women-centred agriculture is a sustainable agriculture"?

The *abahingi mukazi*, the women who dig in southwestern Uganda, the same women whose stories and struggles inspired the seeds and the beginning of this book, told me that they would not wait around for the government to provide land, seeds, tools, and training for their efforts to grow more food. I witnessed their conviction and resolve to attain self-determination in the steady, untiring way they swung the *efuka*, the crude hand hoe, from sun up to sun down, how they gathered together, sang, laughed, wept, pooled their resources, and planned for their futures. The stories of violence that I listened

to—stories of women being killed or beaten for attempting to sign their husbands' land into their own names—were horrific examples of the violence and insecurity that women faced in Uganda. When would the law change to protect women's land and bodily rights in Uganda? To an outsider, the situation felt hopeless. But change, I was reminded by a good friend named Lilian, the daughter of a farmer, was forever in flux, even if you couldn't see it at the surface.

"Women," said Lilian with a knowing smile, "women are a current in a great, wide river. At the surface the water appears to move slowly. But underneath, the strength of the river is so great it can wear down any obstacle it encounters. Like water, women can move mountains." I knew Lilian was right. I had witnessed it in eight different countries around the world: women resisting the forces that prevented them from growing food and succeeding in the face of the oppression of patriarchy, market disparities, gender-based violence, and climate change.

Today and tomorrow, women will change food systems. They will feed the world.

They will remake history.

ACKNOWLEDGEMENTS

I want to express my deepest gratitude to all of the women farmers and farmworkers whom I interviewed in Canada, the United States, Nicaragua, Guatemala, Uganda, India, Cuba, and the Nakivale Refugee Settlement. Thank you for opening up your lives to me, for teaching me, moving me, challenging me, and for inspiring the pages of *Women Who Dig*. Your work as farmers feeds my own as a writer.

I also want to recognize the grassroots community organizations that were instrumental in helping me to facilitate research for the book: Asociación Maya-Mam de Investigación y Desarollo—AMMID (Guatemala), Centro Humboldt (Nicaragua), the Kigezi Healthcare Foundation (Uganda), the Graton Day Labor Center and Líderes Campesinas (United States), The Antonio Jimenez Foundation for Man and Nature and The Urban Farmer (Cuba).

I'm indebted to Bruce Walsh and his amazing team at the University of Regina Press: Alex Schultz, David McLennan, Duncan Noel Campbell, Donna Grant, and Marionne Cronin. Thank you for your enthusiasm, creativity, and commitment to bringing *Women Who Dig* to life.

I want to thank my agent, Marilyn Biderman, who believed fiercely in this book from the beginning and who was willing to take a new writer under her literary wing. Marilyn, you've gone *way* beyond the call of duty. Thank you for being the kind of agent who is also an editor, advocate, mentor, and friend. Your vision and tough love helped to polish a handful of stories into a published book.

Big gratitude to KJ Dakin, whose talent behind the lens (and on the 'off-the-beaten-path') put a visual lens on *Women Who Dig*. KJ, your work continues to inspire my own. *Mil gracias, hermana.*

Erinne Sevigny Adachi, this book wouldn't exist without you. Thank you for being my writing coach, advisor, and dear friend every step of the way. Also, thanks to you and Paul for always welcoming me back into the country and, oftentimes, into your home.

I want to thank Lilian Kamusiime, *webare munonga*. Lilian, thank you for being an amazing teacher, friend, translator, and guide. I'll never forget our adventures in southwestern Uganda, pushing a broken-down *boda-boda* taxi up the mountainside, meeting with dozens of women in their homes and gardens, and discussing the themes that eventually became the backbone of this book.

The heart of this book was born in southwestern Uganda. Thank you to all of my former colleagues at the Kigezi Healthcare Foundation (KIHEFO) who helped shape the ideas for this book, in particular, Dr. Anguyo Geoffrey, Caroline Kyampeire, and Alphonse Twinamatsiko.

To Ruben Feliciano and his inspiring team of social workers and agricultural technicians at AMMID in northwestern Guatemala, *Chjonte*. To Amado Ordóñez Mejía and all of the dedicated staff at Centro Humboldt in Nicaragua, *muchas gracias*. Special thanks to Sudarshan and Hema Pandey, along with their loving family, who hosted me in their home on Diwali and organized travel and research logistics in India. In Sonoma Valley, thanks to Jesus Guzman and Rosa Gonzalez at the Graton Day Labor Centre. Also, big gratitude goes to "Big

Bob" who hosted two crazy Canucks for that extra week. I'm indebted to Ron Berezan (The Urban Farmer) for having me tag along—*muchas veces*—on his inspiring organic farm tours in Cuba. Ron, thank you for introducing me to Cuba and facilitating the *gran amor* I have for the country and people today. You are an inspiring mentor and friend.

I want to acknowledge the Alberta Foundation for the Arts (AFA) for providing financial assistance in 2014 and 2015, which enabled me to write the first draft of the book. In addition, special thanks to the generous individuals who backed my crowdfunding campaign to cover my travel and research costs to Central America in 2014, particularly Dawn Boileau and Kate Hook, Brandon Bailey and Caitlynn Cummings, Linda Marsh, Lillith Smith, and Jody Wasend.

Special thanks to the editorial staff, especially Andrew Loewen and Tanya Andrusieczko, at *Briarpatch Magazine*, who published some of my earliest writing on gender and agriculture. I'm grateful *Briarpatch* provides me, and other emerging writers, with space to reflect and publish writing on critical social and environmental justice issues.

I want to thank three Albertan writers, in particular, who have been important mentors to me throughout this journey. Thank you to Marcello Di Cintio, along with Jennifer Cockrall-King, for early and ongoing encouragement to write this book. Enormous gratitude to Jannie Edwards, poet, teacher, and friend. Jannie, thank you for your decade-spanning belief in my writing. It all began with an orange suitcase and a one-way ticket to *open secret*.

To my dear friends in Edmonton, Peace River, and Kabale, as well as those who are scattered in too many cities and countries to mention here, thank you for sharing with me in the highs and lows of this journey, for uplifting and grounding me, and for always reminding me who I am. Special thanks to Melissa St. Dennis, Caitlin Jackson, Ashton James, Ravi Jaipaul, and Diane Connors for reading drafts and providing critical feedback and encouragement.

For Atayo Benson, *ma pati*, thank you. I couldn't have written this book without your unwavering faith and friendship—not to mention your amazing knack for delivering the right proverb at the right time. "The tortoise is slow, but always gets to where it wants to go."

To my family, thank you for your unconditional love and support. To Liz, Ken, Andrew, and Duncan Gurr; Mike, Lynne, and Oscar Moyles; Cindy Sirko; my brother, Brendan Moyles, Alisha, and my sweet nephew and niece, Masen and Brielle.

To Eli, for finding friendship in unexpected places; thank you for supporting me throughout the very last rounds of editing and publishing—and for our many adventures together.

And finally, to my parents, Linda and Dave Moyles: thank you for nurturing the writer, traveller, and activist in me, for teaching me to love, listen, and speak out. To you, I owe everything.

Trina Moyles

ACKNOWLEDGEMENTS: KJ DAKIN

I would like to give my heartfelt thanks to all the people who made this book come into being. First and foremost, I am so honoured and humbled by the generosity of every woman who opened up her world and her vulnerability to me and to my camera lens. You trusted me to capture not only your pain but also your strength and your dignity, and I am so grateful.

Thank you Bruce Walsh for taking a chance on an unusual topic and valuing our vision of a book that combines story with image. I would also like to give deep thanks to all the generous people, friends and beyond, who donated from their pockets, making it possible for me to travel to Guatemala and Nicaragua when I was flat broke. In particular I would like to thank Joan Manz, Ross Crockford, Lena Chorney and Shannon Lynch, David Fox, Mike Demyen, Shawn Smith, Edana Beauvais, Sal Robinson, James V. Scarrow, and Piet and Ina Visser for all of your incredible generosity.

To those who have supported me in becoming the artist and photographer I am still learning to be, my thanks are manifold and inadequate. Thank you, Misagh Ismailzai, for your unwavering belief in me and for helping me move beyond a Luddite's fear of technology. Thank you, Jonathan Clifford, for knowing there is an ebb and flow to creativity and photojournalism and encouraging me to keep doing what feels right to me, rather than what is fashionable. Thank you, Trina, for inviting me to collaborate. Working with you is always exciting, inspiring, fun, and an honour. May we rise together.

KJ Dakin

REFERENCES

PREFACE
King, Thomas. *The Truth About Stories.* Toronto: House of Anansi Press, 2003.

INTRODUCTION
Adovasio, J. M., Olga Soffer, and Jake Page. *The Invisible Sex: Uncovering the True Roles of Women in Prehistory.* Abingdon: Routledge, 2009.

Barber, Elizabeth Wayland. *Women's Work: The First 20,000 Years, Women, Cloth, and Society in Early Times.* New York: W. W. Norton, 1995.

The Canadian Encyclopedia (online). "Dominion Lands Act." www.thecanadianencyclopedia.ca/en/article/dominion-lands-policy/.

The Canadian Encyclopedia (online). "Homesteading." www.thecanadianencyclopedia.ca/en/article/homesteading/.

Mosby, Ian. *Food Will Win the War: The Politics, Culture, and Science of Food on Canada's Home Front.* Vancouver: University of British Columbia Press, 2014.

Patel, Raj. *Stuffed and Starved: The Hidden Battle for the World Food System.* Brooklyn: Melville House, 2012.

CHAPTER 2
"The Social Side of Mining – Marlin's Socio-Economic Legacy." *Above Ground* (blog), June 2017. http://www.goldcorp.com/English/blog/Blog-Details/2017/Marlins-Socio-Economic-Legacy-Lives-On/default.aspx.

CHAPTER 3
Belli, Gioconda. "And God Made Me Woman." In *From Eve's Rib.* Curbstone Press, 1993.

CHAPTER 4

Cediel, A., and L. Bergman. *Rape in the Fields. Frontline.* PBS, 2013.

García, Mario T. (ed.). *A Dolores Huerta Reader.* Albuquerque: University of New Mexico Press, 2008.

Khokha, Sasha. "Teen Farmworker's Heat Death Sparks Outcry." NPR. June 6, 2008. http://www.npr.org/templates/story/story.php?storyId=91240378

CHAPTER 5

Bissett-Johnson, Alastair. "The Murdoch Case." *The Canadian Encyclopedia.* Historica Canada, 2001– . Article published February 7, 2006; updated January 23, 2014. http://www.thecanadianencyclopedia.ca/en/article/murdoch-case/.

CHAPTER 6

Guad, William. "The Green Revolution." Address to the Tenth Annual Conference of the Society for International Development, Washington, DC, March 18, 1968.

"'My daughter was Jyoti Singh': Nirghaya's mother says not ashamed to take daughter's name." *FirstPost.* December 17, 2015. http://www.firstpost.com/india/my-daughter-was-jyoti-singh-nirbhayas-mother-says-not-ashamed-to-take-daughters-name-2548860.html.

Sharma, Betwa. "A Year Later, Family of Delhi Gang Rape Victim Press for 'Full Justice'." *New York Times.* December 16, 2013. https://india.blogs.nytimes.com/2013/12/16/a-year-later-family-of-delhi-gang-rape-victim-press-for-full-justice/?mcubz=0.

Udwin, Leslee. *India's Daughter. Storylines,* BBC, 2015.

Varadarajan, Tunku. "Jyoti Singh: Let's say it aloud, again and again." *The Indian Express.* December 20, 2015. http://indianexpress.com/article/opinion/columns/nirbhaya-jyoti-singh-december-16-gangrape/.

CHAPTER 7

"Rape: Weapon of War." Office of the High Commissioner, Human Rights, United Nations. http://www.ohchr.org/EN/NewsEvents/Pages/RapeWeaponWar.aspx.

CHAPTER 8

"Women's Work: Gender Equality in Cuba and the Role of Women Building Cuba's Future." Center for Democracy in the Americas. 2013. Washington, D.C. https://thecubaneconomy.com/wp-content/uploads/2013/03/CDA_Womens_Work1.pdf

Acosta, Dalia. "Cuba: Women's Department Draws Attention to Inequality." *Inter Press Service News Agency.* October 12, 2011. http://www.ipsnews.net/2011/10/cuba-womenrsquos-department-draws-attention-to-inequality/.

"The Farmer Who's Starting an Organic Revolution in Cuba." *The Guardian.* August 31, 2015. https://www.theguardian.com/world/2015/aug/31/organic-food-revolution-farming-cuba-restaurants.

CONCLUSION

Adrian, Edwards. "Global forced displacement hits record high." UNHCR. June 20, 2016. http://www.unhcr.org/news/latest/2016/6/5763b65a4/global-forced-displacement-hits-record-high.html

Ahmed, Nafeez. "Small-Scale Traditional Farming Is the Only Way to Avoid Food Crisis, UN Researcher Says." *Yes! Magazine.* October 3, 2014. http://www.yesmagazine.org/planet/un-only-small-farmers-and-agroecology-can-feed-the-world.

Wake up before it is too late: Make agriculture truly sustainable now for food security in a changing climate. Trade and Environment Review 13. Geneva: United Nations Conference on Trade and Development, 2013.

TRINA MOYLES is a freelance journalist, photographer, human rights activist, and community organizer. *Women Who Dig: Farming, Feminism, and the Fight to Feed the World* is her first book.

For over a decade, Moyles has worked with grassroots organizations to support rural development initiatives in Latin America, the Caribbean, East Africa, and Canada. In 2010, she co-founded the Ceiba Association, a youth-run organization in Edmonton, Alberta, to promote social justice in local and global communities. In 2012, she worked with The Urban Farmer to facilitate a permaculture internship program in central Cuba. From 2013 to 2015, Moyles developed a global public health learning program, focused on maternal health, child nutrition, and sustainable agriculture, in southwestern Uganda, working with Child Family Health International (CFHI) and the Kigezi Healthcare Foundation. In 2015, the Alberta Council for Global Cooperation recognized Moyles as a "Top 30 Under 30" for her outstanding commitments to supporting grassroots development in rural communities.

Her award-winning writing, often focusing on social and environmental justice issues, appears in *Alberta Views, Briarpatch, Modern Farmer, Permaculture Magazine, Swerve*, and *Yes! Magazine*, amongst other publications. Today, Moyles lives in Peace River, Canada, where she is currently writing a book about her experiences working at a remote fire tower in Alberta's northwestern boreal forest.

To read more visit: *www.trinamoyles.com* and *www.womenwhodig.com*.

PHOTO CREDIT: JONATHAN CLIFFORD

KJ DAKIN is awed and horrified by humanity. As a photojournalist and writer, she aims to complement the power of images with the context of words.

She has worked in a wide spectrum of locations and cultures, from the border of Turkey and Syria, to the mountains of Indigenous Guatemala, to the northernmost west coast of Canada. She has covered xenophobic policies in Cape Town and the lives of undocumented workers on Californian vineyards.

KJ has published in a variety of outlets, including: Al Jazeera America, *VICE, YES! Magazine, Briarpatch Magazine* and *Verge.*

Look for her hitchhiking, planting trees across Canada's remote mountains, or sipping whisky in smoky watering holes.